DETECTIVE

16 PAGES of COMICS

DAN TURNER

QUEENIE STARR

MURDER MUSCLES IN

by
ROBERT L. BELLEM

32 MORE PAGES—BETTER STORIES THAN EVER!

DANGER

is my business

An Illustrated History of the Fabulous Pulp Magazines.

Lee Server

Chronicle Books

SAN FRANCISCO

Table Of Contents

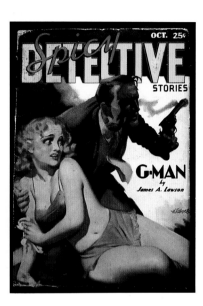

Introduction

THE PULPS CAME and went in the span of a human life. When the last of them expired in the 1950s, they had been looked upon for some time as primitive and outmoded—publishing's tawdry dinosaurs. Americans had found new sources for cheap thrills in paperback novels, comic books, and television. Once, though, in their heyday between the two world wars, pulp magazines had crowded the country's newsstands and drugstores with hundreds of titles and could claim a faithful readership in the tens of millions each month. By bland definition, the pulps were rough-hewn all-fiction periodicals costing from five cents to a quarter, but this gives no hint of their actual, extraordinary nature. Thriving on unconstrained creativity, held accountable to few standards of logic, believability, or "good taste," the pulps were literary dream machines, offering regular entry to intensive worlds of excitement, danger, glory, romance. Each brittle page held the promise of escape from mundane reality, a promise gaudily fulfilled.

The pulps took you to the Wild West and to outer space; to ancient Rome, South Seas islands, desert outposts of the Foreign Legion, gangland haunts, and haunted houses;

Left: This 1936 issue of Spicy Detective *offered the staple ingredients of the "Spicy" line of pulps, a smoking gun and a young woman in lingerie.*

The airbrushing technique and abstraction distinguish this cover of an obscure 1940s pulp, Leading Western. Western titles almost always featured more bluntly realistic illustrations.

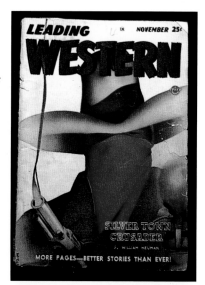

Adventure was one of the earliest, longest-running, and best of all the pulps. The issue for April 1936 featured a typically glistening portrait by the magazine's regular cover artist, Hubert Rogers.

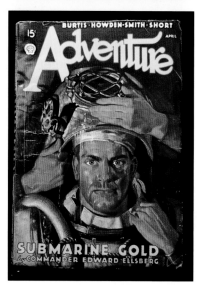

to the adventurous domains of Tarzan the Ape Man and Conan the Barbarian, the hospital corridors of Dr. Kildare, the mean streets of Sam Spade, and the violent realms of The Shadow, The Spider, and Doc Savage. On pulp pages, the imagination was loosed and roamed nearly out of control. When the pulps exhausted the possibilities in extant character types and popular fiction categories, they invented new ones—science fiction, sword-and-sorcery, hard-boiled detectives, occult detectives, erotic cowboy stories, tales of "Weird Menace," gangsters, flying spies, superheroes, masked avengers.

In the creative boom years of the 1920s and 1930s, new pulps flared in all directions, offering a manic diver-

sity of titles—*Weird Tales, Astounding Science-Fiction, Spicy Detective, Romantic Detective, Ranch Romances, Underworld Romances, Gun Molls, Gay Love, Pocket Love, RAF Aces, Fight Stories, Jungle Stories, Ozark Stories, Wall Street Stories, Railroad Stories, Oriental Stories, Courtroom Stories,* and *Zeppelin Stories,* to name a few. Something for every reader's taste, no matter how narrow or obscure, and quite a few things left over with no known appeal at all.

THEY WERE seven inches wide and ten inches high. The covers were printed on coated paper and featured three-color painted illustrations, most in the notorious pulp tradition of bright hues and flamboyant action, displaying brawny men and half-dressed women, figures frozen in a moment of maximum impact, a knife plunging into flesh, ack-ack guns exploding, or a terrified damsel poised in mid-scream. Between the covers, one found the cheap, drab-colored paper stock from which pulps got their name, pages like nubby slices of raw tree, the unbound side untrimmed, making the edges difficult to maneuver.

The front and back pages were given over largely to advertisements. With their reputation for sensationalism and low-class readers, the pulps seldom attracted brand-name or high-ticket ads. These went to the mighty "slicks"—*Cosmopolitan, Colliers, The Saturday Evening Post.* The pulps had to make do with advertising for the frowziest sort of oddball services and mail-order junk: general issue false teeth ("60 Days Free Trial"), remedies for piles, correspondence courses for aspiring private detectives and magicians, offers of "Coffee Agency franchises" ("... All applications will be held *strictly confidential!*"), "physical love" manuals, and quack medical digests ("Do YOU have epilepsy and don't know it?"). The contents page of each pulp detailed an editorial package of from three or four to a dozen or more items. There was usually an assortment of short features and fillers such as editorials, readers' mail, advice from experts ("To be perfectly frank, your method of handling snake skins is somewhat crude ..."), little poems ("Kisses—I have had many/One was like the pretty peck of a robin"), and pen-pal and personals columns ("I am a youth of twenty summers, tall, with steel blue eyes. I am a forest ranger ..."). The rest—85 percent of the total—was fiction, densely typeset, two-column expanses of imaginative writing in all styles and sizes. No exact count is possible, but approximately one million stories were published during the pulps' 60-odd years in existence.

Thousands of people contributed to this mountain of

fiction, but few of them could be properly called "pulp writers." That title belongs only to a small corps of professional storytellers, a few hundred men and women who produced a highly disproportionate share of all the pulp fiction. The work paid very little—an average of a penny a word and sometimes as little as one-tenth that rate. The more unscrupulous editors printed stories and never paid for them at all. Steady markets could fold overnight. Some stories might never find a buyer. It was a tough line of work. The only writers who could make a living from the pulps were the ones with the right combination of talent, instincts, stamina, and mania to produce good commercial fiction on a constant, almost round-the-clock basis.

Long before Kerouac, the pulpsters had, by necessity, invented their own form of automatic writing. "Up in the morning and hit the typewriter," says pulp veteran Richard Sale of his work routine in those days. "I wrote a story a day. Three thousand words, five thousand words. Sometimes it carried over into the next day if you were doing novelettes—that would be 12,000 words. You might spend some more time for the top magazines—*Argosy, Adventure, Blue Book*—but for the others you really rattled them off. First draft was the last draft, straight out of the typewriter and send it off. You had to keep them coming all the time ... otherwise you'd starve."

Hugh Cave, who began writing for the pulps in 1929 and continued to do so for the next 12 years, selling over eight hundred stories, recalls, "For most of that period I tried to average two sales a week. But sometimes you had to write a lot more than that in a week. A story might take weeks or months to sell. It was a full-time job. More than full-time. I used to put in 18 hours a day at the typewriter. A lot of writers stayed with one type of fiction but that limited your prospective markets. I tried to do them all. Detective, Western, horror, supernatural, "Spicy" sex, historical, Far East adventure, jungle adventure ... everything but love stories. I contributed to around one hundred different magazines in those years. I have a list here ... *Ace High, Ace Mysteries, Action Stories, Adventure, All Detective, All Fiction Detective, Argosy, Astounding,* let's see, that's the 'A's ...'"

The top pulp writers churned out 500,000 and one million words per year, year after year, a prodigious feat of typing, let alone original, coherent storytelling. Frederick Faust (a.k.a. Max Brand and assorted other pen names), Walter Gibson, Arthur J. Burks, and a few others could manage a staggering, finger-bruising annual production of two and three million words. Burks, a burly

"I tell you I'm Sieur de Caulain."
2

An illustration for the story "Dead Man Alive" in the December 1938 Golden Fleece.

ex-Marine who wrote his first story while fighting revolutionaries in Nicaragua, was known as the Speed Merchant of the Pulps, a writer so fast and so successful that he was a legend even among other prolific pros. "He was the fastest of them all," says Hugh Cave. "And he could do it anywhere, in a room full of people talking, could sit down without thinking and start writing a story, beginning to end." "Burks was so fast," says Jean Verral, a pulp editor at Clayton and Popular in the 1920s and early 1930s, "that he would write right past the end of the story and keep going for another couple of pages with almost a new plot starting. You just had to edit that out ... one time I bought a story from him and as a joke I sent back the

Shadow

10 CENTS

TWICE A
MONTH
MAY 1st
1939

A STREET & SMITH
PUBLICATION

DEATH'S HARLEQUIN

COMPLETE SHADOW NOVEL
AND OTHER STORIES

last two pages and told him, 'We only want to buy up to page 20.' He never rewrote anything once it left his typewriter and he put his rejected stories into a trunk and never looked at them again."

The professional pulp writer could not lie around and wait for inspiration, he had to develop ways of accessing it on demand. "Sometimes," says Richard Sale, "you'd sit there at the typewriter and just look around the room and pick an object, anything ... or think of something impossible, find an absolutely impossible thing and then literally go backwards and solve it." Some writers used mechanical aids to come up with story ideas. Neophytes and desperate pros invested in a thick, expensive book called *Plotto*, containing brief, algebraic descriptions of every possible story construction known to mankind. Pulp scribes studied the work of their competition, searching for new angles, fresh formulas. Anything new and successful was sure to generate a hundred immediate pastiches and variations. Some writers plagiarized themselves, recycling or repackaging the same material for different markets. Change the setting from Tombstone to Malaya, turn the marauding Apaches into marauding headhunters, and an old or rejected Western became a new jungle adventure story. Many writers had their own particular, idiosyncratic approach to literary creation. "When I needed something to start the mind going," says Hugh Cave, "one of the things I did was to buy a *Racing Form*, open it up and look at the names of the horses running that day— you know, the horses have very colorful names. And I would pick out a string of those names—let's say one was Lucky Lady and another was Sailor Boy and so on—and I would play with those and get the skeleton of a plot going." A writer for *Weird Tales*, the horror and fantasy magazine, had a unique source for some of his bizarre story ideas: the ranting, violent confessions contained in "fan mail" he regularly received from a reader/psychopath. A pulp pro took his inspiration where he found it and didn't look back.

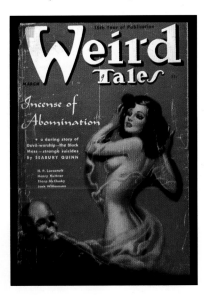

PULP WRITERS were a disparate group—ex-newspapermen, lawyers, retired soldiers of fortune, con men, convicts, poets, ranch hands, and hermits. Dashiell Hammett, who wrote detective stories, had been a detective.

Bruno Fischer, who specialized in sadistic *Weird Menace* stories, had been the editor of the Socialist party newspaper. Walter Gibson, author of hundreds of *Shadow* novels, was a magician. Tough-guy writer Roger Torrey was a lumberjack in Klamath Falls, Oregon. Borden Chase—real name Frank Fowler—a star contributor to *Argosy* and *Adventure*, was a chauffeur for Frankie Yale, the well-known bootlegger and king of the protection rackets; when some friends of Al Capone shot Yale 110 times, Chase started looking for another line of work.

Pulp writers were scattered all over the country, with another handful in Canada and England, and for many years Max Brand wrote his cowboy stories in a Renaissance villa in Italy. There was a sizable contingent of pulpsters in Hollywood, California, and an odd colony existed in the pinpoint-sized Florida town of Anna Maria, where the local residents became spooked by all the odd visitors pacing the beach, plotting murder mysteries and spicy sex stories. The foremost gathering place for pulp writers—accomplished and aspiring—was New York City. Manhattan was the world capital of rough-paper publishing, home to all the major houses and most of the minor ones: Munsey's downtown at 280 Broadway; Street & Smith in its own building at 79 Seventh Avenue, being shaken apart by the big presses running in the basement; Dell at 100 Fifth; Popular Publications at 205 East 42nd

Above: Although never one of the more financially successful titles, Weird Tales *was the artistic peak among pulp publications. This issue for March 1938 features one of the exquisitely erotic covers by Margaret Brundage.*

Opposite: The erotic and the bizarre frequently mingled on the cover of a pulp.

Street; Fiction House a few doors down at 220 East; Standard at 22 West 48th; Warner at 515 Madison; Culture Publications at 480 Lexington; Clayton Magazines at 155 East 44th. From these addresses flowed the manna of countless story assignments and paychecks.

During the Great Depression, writers by the hundreds came to New York like Dorothy to Oz. Portable Remingtons in hand, they checked into cheap residential hotels in midtown Manhattan. The big library on Fifth Avenue was nearby, handy for doing necessary research on the crusades, or witchcraft, or headhunters. With a new story to peddle, a New York–based writer could take it to the publishers in person, hoping for a face-to-face with an editor, and an assurance that the manuscript wouldn't go to the bottom of the slush pile. Some pulp houses were friendlier than others; at Popular, there was a ping pong table and on occasion there was a game of craps going in somebody's office, publisher Henry Steeger a frequent participant.

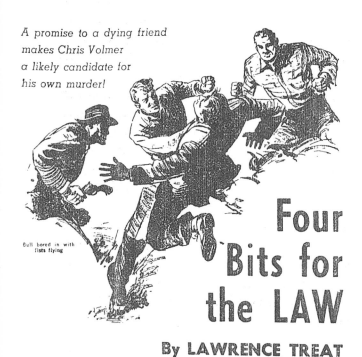

A promise to a dying friend makes Chris Volmer a likely candidate for his own murder!

Bull bored in with fists flying

Four Bits for the LAW

By LAWRENCE TREAT

Pictured, a typical rough-and-tumble detective story.

Editors were generally overworked and underpaid. Some were creative and some were hacks. They numbered nearly as high a percentage of eccentrics as the writers. There was John Campbell at *Astounding*, always ready to engage a visitor in arcane technological speculation; *Black Mask*'s Joseph Shaw, master of the épée, toting a sword cane to work; Charles Ingerman, philologist, fluent in nine languages, the somewhat unlikely editor of *Detective Fiction Weekly*. Another detective story editor was an active Communist. "He thought no one knew—I think he got into some trouble about it years later," recalls writer Lawrence Treat, "but he would get very excited if a story had a businessman as the killer, and if the murder victim was in a union you had a guaranteed sale." Ken White, editor of *Dime Detective*, did not like meeting writers. He told one, "I get a picture of a writer from his stories and think he's a big tough guy and then he comes in and he's a pip-squeak who wouldn't talk back to a schoolteacher. You're better off with me if you don't ruin my illusions."

But if an editor putting an issue to bed suddenly needed a particular-sized story by the next morning, a visiting writer could grab the assignment. Sometimes the editor's needs were even more pressing. Richard Sale remembers being strong-armed in the halls of Munsey's. "Jack Byrne, an editor there, caught me, said he needed a story in a hurry. Emergency! So he sat me down and I knocked out a three-thousand-word story...turned out to be a good little story. But I just happened to be there when the editor needed that space filled *now*. I gave him the story, went to the window, and they issued me a check right then and there and I went home. I got 90 bucks."

The fledgling pulp writer with no luck and no contacts in the business had one last hope, a visit to the desk space of Ed Bodin, a seedy pulp agent and king of the low-end sale. Bodin marketed any story you brought him for a $1 handling fee; he shared a small office room with a private detective, a button broker, and a repo man.

In New York, pulp writers got to know each other socially at publishers' annual Christmas parties, Art Burks' bathtub gin parties, certain after-hours watering holes, and regular meetings of the American Fiction Guild (membership secured with five pulp sales). "There was a great deal of camaraderie," says Lawrence Treat, writer for dozens of detective pulps. "The literary establishment did not hold us in high esteem and it was an us against them kind of feeling we had. I made some very great friendships in those days." The American Fiction Guild put out a newsletter

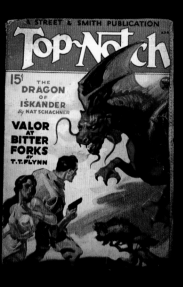

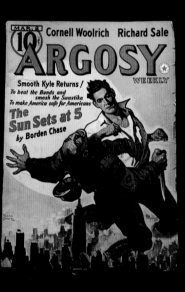

Top: One of the most successful titles of the pulps' first two decades was Top Notch. By the '30s, it was just one of many struggling adventure magazines, occasionally enlivened by an appealing Tom Lovell cover painting.

Above: Argosy was the magazine that began the pulp era. For many decades it was a top-seller and a respected purveyor of mainstream adventure and mystery stories.

with marketing tips and met every other week at Rosoff's restaurant in midtown. "It was a very friendly atmosphere," Richard Sale recalls. "You could talk over a story problem, or if a guy had an offer that he couldn't fulfill he'd pass it on to you ... You know, it was nice to have an audience because writing was a very lonely life."

"Some of those fellows," says Henry Steeger, "they really worked hard ... writing for days on end, never seeing anyone. It took some very talented people to work like that and write so many good stories, thousands of stories when you add them up ... I don't know how they did it ..."

THE PULPS in their time were looked down on as publishing's poor, ill-bred stepchild. One glance at their gaudy covers, ugly paper, and endless gray blocks of type was enough to condemn them in tasteful circles. Without the sophisticated design, the pretty pictures, and the name-brand authors of the expensive, slick magazines, the pulps had to make do with imagination and the power of the written word. This, as it happened, was their glory. Although it was not understood at the time, the pulps were creating an innovative and lasting form of literature—introducing new styles of writing and genres of popular fiction, discovering writers who would become some of the most widely read authors in the world, including Edgar Rice Burroughs, Max Brand, Raymond Chandler, H. P. Lovecraft, Louis L'Amour, Dashiell Hammett, Robert E. Howard, John D. MacDonald, Ray Bradbury, Erle Stanley Gardner, Robert Heinlein, and Kenneth Robeson (a.k.a. Lester Dent, author of the best-selling adventures of Doc Savage). The work of these and other pulp graduates continues to find a large and international readership, and the pulp-created genres—science fiction, horror, private eye, Western, superhero—now dominate not only popular literature but every sort of mass entertainment, from movies and television to comic books. This legacy will remain long after the last of the pulp magazines themselves—haphazardly saved and physically unsuited for preservation—have all turned to dust.

The following chapters attempt to chart the course of the pulp era and to detail some of its highlights, drawing on rare materials and the generous recollections of veteran writers, publishers, artists, and editors. It is my hope that these pages will bring back at least a glimpse of the creative excitement of a time long gone ... the fabulous days of the pulps!

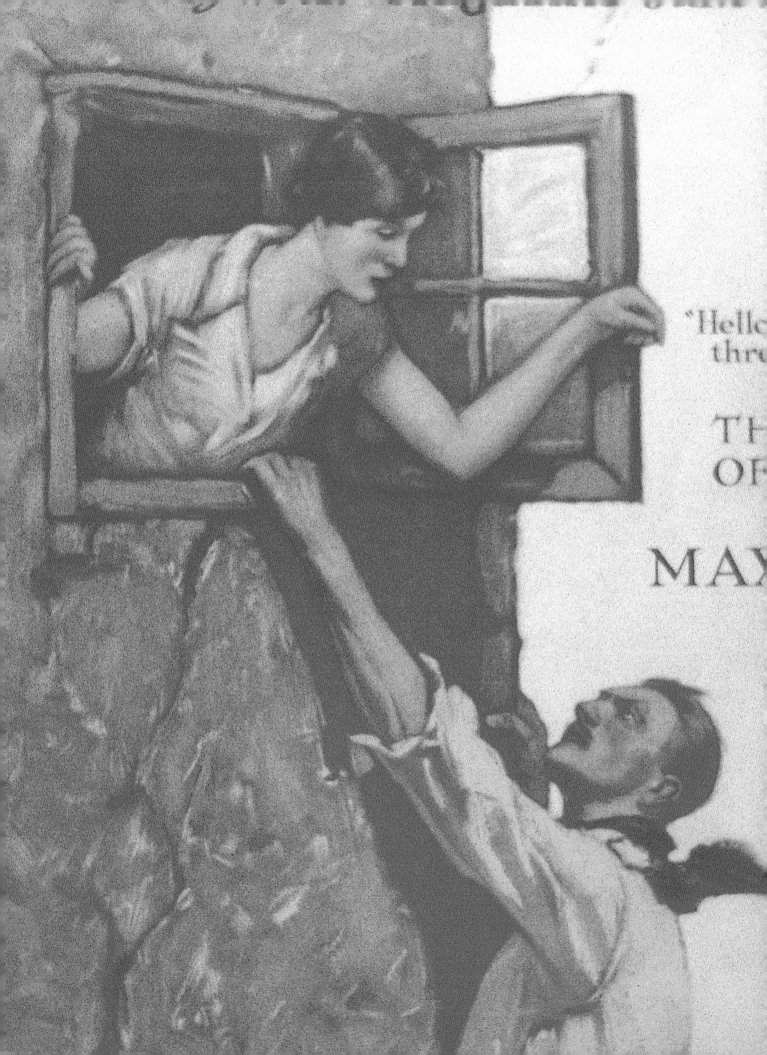

"Hello
thro

TH
OF

MAX

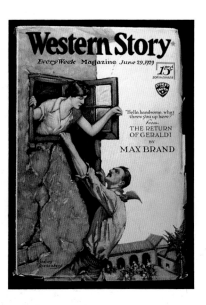

Fiction Factories

—————

THE BIRTH AND LIFE OF THE PULPS

It is certainly better for certain classes of persons to read exciting stories than to be doing what they would be doing if not reading.

<div align="right">

—FROM A SPEECH GIVEN AT A
CONFERENCE OF LIBRARIANS (1879)

</div>

THE PULP MAGAZINE was officially fathered by Frank A. Munsey with his publication of *The Golden Argosy* in 1882, but the tradition to which the pulps belong—that of cheap, popular, and sensational periodic literature—began some 50 years earlier. Reading for pleasure had once been the exclusive province of the upper echelon of American society, but in the 1830s a confluence of factors— the invention of the steam printing-press, the expanding postal services and railways, and a growing literate working class—made fiction affordable and accessible to the "common man." The first of the cheap, mass-produced publications were the so-called story weeklies, four pages long,

printed on newspaper, containing reading matter plagiarized from the high-priced American and English magazines. When the many competing weeklies found themselves all printing the same stories, they began to look for *original* material to steal. They sponsored various story-writing contests, offering prizes of $100 or so to the winning entry, along with the stipulation that all non-prize-

The story weeklies, with names like *Uncle Sam*, *The Star Spangled Banner*, *Saturday Night*, and *The New York Weekly*, designed their contents for the tastes of a readership of working-class Americans and immigrants. The stories were eventful, colorful, and sentimental. Subtleties and complexities were left for the elitist magazines. One weekly boasted of its contents as containing "sensational

winning submissions became the property of the weekly and could be published without remuneration. The story weeklies might then obtain a year's worth of new fiction without paying for it (the prize offers were usually bogus, in any case). In this way was a young and understandably gloomy Edgar Allan Poe suckered out of a half-dozen of his first short stories.

Eventually, the owners of the weeklies realized that to maintain a steady flow of usable material, they were going to have to pay for it. And from this need, the hack fiction writer was born. Before that time, it was generally assumed that the creation of stories was done only at the commands of a tortured muse, and the creation of stories for a living was possible by only a tiny number of the supremely talented. But the cheap story weekly publishers found out that fiction—like so many other items produced in the heady days of the Industrial Revolution—could be manufactured to specifications and on demand, written not out of the authors' life experiences, philosophical insights, or aesthetic visions, but rather out of the demands of the market. Fiction became a commodity, like the industrial-age items of clothing that no longer had to be hand-made, one at a time.

fiction with *no* philosophy!" Escapist literature, intended to be easily consumed and just as easily forgotten, came into its own in the pages of the weeklies, with their action-packed tales of the high seas and urban lowlife, melodramatic mysteries and romances. Ever mindful of consumer trends, the publishers turned every popular story into an instant genre, commissioning countless variations on a successful character type, setting, or plot twist. If readers enjoyed one story about an innocent girl being abducted by white slavers, or about an orphan newsboy making his fortune, or about an evil guardian putting his rich ward in an insane asylum, they would get to enjoy many, many more.

The authors of these lurid tales were a new breed of writer. Disparaged as "penny-a-line scribblers," they would never have found their calling in the gentlemanly fiction publications that existed before the story weeklies. But then few of the sophisticated and literary authors of the day would have had any idea how to please the weeklies' humble audience. The fiction hacks saw themselves not as artists but as craftsmen, taking a craftsman's pride in the work—its mass readership, the speed at which it was written, the paycheck it earned. Some fic-

tion hacks became famous. In 1840s America, the name of Joseph Holt Ingraham was known far and wide as the author of the immensely popular *Fanny H.—Or the Hunchback and the Roué*, and hundreds of other serialized novels. Longfellow said of him, "He is tremendous—really tremendous. I think we may say that he writes the worst novels ever written by anybody." Edward Zane Carroll Judson, who used the pen name Ned Buntline, had been a sailor and a soldier and was once unsuccessfully hanged by a lynch mob before he turned to writing for the weeklies. Wandering in the Far West after the Civil War, he became acquainted with a 23-year-old buffalo hunter named William Frederick Cody. Judson renamed the young man Buffalo Bill and began recording romanticized versions of his exploits for *The New York Weekly*. Buntline's tales of Bill and assorted other frontiersmen and gunslingers would be translated and published around the world. Even greater success was achieved by a shy Unitarian minister turned writer named Horatio Alger, Jr., author of 119 stories of poor orphan boys whose honesty is invariably rewarded in the end. Alger's fiction was thought to be inspirational, and to this day the phrase "a Horatio Alger story" is invoked to describe any born-poor American who has ever worked, inherited, or stolen his way to success.

Of course, the majority of fiction hacks did not find fame from their writing, and many did not even receive credit. Bylines were frequently assigned to established house names controlled by the publisher. Authorship was just another commodity to the publishers, important only insofar as it could be used to sell more copies. A popular but dead or overpriced author such as Dumas would have his name appropriated and affixed to the work of an anonymous hack. Similarly, another hack's work might necessitate the creation of a new, more appropriate and exploitable authorial personality. When, for example, *The New York Weekly* printed a sentimental fiction about Manhattan lowlife, the story was falsely ascribed to a young slum girl. The cynical editors even pref-

aced the story with a cover letter from the imaginary waif:

These sheets . . . have been written by work-weary hands; they have been wet with almost hopeless tears . . . Oh! do print it, if it is worthy, for my whole heart has gone into it. Respectfully, almost hopefully,

Your Orphan Friend,
Julia Edwards

After 1860, the story weeklies shared the cheap fiction market with the dime novels, which appealed to the same tastes and made use of the same writers and popular characters. Many of the "novels" were reprinted serials from the weeklies. Both formats were endlessly formulaic and for the most part atrociously written. The plots were mechanical and the characters bore next to no resemblance to the way real people behaved. Here, from one of the enormously popular adventures of young detective Nick Carter, is a typically breathless and ridiculous encounter:

Opposite and Right: Frank Munsey's Argosy magazine, launched in 1882 as a fiction weekly for children, became the prototype for all pulp magazines to follow. As a fiction weekly, Argosy thrived for nearly 60 years. Pictured here are issues spanning the first fifty.

"I know that you are under the floor of this room directly under the spot where I stand. If you try to escape I will shoot through the floor and certainly hurt you if I do not kill you. If you answer me I may permit you to escape. You understand English or you wouldn't be where you are. If you don't answer I will shoot just to prove that you are not there—or that you are. Are you there?"

"Yes. Me here, allee samee, like lat in a tlap," came the reply in pigeon English.

"Hello! A Chinaman, eh?" said Nick, and he winked at himself in the mirror opposite . . .

The weeklies and dime novels were awful stuff for the most part, but they did create the first mass market for fiction in America. The families and working men and women who had once read nothing more in a lifetime than the Bible, some schoolhouse primers, and a few perennial classics had been taught a reading *habit* by the cheap story papers and books. And this habit remained even after the readers began drifting away from the established forms, bored with the stale and repetitive plots and characters. They were ready for something new—"in ap-

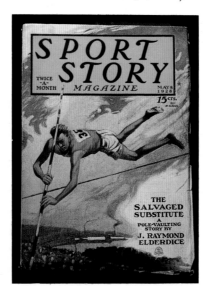

Above: Can one ever get enough stories about pole-vaulting? Here is one from the May 8, 1928, Sport Story.

Opposite: The December 15, 1913, issue of Top Notch offered readers a gripping tale of the now-forgotten sport of automobile polo. From Tangled Battle: "Cleve, his right foot on the forward spring, and his left hand clinging to the steel truss which protected the radiator, leaned far out to make one of his swinging drives . . . "

pearance," as the historian Mary Noel writes, "if not in substance." The pulps would repeat many of the publishing practices invented by the weeklies—the use of continuing series characters, hack writers, house names, the exploitation of popular enthusiasms, the emphasis on action and sensation, and little or no "philosophy." They would also develop their own stale, repetitive formulas and bad writing. And, in their time, the pulps would follow the weeklies/dime novels' trajectory from birth to ubiquity to oblivion. But they would also generate works of lasting merit and a level of creativity that would far outdistance the first, primitive pop-fiction magazines.

FRANK MUNSEY was a Maine telegrapher and aspiring publishing magnate in 1882 when he launched a cheap fiction weekly for children called *The Golden Argosy.* In a country filled to bursting with story weeklies, Munsey's lone entry did not make a dent. Slipping into debt, Munsey tinkered with his periodical, shortening the title to *Argosy* and aiming at an older audience. He started a second publication, modestly titled *Munsey's,* a general-interest magazine with illustrations. *Munsey's* was an unexpected success and inspired a further reworking of *Argosy* as a cheap and thick periodical. Since *Argosy* would be an all-fiction magazine with no pictures, Munsey decided he could cut costs even further by printing on the most inexpensive paper available—it didn't matter how crummy the thing looked, the owner reasoned, as long as the print was legible and there was plenty of it. The late 1890s version of *Argosy* had yellow covers, 191 pulpwood pages, 30 coated stock pages (for advertisements—those had to look a little less crummy), and 135,000 words of miscellaneous novels, serials, short stories, and poetry. The fiction was not at all distinguished, but neither was it the ludicrous stuff of the story weeklies. At ten cents per issue, and heavy as a lead weight, the new *Argosy* was a hit.

In 1905, Munsey launched another fiction pulp, *All-Story,* and in the next few years he would add several more new titles, all variations on *Argosy's* plump package of escapist lit. Other publishers copied Munsey's formula, and refined it. Street & Smith started their own bulky, rough-

DECEMBER MID-MONTH ISSUE
TWICE-A-MONTH
10 CTS.

Top Notch
Magazine

TANGLED BATTLE
Automobile Polo Story
this number

paper collection of light fiction, *The Popular Magazine*, and used illustrated covers, soft-focused paintings by such notable commercial artists as N. C. Wyeth and Henry Reuterdahl. Street & Smith had been a leading purveyor of weeklies and dime novels since the 1860s and would become the archetypal pulp house of the golden age, publisher of *The Shadow, Astounding Stories,* and *Doc Savage. The Popular,* aptly titled, was followed in 1910 by *Top Notch*. Other firms entered the pulp market that same year—Doubleday brought out *Short Stories,* and the Butterick Company launched *Adventure*. The first specialized pulps appeared: *Railroad Stories* and then, from Street & Smith, the first all-crime fiction magazine, *Detective Story*.

Up to around 1912, most of the fiction published in the pulps had been genteel and inconsequential. Now there began to appear more unusual fare—stories that had imagination and impact had created a lingering commotion among readers and a demand for more of the same. Editors with lively minds and discerning eyes had come to be in charge of several titles: the multi-talented Robert H. Davis, Munsey executive and head man at *All-Story;* Arthur S. Hoffman at *Adventure;* Robert Simpson, a colorful Scot and former trader on the African Gold Coast, now editor of *Argosy*. These men and a handful of writers established the parameters for what would become the definitive pulp story—larger than life, lucidly written, plot driven, with strong characters and lots of action, preferably violent.

The February 1912 issue of *All-Story* marked the professional debut of a writer whose importance to the —

history of pulp magazines is comparable to D. W. Griffith's place in the history of film. The first two serialized novels by Edgar Rice Burroughs electrified *All-Story*'s readership, drew new audiences to the pulps, and influenced a generation of pop-fiction scribes. Born in 1875, Burroughs had failed at a dozen jobs and enterprises—clerk, railroad cop, gold miner, soldier, salesman, etc.—before he turned to writing at the age of 35. His first novel, *Under the Moons of Mars* (later published in book form as *A Princess of Mars*), was the story of John Carter, a Virginia gentleman mysteriously teleported to the red planet—known to the local inhabitants as "Barsoom." Soon, Carter is tangling with the 15-foot, four-armed Tharks, the green men of Mars, sword-wielding creatures riding huge, eight-legged beasts. Eventually Carter runs into the luscious Dejah Thoris, humanoid Princess of Helium. Through various eye-popping adventures across the planet's bizarre, warring empires, Carter restores Dejah to her throne, marries her, impregnates her. Their plump, first-born "egg" is nearly ready to hatch when a sudden whirlwind of events

brings John Carter back to Earth. An adventure epic of nonstop invention and exotic action, *Under the Moons of Mars* ends in a rush of unresolved suspense. Breathless readers wailed for a sequel. Burroughs delivered one, *The Gods of Mars*, appearing just six months after the first story ended. It was another explosion of dazzling imagination—strange creatures, hairsbreadth escapes, fierce battles, a welter of bloodshed, and another cliff-hanging climax to leave readers gasping. But in between this double dose of Martian extravagance, *All-Story* published the second work by Mr. Burroughs, a novel that would prove to be even more spectacularly successful than the first: *Tarzan of the Apes*.

It begins in prologue. Lord and Lady Greystoke are abandoned on the uninhabited African coast by a ship's crew of mutineers. A baby boy is born, the parents die of fever and despair, and the child is saved by Kala, an adoring female ape who has just lost her own baby. The "White Skin" boy—named "Tarzan" in ape lingo—grows into young manhood with his primate family, loved by his stepmother, hated by his stepfather, Tublat. Tarzan's supe-

rior intelligence and the knife he finds in the abandoned cabin of his parents enable him to defeat the patriarch in a primal and epiphanic fight to the death:

As the body rolled to the ground Tarzan of the Apes placed his foot upon the neck of his lifelong enemy and raising his eyes to the full moon threw back his fierce young head and voiced the wild and terrible cry of his people.

One by one the tribe swung down from their arboreal retreats and formed a circle about Tarzan and his vanquished foe. When they had all come Tarzan turned toward them.

"I am Tarzan," he cried. "I am a great killer. Let all respect Tarzan of the Apes and Kala, his mother. There be none among you as mighty as Tarzan. Let his enemies beware."

The reaction of *All-Story* readers to Tarzan was virtual frenzy. A saga had begun that would reach every corner of the planet. Incredibly, the Munsey editors turned down the second Tarzan story, *The Return of Tarzan*, and it was quickly picked up by Street & Smith for their *New Story Magazine.* Subsequent sequels over the years went to the highest bidder—*Argosy, Blue Book, Thrilling Adventures*—and the readers followed, increasing when-

Above: Pulp heroes were frequent visitors to dangerous tropical ports. Writer George Worts specialized in Asian-Pacific settings.

Opposite: The early pulp covers were a far cry from the luridly realistic style of the 1930s. The painting for this 1913 issue of The Popular *is the work of Henry Reuterdahl.*

ever the lord of the jungle made a new appearance. Those who know the character only from the great MGM series with Johnny Weissmuller, or its subsequent derivatives, might be surprised to learn that Burroughs' creation transcended his primitive upbringing, becoming a rather sophisticated fellow, comfortable in Paris, London, and Hollywood, a linguist and an airplane pilot. The movies also ignored the encounters Tarzan had with science-fictional monsters and lost enclaves of Crusaders and ancient Romans.

As a writer, Burroughs was uneven, to say the least. His plots were often no more than a piling on of events. Coincidence followed coincidence without apology. His prose could at times reach some very ragged patches. Characterization tended to be a thin as a page of manuscript. But Burroughs had other qualities in abundance—the wild imagination, a gift for describing action, a powerful sense of myth. Burroughs claimed that his stories came to him as daydreams—what has been termed by Robert Sampson a "pre-cognitive reverie," a decidedly intense form of daydreaming in which Burroughs' unconscious shaped his ideas into near-finished form before releasing them to his conscious mind. However it all worked, it worked for most of three decades, producing dozens of book-length adventures of Tarzan and John Carter of Mars, as well as numerous others—Westerns, the *Pellucidar* series, *The Land That Time Forgot*, the *Venus* novels begun in *Argosy* in 1931. Burroughs' gifts waned in the later years, but his name remained a watchword for reading pleasure long past his death in 1950. He made a fortune, the first writer to become a corporation, and his California hometown was renamed Tarzana in his honor.

Burroughs and his colossal creations were followed by a slew of what would come to be seen as archetypally "pulpy" writers and genres. Masked avengers—ubiquitous in the superhero pulps of the 1930s—made their earliest pulp appearances in the stories of Johnston McCulley and Frank L. Packard. Veteran reporter McCulley created Zorro, skilled swordsman and black-clad crusader against the repressive Spanish authorities in Old California. Zorro made his first appearance in a 1919 *All-Story* serial, *The Curse of Capistrano.* Canadian Packard's masked man was

GREAT NAVAL STORY BY EDWIN BALMER

Nº 5 Vol. 27 TWICE-A-MONTH 15 CENTS

The Popular Magazine

MARCH
MONTH-END EDITION
OUT FEB. 23 1913

Painted by
HENRY REUTERDAHL

The Gray Seal, a mysterious crime-fighter by night whose name derives from the mark or "seal" he places on his victims. No one knows that The Gray Seal is the secret identity of Manhattan playboy Jimmie Dale. Jimmie/Gray would be a decided influence on such later avengers as The Shadow, The Spider, and the Phantom Detective.

Science fiction and fantasy attained new heights of popular acclaim in the brilliant stories by a newsman named Abraham Merritt. His first published fiction was a short story titled *Through the Dragon Glass*, a hauntingly effective tale of a man who discovers a passage through an ancient Chinese mirror into a bizarre alternative world of both beauty and horror. Longer works followed—*The Moon Pool, The Conquest of the Moon Pool, The Face in the Abyss, The Ship of Ishtar*—most of them lost-civilization stories in a tradition pioneered by H. Rider Haggard. Merritt's work was profoundly imagined and written in a distinctive, lyrical prose style. His stories had all the compulsive readability of Burroughs but with additional layers of meaning, symbolism, and poetic reflection. Merritt affected readers deeply—ten and twenty years after their first publication, his stories such as *The Moon Pool* and *The Ship of Ishtar* were voted to the top in polls of all-time favorites.

The Western would become the single genre most closely identified with the pulps. And no writer was more closely identified with the pulp Western than Max Brand. Brand was actually a pen name—one of many—belonging to Frederick Schiller Faust, a tragic poet manqué who became one of the most popular and productive—30 million published words, the equivalent of 530 books—writers who ever lived. Professionally speaking, Faust was a deeply schizophrenic personality. He lavished time and anguish on the slow production of his classically styled poems, the only works for which he willingly took public credit. His audience for these creations could be counted by name. He wrote his pulp fiction, conversely, with an almost unconscious ease, as fast as the contemporary mechanics of a typewriter would allow, producing reams of highly remunerative and sought-after work. He derived no pleasure from these stories and hid from recognition for them behind an army of pseudonyms (Brand, John Frederick, George Challis, George Owen Baxter, David Manning, Nicholas Silver, Martin Dexter, Peter Henry Morland, etc). The writer who would do as much as anyone to popularize the mythical dimensions of the Western professed to find the actual West "disgusting" and wrote most of his Western tales amidst the Renaissance

splendors of his villa near Florence, Italy.

Faust was an aimless, penniless 24-year-old college-educated poet at loose ends in New York City when he wangled a letter of recommendation from the sister of Samuel Clemens to Robert Davis at Muncey's. Davis, who disliked the importuning of Faust's elderly patroness, gave him paper and a plot and dismissed him. Faust stunned Davis when he returned before the end of the day with a completed professional piece of fiction. The story, *Convalescence*, appeared in the March 1917 *All-Story*, and an extraordinary career was begun. Faust began turning out an inexhaustible supply of first-rate pulp fiction, earning $8,281 in the first nine months, an enormous sum of money by the standards of the time. His first Western, *The Untamed*, published in serial form beginning with the December 1918 *All Story*, set the course for much of his fiction to come. Previously, Western literature had been concerned with an aura of realism and a historical context. Faust had no interest in these things. His West was a poeticized location with few reference points to specific times or locales. He used the idea of a violent, frontier America as an almost abstract setting for retellings of ancient epics and classical myths. The hero of *The Untamed*, the mysterious youth "Whistlin'" Dan Barry, is explicitly linked to "the great god Pan." *Trailin'* uses the story of Oedipus, *Pillar Mountain* the Theseus myth, and *Hired Guns* is a Western version of the *Iliad*. In this way were Faust's Westerns both phonier and grander than earlier stories in the genre. Characteristically, when Faust's publishers sent him on a trip out West to soak up atmosphere, he spent nearly all his time inside a hotel room, pounding out more of his inauthentic and phenomenally popular Westerns.

Faust's production rate was so high that *Western Story* or one of his other regular markets would print several of his stories in a single issue, each under a different pen name. This, of course, was unknown to the readers, who wrote in to debate the relative artistry of Faust's various identities. His most familiar byline, "Max Brand," was created with the help of playwright Sophie Treadwell, who advanced the theory that the successful pseudonym always consisted of two monosyllables with the same vowel sound in each. Her theory, as applied to Max Brand, was proven entirely sound.

Faust's one-man storytelling factory produced not only Westerns by the hundreds but numerous historical novels, detective stories, and adventure stories, and countless miscellaneous melodramas. His stories about the noble

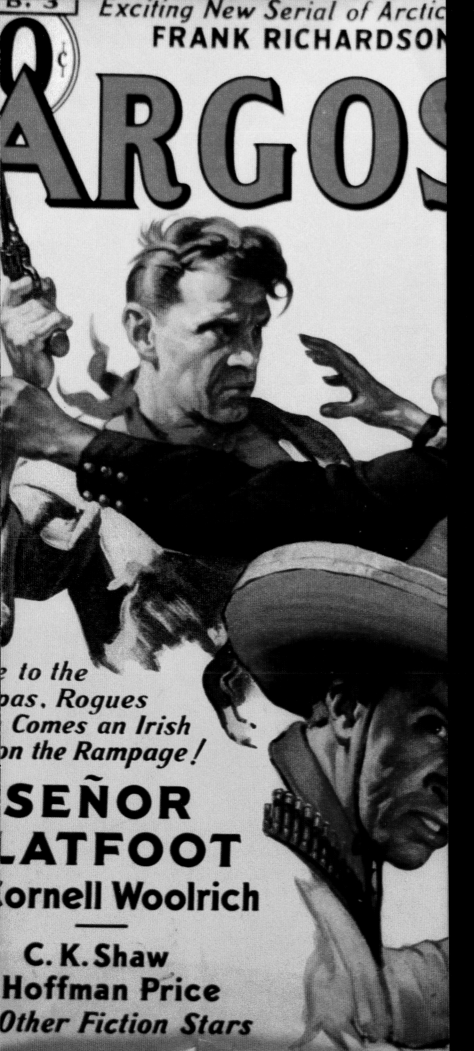

Exciting New Serial of Arctic
FRANK RICHARDSON

0¢

ARGOS

...e to the
...pas. Rogues
...Comes an Irish
...on the Rampage!

SEÑOR
LATFOOT

Cornell Woolrich
—
C. K. Shaw
Hoffman Price
Other Fiction Stars

B. 3

Above and left: Each week, Argosy offered a new collection of action-packed stories and serials. Here are three typical issues from the 1930s.

FICTION — FACTS — PICTURES

RAILROAD STORIES

APRIL
15¢

ALL COMPLETE

14008

DINING

$25 Cash for Best Title to This Picture (*See Page*)

Dr. Kildare were nearly as popular as his shoot-'em-ups. Faust had a talent for fast, gripping, straight-ahead narrative that knew few equals. It earned him a great deal of money. In the years before the Depression, when a huge pulp readership was shared by only a handful of magazines, publishers could pay their top writers as much as ten cents per word. These rates, plus frequent story sales to Hollywood, meant a very nice—if busy—life for Faust. Looking for a residence conducive to the creation of epic poetry, he settled in Italy, buying a villa on the bank of the Arno, overlooking the birthplace of the Renaissance. In the mornings, he applied a furious hunt-and-peck technique to an Underwood perched on a desk that once belonged to a Benedictine monastery. In the afternoons, he stretched out in a leather easy chair, quill pen in hand, and worked on poems with such titles as *Dionysus in Hades.* In the evenings, he taught himself Greek so as to be able to read Homer in the original.

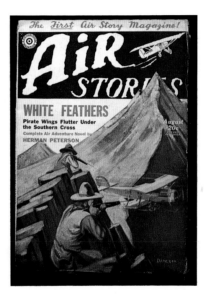

Faust was by all accounts a fascinating, knowledgeable, and generous individual. When war became imminent in Europe—and market conditions cut his pulp rates in half—he returned to America and spent some of his last working years at the Hollywood studios, making a large salary as an indentured screenwriter for Warner Bros. and MGM. When he died, at the age of 52, the "King of the Pulps" received editorial tributes in a range of international publications, from *The Infantry Journal* to the *London Times.* Journalist Quentin Reynolds wrote, "No man could invent so many plots (not even Balzac) or so crowd a few thousand words with action as Max Brand." Faust's biographer, Robert Easton, believed the writer was an exemplar of his age: "...what Babe Ruth and Red Grange were to sports, Charles Lindbergh to flying, Henry Ford to industry: the expression of an expansive time, when horizons seemed larger and possibilities less limited."

THE PULPS had been evolving at a stately and conservative pace. After more than two decades, there were just two dozen pulp titles in existence. Developments came much more rapidly in the fast-paced 1920s. The number of titles grew exponentially, the number of publishers did the same, and the pulps showed increasing specializa-

Below: The August 1929 Air Stories *featured this ethereal cover painting by Charles Dameron: riflemen on a cliff shooting down at a passing bi-plane.*

Opposite: Railroad Stories *was one of the first special interest pulps. It contained, besides fiction, true tales of railroad workers and hobos, and photos of notable locomotives.*

tion and experimentation. The 1920s saw slimmer, faster pulps. The old thick monthlies—some offered more than two hundred pages of small type—began to disappear, replaced by a trim 128-page standard issue. Cover illustrations moved away from the muted tones and quiet poses of the past; publishers discovered the audience appeal of bright primary colors and voluptuous images of sex and violence. Where the early pulps had offered an average of three serials per issue, the streamlined pulps offered one. Stories would now become shorter, move faster. The elaborate Victorian prose was on its way out, to be replaced by livelier, more idiomatic writing (although some pulps would always retain a special place for purple excesses).

The two pioneering pulp houses, Munsey's and Street & Smith, continued to dominate the field in the 1920s but the competition was arriving in droves, everything from established publishing empires like Macfadden to hole-in-the-wall operations whose assets were a registered title and an armful of manuscripts.

Significant newcomers to pulp publishing in the late 1920s and early 1930s included George Delacorte, Jr.'s Dell Publishing, founded in 1922. Along with movie and confession magazines aimed at the working classes, Dell put out such pulps as *Cupid's Diary, Scotland Yard, War Birds* (later transformed into *Terence X. O'Leary's War Birds*), *Public Enemy* (later *Federal Agent*), and the short-lived super-villain title *Doctor Death.* William Clayton had a thriving rough-paper chain in the 1920s, his assets in-

cluding *Ranch Romances, Cowboy Stories, Clues, Strange Tales*, and *Astounding Stories*, one of the first science-fiction magazines. Clayton bought out his partner, ran into unforeseen financial difficulties, and went bankrupt in early 1933. A. A. Wyn's Ace Magazines produced some of the livelier second-rung pulps in the golden age, among them *Secret Agent X, Eerie Stories*, and *Ten Detective Aces*. Fawcett, the publishers of *Battle Stories, Triple X*, and *Startling Detective Adventures*, operated off the beaten path in Robbinsdale, Minnesota. Owners W. H. (Billy) and Roscoe Fawcett were World War I veterans and used their ranks of captain on appropriate mastheads. The editorial page of *Battle Stories* carried a photo of a rakish Roscoe in his flying helmet and goggles. Fiction House was built on no-nonsense masculine interest magazines—*Action Stories, Air Stories, Wings, Fight Stories*. It was founded by two pulp "road men," Jack Kelly and Jack Glenister, who pooled their money and rented a tiny office in the shabby neighborhood west of Penn Station. Their *Air Stories*, about flying adventures of all sorts, and *Fight Stories*, about boxing, were pioneering and successful examples of the narrowly specialized pulps.

Narrow interest titles were a fatal obsession with publisher Harold Hersey, the king of the laughably esoteric pulp. A former boy wonder editor at Street & Smith and Clayton,

Hersey started his own company in the 1920s, and he was soon giving birth to as many new titles as the big, established publishing houses. However, unlike the offspring of the big houses, almost none of Hersey's titles ever grew old—many, in fact, expired after a single issue. Hersey was what you call an "idea man," and the problem was that most of his ideas were no good. He came up with the pulp called *Strange Suicides*, featuring stories about people who killed themselves. *Lucky Stories* took the opposite perspective, upbeat tales of people who thought life was swell. The first issue included a true story about ex-President Wilson and how he believed in luck, a story about how college students were superstitious, and a novelette titled *A Murderer's Lucky Break*. The cover urged, "Buy this Magazine for Good Luck..." The first issue was also the last. Another one-shot was *Fire Fighters*, with nothing but stories about putting out fires. *Speed Stories* offered fiction containing fast-moving vehicles. Then came *Medical Horror Stories*, a combination of light reading and muckraking, with its exposés of medical quackery and bogus elixirs. Since a large percentage of pulp sales happened at drugstore newsstands, *Medical Horror Stories* was considered biting the hand that fed, and Hersey caught hell from numerous quack-druggists. He quickly put the whistleblowing magazine out of its misery. Hersey's *Courtroom Stories* debuted with a lengthy narrative retelling of

From Harold Hersey's Courtroom Stories, The Trial of Oscar Wilde.

The Trial of Oscar Wilde

By ROBERT W. SNEDDON

The name of Oscar Wilde is surrounded by an aura of gossip, half-truths, bitter memories—and at the same time we recognize him as the supreme critic of all the ages. This gripping true story

The Trial of Oscar Wilde. The cover painting depicted a matronly Oscar under cross-examination ("Wilde admitted his friendship with Fred Atkins, bookmaker's clerk. 'After lunch,' asked counsel, 'did you suggest he should have his hair curled?'"). This magazine was a relative hit, lasting several issues. Even Hersey's conventional genre magazines could be a bit "off," as in the case of his ambiguously titled fortnightly, *Twice a Month Love.* Typical of his luckless instincts, Hersey chose for his company colophon the same ancient broken-cross design adopted by the Nazis.

The dawn of the Great Depression saw the start of two pulp houses that soon owned huge shares of the cheap fiction market. Standard Publications was begun by fiat. A magazine distributor, the American News Company, lost their biggest client, Street & Smith, and encouraged 25-year-old Ned L. Pines to start a new line of pulps for them to distribute. Pines turned the editorial reins over to a young Munsey veteran, Leo Margulies, an aggressive character with bluntly commercial instincts. Standard—also known as Beacon and Better Publications—had such quintessential pulp titles as *The Phantom Detective, Startling Stories,* and *Captain Future.* They were particularly known for their signature faith in the word *thrilling* as a component in a magazine title, namely: *Thrilling Detective, Thrilling Love, Thrilling Western, Thrilling Mystery, Thrilling Adventures, Thrilling Spy Stories, Thrilling Wonder Stories,* and *Thrilling Ranch Stories.*

Popular Publications was founded in 1930 by Henry Steeger and Harold Goldsmith. Borrowing $5,000 each, they came out with four titles: *Battle Aces, Gang World, Detective Action Stories,* and *Western Rangers.* Ten years later, Popular was the biggest all-pulp publisher in the world. Goldsmith had come from the financial department at A. A. Wyn's company. Steeger, a young Princeton graduate, did a two-year apprenticeship at Dell. "We started with four titles with the hope that at least one would be a success," Steeger recalled for me. "And that was what happened. Only the air book sold. Things were uncertain for a long while. We were always slipping out of the office to hide from creditors. Then, in our second year in business we came out with *Dime Detective* and that hit. That one was selling 300,000 copies for us and was very profitable. In the beginning, I did everything that had to be done—editor, art director, ideas for new books. We had Edith Symes, an editor who had been with Dell, helping—she later married Steve Fisher—and that was about it for the first year or so. I found the stories and when we had the

A dozen years and more after the Armistice, pulp readers were still enjoying fiction about the war. These covers from Over the Top and War Stories show similarly agonizing images from No-Man's-Land.

series characters—The Spider, Operator #5—I came up with many of the storylines. I also had a great deal to do with the choice of artists and covers for the magazines we did." Steeger was the first publisher to apply a kind of scientific principle to the choosing of cover illustrations, determining what were the consistently best-selling color schemes (red, yellow, black for men's magazines; blue and green for women's). "Most of our sales were on the newsstand, little subscription," Steeger explained. "The covers were our entire advertising campaign, our sales pitch. There was a lot of competition out there and you had just a few seconds to catch someone's eye, so the covers had to do an effective job in a hurry." Popular had some of the pulp era's best and most distinctive magazines. *Dime Detective* was second only to *Black Mask* in the quality of its private-eye stories. *The Spider* and *Operator #5* brought an adult perspective and visceral action to the otherwise juvenile "hero" genre. *Dime Mystery, Terror Tales,* and *Horror Stories* were the flagships of a memorably bizarre Steeger-created pulp genre known to infamy as "Weird Menace." Steeger was certainly one of the most creative and competent figures in the magazine business. In less than five years, Popular became the leading publisher in the field, with a combined circulation of 1,500,000 per month. As it grew, the company would eventually encompass some of its most notable competition, taking control of such landmark titles as *Adventure, Black Mask,* and that venerable and groundbreaking all-fiction creation of Frank Munsey's, *Argosy.* The company that invented pulp magazines went out of business in 1942.

ghost STORIES

Four Skeptics—
and the Prowler

Haunted Gold

The Leopard Woman

Macfadden Publications entered
the "weird fiction" field with the
short-lived Ghost Stories.

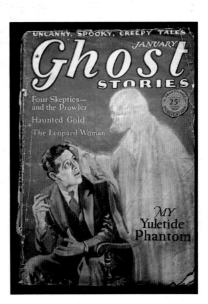

Empire of the Necromancers

HORROR AND FANTASY PULPS

If you have an idea which you have considered too bizarre to

write, too weird or strange, let us see it.

<div align="right">

—NOTICE TO WRITERS
THE THRILL BOOK

</div>

T HE FIRST MAGAZINE to be devoted to tales of horror and the fantastic appeared on newsstands in February 1919. *The Thrill Book*, published by Street & Smith, was an inelegant-looking creation, done in the physical format of the dying dime novels, and at 48 pages was less than half the size of the average pulp. But it arrived full of purpose and potential. The editor, 26-year-old Harold Hersey, had detailed his hopes and needs for the new magazine in a two-page "Notice to Writers:"

We are strongly desirous of securing strange, bizarre, occult, mysterious tales—novelettes of ten thousand words

containing mystic happenings, weird adventures, feats of leger-de-main, spiritualism, et cetera . . . If we were to give you a formula we would say—sum up the demands of all other magazines, and then give us good stories which not one of them would take because of their odd qualities and harrowing nature.

The initial offerings were reasonably odd if not particularly harrowing or good. The lead story came from the *Popular Magazine* slush pile. *Wolf of the Steppes* was the first published fiction by Greye La Spina, the only female newspaper photographer in New York. Awkwardly told in a series of flashbacks within flashbacks, the story concerns an elderly doctor's rescue of a terrified young Russian woman. She has escaped from her nemesis, Serge Vassilovich, a magician-werewolf with unusually hairy eyebrows and long forefingers. Old Dr. Greeley and his mystical friend Dr. Thomas Connors lay a trap for Serge, killing him and then returning him to his lupine form to beat a murder rap. *The Ivory Hunters* by Will Gage Carey was comical nonsense about lost sailors and baseball-playing, cannibalistic Eskimos. There were two opening installments of outlandish serials. J. Hampton Bishop's *In the Shadow of Race* was derived from Haggard by way of Burroughs with its African explorers, blonde jungle goddess, and trained apes. J. C. Kofoed's *The Jeweled Ibis* was a ludicrously complicated tale of Egyptian spells and sleeping priestesses. Another short fiction, *The Man Who Met Himself*, by Donovan Bayley, detailed a battle of wits between a drunk and his naked subliminal self. An editorial, a pair of poems, and some factual odds and ends (*Halted by Ghosts on Way to Work*, *Finds Queer Race in Malay*, *Says Earth Is on Wane*, etc.) rounded out the historic first issue. The next seven offered similar collections of second-rate thrills. Hersey was fired at that point, replaced by Ronald Oliphant, and the magazine grew to conventional pulp size and began to publish some recognizable names of the time—H. Bedford-Jones, Tod Robbins, Murray Leinster— along with the nonentities. Another eight issues were filled with an indiscriminate mix of outré fiction and swashbuckling adventure. Having failed to find a sizable readership or a coherent editorial policy, *The Thrill Book* was canceled abruptly after its 16th appearance, a little more than seven months after its debut.

The next pulp to specialize in the supernatural would have a considerably longer life—over 30 years, 279 issues—

and published some of the best work in the genre—a substantial portion, in fact, of the all-time greatest work in the history of weird and fantastic literature. A Chicago-based, shakily financed monthly, *Weird Tales* was the primary— and at the time the only—forum for the era's masters of the macabre. In its pages, readers confronted the terrifying, the bizarre, the spectacular, and the perverse. One more refutation of the stereotypical image of "pulp" as predictable formula, *Weird Tales* was unique, complex, daring.

The magazine was created by Jacob Clark Henneberger, publisher of *College Humor* magazine, a lifelong Edgar Allan Poe enthusiast, and an idealist: "I must confess that the main motive in establishing *Weird Tales* was to give the writer free rein to express his innermost feelings in a manner befitting great literature." The cover story for the first issue was *Ooze* by Anthony M. Rud, an "extraordinary novelette" concerning the eating habits of a giant amoeba in the deep South—not quite great literature yet. But a writer's free rein was certainly evidenced in the notorious C. M. Eddy story *The Loved Dead*, with its necrophiliac narrator: "One morning Mr. Gresham came much earlier than usual—came to find me stretched out upon a cold slab deep in ghoulish slumber, my arms wrapped around the stark stiff, naked body of a fetid corpse." Actually, most of the early stories, chosen by editor Edwin Baird, were tame and old-fashioned. Things began to improve rapidly when Baird was replaced by his assistant, Farnsworth Wright, a man of erudition and literary insight and adventurousness. Born in 1888, Wright had served as a French interpreter in the U.S. Army during World War I. He contracted a case of sleeping sickness, which developed into the relentlessly debilitating Parkinson's disease. The constant shaking caused by the disease eventually left him unable to sign his name without using both hands. Some visitors to the *Weird Tales* office were taken aback at their first meeting with Wright, imagining his trembling was the result of reading too many scary stories. Wright's tastes in fantastic fiction were both catholic and inspired. The stories he bought ranged across a limitless spectrum of the imaginary, from folkloric tales of vampires and werewolves to galactic science fic-

Opposite: Weird Tales, begun in 1923, quickly became and remains the greatest of all horror and fantasy publications. The vampiric flapper pictured here is the work of Margaret Brundage.

Weird Tales

Oct. — 25¢

THE VAMPIRE MASTER by Hugh Davidson

tion, historical speculations, arabesque fantasies, psycho-pathic memoirs, ghost stories, exotic adventures, sword-and-sorcery epics. Although he continually tried to find material he hoped would slow the magazine's perennial slide toward financial ruin (sales were seldom much above the break-even point), Wright found it difficult if not impossible to reject a story simply because it was "taboo" or not "commercial." In turn, most contributors to the magazine held Wright in the highest esteem. "He was a great man, a great editor," says Jack Williamson. "He struggled nobly in the face of his physical infirmities and really loved literature and the fantastic. He didn't look down on the pulps, and in fact his dream project was a 'Wright's Edition' of Shakespeare in pulp format, but he only got as far as one volume, with illustrations by Virgil Finley."

Highlights from the magazine during Wright's tenure

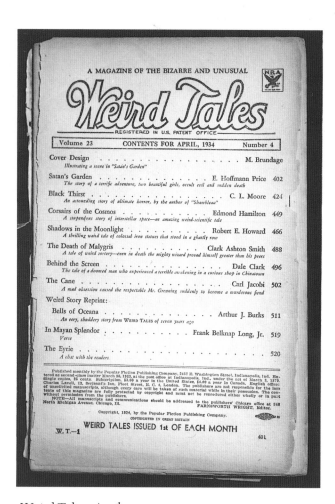

Weird Tales, April 1934.

would fill many thick volumes and have done so: *Jumbee*, a story of voodoo in the Caribbean by Henry S. Whitehead, the Archdeacon of the Episcopal Church in the Virgin Islands; Arthur J. Burks' great ghost story *The Ghosts of Steamboat Coulee*; Edmond Hamilton's three-part epic *Across Space*, in which Martians attempt to pull the Earth out of its orbit; *Mive*, by Carl Jacobi, a tale of giant carnivorous butterflies; Mary Elizabeth Counselman's stunning short-short *Three Marked Pennies*; *The Werewolf of Ponkert*, by H. Warner Munro, told in the voice of the tortured title character; Nictzin Dyalhis' *The Sea Witch*, a haunting story of an old man's return to youth; *The Horror on the Links*, the first of Seabury Quinn's 93 stories about French occult detective Jules de Grandin. From his home base in Harrisonville, New Jersey, the Poirot-ish de Grandin battled the gamut of supernatural bad guys—mummies, werewolves, ghosts, zombies, a surprising number of them operating in the otherwise quiet New Jersey town. The stories featured breakneck action and lots of kinky sexuality and were among the readers' favorites.

There were grand-scale serials in the tradition of Burroughs and A. Merritt: Otis Adelbert Kline's *Tama, Son of the Tiger*, Thomas Kelley's *I Found Cleopatra*, Jack Williamson's *Golden Blood*. The last was a superb fantasy-adventure about a soldier of fortune (character based on pulp scribe E. Hoffmann Price) and a lost civilization in the Arabian sands (atmosphere courtesy of T. E. Lawrence's *Revolt in the Desert*), and it inspired one of the magazine's best cover illustrations, by J. Allen St. John. Wright wrote breathlessly of it to Williamson: "that colossal golden tiger looming gigantic against the sky…and in the fore-ground Price and Fouad sitting astride their white camels and looking quite Lilliputian by comparison…What a gorgeous splash of color—the golden-yellow tiger, the vivid green of Vekyra's robe and the intense crimson of Malikar's garment. Allah!"

It could be said with only slight exaggeration that any issue of *Weird Tales* from the mid-'20s to the mid-'30s constituted a "Best Of" collection, so frequently did Wright's editorial choices strike gold.

Although it was considered a difficult market to crack, and Wright cultivated a group of regular contributors, he had no predisposition against unpedigreed talent, and many a neophyte writer made his or her first sale to the (even then) legendary magazine. E. Hoffmann Price, *Weird Tales* regular and Wright's friend and fellow Oriental-rug enthusiast, recalled: "Wright's enthusiasm upon getting a

A C. L. (Catherine Lucille) Moore story for Weird Tales.

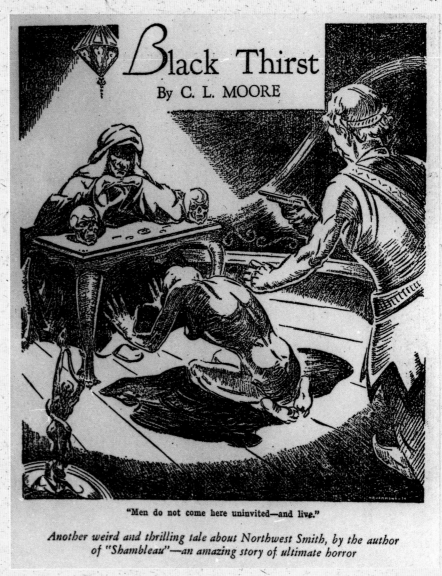

Black Thirst
By C. L. MOORE

"Men do not come here uninvited—and live."

Another weird and thrilling tale about Northwest Smith, by the author of "Shambleau"—an amazing story of ultimate horror

new name from the slush pile was beautiful to see. And the time, I think in the early thirties, when I bounced into Chicago he was fairly babbling and stuttering, he had no time to greet me. He handed me C. L. Moore's first manuscript and paced the floor and muttered as I read, and then he closed shop and declared it 'C. L. Moore Day.'" The slush pile discovery was *Shambleau*, the first of the Northwest Smith stories. The outlaw-spaceman hero rescues a girl from a Martian mob but soon discovers she is not a girl at all but a Shambleau, a bizarre female monster. Moore's writing was richly atmospheric, full of surreal imagery and a grim nihilism. The Smith stories took the Burroughsian vision of interplanetary adventure—spaceships and swords—and added in-depth characterization and dark poetry. It was an astonishing series. Nearly as good were Moore's six tales of Jirel of Joiry, a swashbuckling swordswoman in an imaginary medieval world of

black magic. Both Smith and Jirel were so popular with readers that they demanded the pair meet. Moore obliged with *Quest of the Starstone* in the November 1937 *Weird Tales*. It was not at first widely known that C. L. Moore's initials stood for Catherine Lucille. A fan letter from another writer of fantasy fiction, Henry Kuttner, was addressed to "Mr." Moore. The confusion was sorted out and the two writers were married.

Among Wright's other notable discoveries was a youthful Tennessee Williams, whose first published story, *The Vengeance of Nitocris*, appeared in the August 1928 *Weird Tales*. In this short story about ancient Egypt, a decadent pharaoh commits an angry desecration of the altar of Osiris and is torn to pieces by the outraged Theban citizenry. His sister, the new Queen Nitocris, plots an elaborate and satisfying but suicidal revenge. After much carnage, the final paragraph is poignant.

Therefore, upon her entrance into the palace she ordered her slaves to fill instantly her boudoir with hot and smoking ashes. When this had been done, she went to the room, entered it, closed the door and locked it securely, and then flung herself down upon a couch in the center of the room. In a short time the scorching heat and the suffocating thick fumes of the smoke overpowered her. Only her beautiful dead body remained for the hands of the mob.

Not bad for a 14-year-old.

The January 1935 issue of *WT* included the professional debut of another young author, Robert Bloch. A devoted reader of the magazine since the age of ten, Bloch was a mainstay of the letters column, called *The Eyrie*, and as a member of the so-called Lovecraft Circle—more about that in a moment—corresponded with many of the magazine's leading contributors. "I saw my first copy of *Weird Tales* in August 1927," Bloch recalls, "and its pages opened up a whole new world for me ... It became a sort of nontheological Book of Revelation. The sale of my first story to the magazine was the most exciting event in my 17-year-old life." Bloch's shocking *The Feast in the Abbey* was followed by 66 other stories for *Weird Tales*—among them, such classics as *Yours Truly, Jack the Ripper, Enoch,* and *The Skull of the Marquis de Sade*—all distinguished by the author's mordant wit and ironic prose style.

Three writers in particular have come to represent the great and unique qualities of *Weird Tales.* They are the holy trinity of *WT*: H. P. Lovecraft, Clark Ashton Smith, and Robert E.

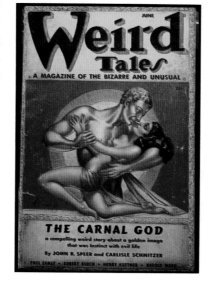

Howard. Each man would have a relatively short writing career—two would die untimely deaths—and each would produce a body of work of stunning originality and imaginative brilliance.

Howard Phillips Lovecraft was born on August 20, 1890, in Providence, Rhode Island. The Lovecrafts were an Usher-like clan of crumbling aristocrats, touched by madness and consumed by eccentricity. H. P.'s father was institutionalized, and his mother was neurotically obsessed with keeping her son from contact with the outside world. "I was very peculiar," he wrote of his younger self. The isolated child became a precocious reader in his grandfather's old library, soaking up the lore in musty volumes on Greco-Roman mythology, the mysterious East, and colonial New England. He adored the stories of Edgar Allan Poe, Jules Verne, and, later, Lord Dunsany, the British peer and fantast who wrote of imaginary worlds, complete with their own gods and myths. In his late 20s, still reclusive and by conventional standards "peculiar," Lovecraft began writing fantasy stories and sketches for amateur publications. These came to the attention of Henneberger, *Weird Tales*' founder, and he solicited submissions from the Rhode Island hermit. The handwritten manuscripts Lovecraft sent in were dismissed by editor Edwin Baird but the publisher overruled him. The Lovecraft byline appeared in *Weird Tales* for the first time in the October 1923 issue, accompanying a short story titled *Dagon*, an exercise in sheer hysteria.

Henneberger saw clearly the man's enormous talent. Aside from buying everything Lovecraft initially submitted, the publisher hired him to ghostwrite a story for *Weird Tales*' most famous contributor, Harry Houdini. Written in a tongue-in-cheek but still hair-raising style, *Imprisoned with the Pharaohs* was finished, lost, and then written again from scratch on Lovecraft's wedding night. "When I buckled down to the under-the-pyramid stuff," he joked to a correspondent, "I let myself loose and coughed up some of the most nameless, slithering, unmentionable HORROR that ever stalked cloven-hoofed through the tenebrous and necrophagous abysses of elder night." Lovecraft's marriage, perhaps needless to say, did not last long.

Above: Despite the magazine's often grim and gruesome contents, Weird Tales' most frequent cover artist Margaret Brundage preferred the erotic to the horrific. Her distinctive cover art was drawn with pastels.

Opposite: H. P. Lovecraft in the 1930s.

H. P. Lovecraft

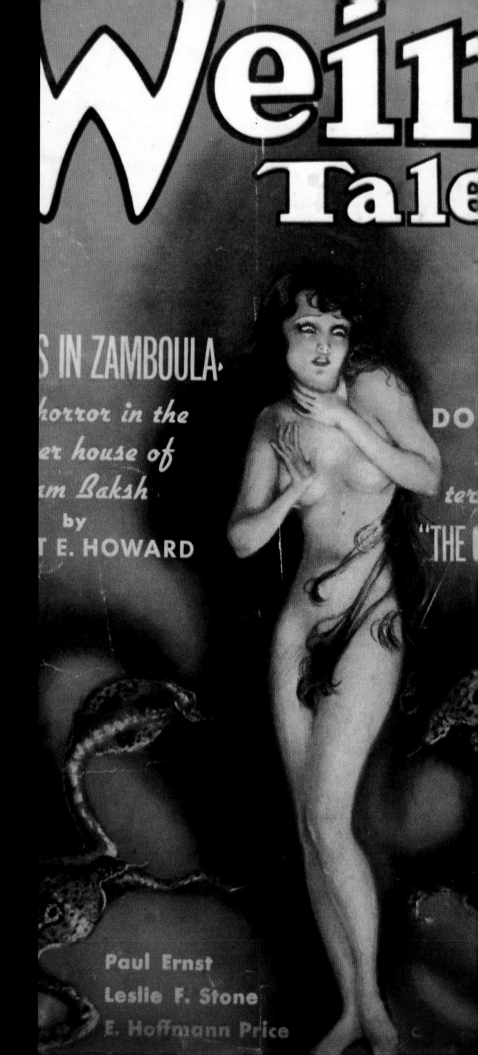

Above: Strange Tales *was Clayton's answer to* Weird Tales. *Editor Harry Bates used many of the WT regulars, paying them more money, more frequently.*

Right: The November 1935 Weird Tales *featured one of the popular Conan stories by Robert E. Howard. One of the magazine's most important regular contributors, Howard ended his life abruptly at the age of 30.*

He hit his stride in the March 1924 issue with *The Rats in the Walls*, the first of his now-classic tales of skin-crawling horror. The final, metrical sentence is a clear echo of Poe:

They must know it was the rats; the slithering scurrying rats whose scampering will never let me sleep; the daemon rats that race behind the padding in this room and beckon me down to greater horrors than I have ever known; the rats they can never hear; the rats, the rats in the walls.

Lovecraft's greatest work belongs to an unofficial story cycle that has come to be known as "The Cthulhu Mythos". Reshaping and expanding on ideas culled from the writings of Dunsany, Arthur Machen, and Robert W. Chambers, Lovecraft created a series of fictions that, he wrote, "are based on the fundamental lore or legend that this world was inhabited at one time by another race who, in practicing black magic, lost their foothold and were expelled, yet live on outside ever ready to take possession of this earth again." Lovecraft's exiled beings, the Ancient Ones, with such names as Cthulhu, Nyarlathotep, Yog-Sothoth, continually and horrifically return to Earth with the assistance of ignorant or evil mortals. Their bios and the secrets of the planet's dread early history are contained in the mouldering pages of the few remaining copies of the mad Arab Abdul Alhazred's ancient volume *The Necronomicon*. The first installment in the Mythos, *The Call of Cthulhu* (*WT*, February 1928) is eerie enough but distanced by a series of narrative frames. *The Dunwich Horror*, published in April 1929, has a more direct impact, with its rampaging, "teratologically fabulous" monsters. The story was inspired in part by a trip Lovecraft took to western Massachusetts in the area of Athol, which he transformed into the infernal Cold Spring Glen, home to the "repellently decadent" Whateleys. The theme of death and rebirth, the nasty nativity and crucifixion of the Yog-Sothoth-fathered creature, can be read as an outrageous remake of Christian myth. The story cycle continued with *The Whisperer in Darkness*, *The Shadow over Innsmouth*, *At the Mountains of Madness*, *The Haunter of the Dark* (in which he kills off his real-life correspondent and acolyte Robert Bloch), and a half-dozen other loosely connected nightmares.

Lovecraft affected a dispassionate attitude toward the supernatural and denied any personal, psychological impulse for his work. To be sure, much of the terrifying effectiveness of his fiction comes from skilled storytelling. Lovecraft cleverly gave the god-awful events a heightened sense of reality by making many of his narrators or protagonists sober-sided rationalists—professional men or academics from the distinguished Miskatonic University, home to one of the hideous extant *Necronomicons*. When people such as these bear witness, the monstrous happenings *must* be true. And in the Mythos stories, Lovecraft instills a disturbing afterglow—whatever the conclusion of an individual story, the reader realizes that the foul Ancient Ones are still *out there somewhere*, waiting to return. However, regardless of these and other entertainer's calculations, the real power in Lovecraft's work doubtless came from a deeper source. Many of the horrific concepts and the grotesque imagery in the stories Lovecraft witnessed in his dreams, and the continuing themes of madness and familial decay were obviously matters of personal concern for the writer.

After the end of his brief marriage and "period of exile," as he called his wedded stay in Brooklyn, New York, Lovecraft returned to the family home in Providence, Rhode Island, forever. He resided with his two elderly aunts, his living expenses barely met by a small inheritance and the pittance he made from the sale of his pulp stories. He had few acquaintances and no further intimate contacts with women. But Lovecraft was an obsessive letter-writer, and formed an epistolary relationship with a large network of *Weird Tales* fans and fellow writers, including August Derleth, E. Hoffmann Price, Henry Whitehead, Clark Ashton Smith, Robert Howard, Bernard Austin Dwyer, J. Vernon Shea—the Lovecraft Circle, as it was known. Depending on the correspondent, his letters could be acidulous or sweet. He encouraged many an aspiring writer and helped the talented ones break into print, including a teenaged Robert Bloch.

On March 15, 1937, the 46-year-old Lovecraft died from intestinal cancer and Bright's disease. At the time of his death, Lovecraft was little known beyond the readership of the "tasteless" *Weird Tales*, and his passing went unnoticed by the media and the literary establishment. Only many years later, with countless worldwide republications and translations of his work, did he come to be seen as the greatest writer of horror stories since Edgar Allan Poe.

LIKE LOVECRAFT, Clark Ashton Smith was a hermetic personality and ill at ease in the 20th century. He lived most of his life with his parents in a primitive cabin in rural Auburn, California, near the gold mines of Placer County. In this unlikely region, the self-educated

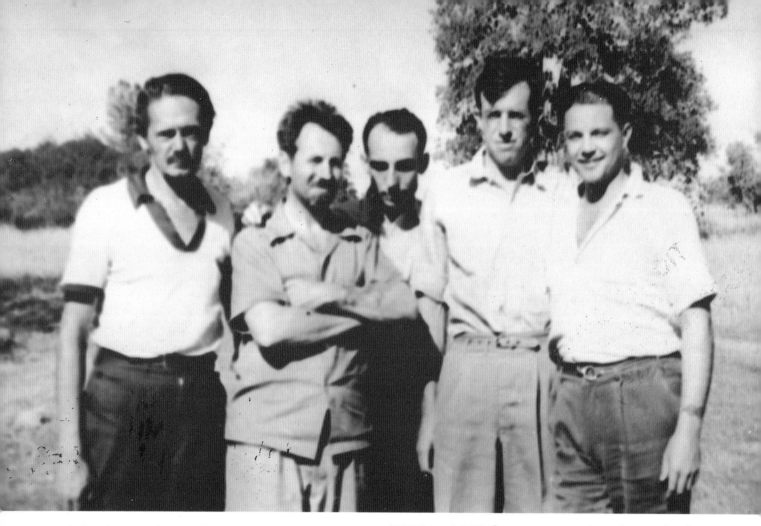

Clark Ashton Smith, E. Hoffmann Price, Edmond Hamilton,
Jack Williamson, and Monte Lindsley, in Auburn,
California, 1940.

Smith became a highly regarded poet of *fin de siècle* traditional verse. His first book of poetry, *The Star-Treader and Other Poems*, was published in 1912 when he was 19. It was not until the late 1920s, after a strangely affecting experience in the Donner Pass in the Sierras, that Smith began to write his otherworldly fiction. For the next dozen years or so, he became a regular and acclaimed contributor to *Weird Tales* and to the handful of pulps dedicated to science fiction and fantasy.

Most of Smith's 110 stories were set in one of four wholly imagined earthly locales: Zothique, the last barely habitable continent in a fading future where magic has replaced science; Poseidonis, one of the isles of doomed Atlantis; medieval Averoigne; and the prehistoric polar continent of Hyperborea. In addition, there were several jaunts to the extra-terrestrial settings of Mars and planet Xiccarph. Smith could write conventional horror-show fiction, and he created some of the most grotesque and unsettling beasts in the literature. *The Vaults of Yoh-Vombis* (*WT*, May 1932), for instance, an electrifying tale of a group of archaeologists encountering leechlike, skull-sucking monsters in an aeon-deserted Martian catacomb, is pure scream-out-loud entertainment. But his most characteristic and singular work was complex, profound, haunted by specters of loss and regret. His settings are often worlds on the eve of destruction, his dying-race characters "grown hopeless of all but oblivion." The malevolent and powerful wizards and necromancers who figure in many of the tales are at the end of their reign, resigned and melancholic. There is Malygris, the magician of *The Last Incantation*, whose reviving of the long-dead girl he loved in his youth is a soul-shattering disaster—"He could believe no longer in love or youth or beauty, and even the memory of these things was a dubitable mirage, a thing that might or might not have been." In *The Maze of Maal Dweb*, a tour de force of compact imagining and descriptive power, a valiant young man of Xiccarph pursues his kidnapped lover to the dangerous labyrinth of a tyrant-wizard. In a stunning climax, the brave hero is suddenly, horribly defeated and the perspective abruptly switches to evil Maal Dweb himself, rueful and alone with his metal automatons: "And it may have been that there were times when he wearied a little

even of this, and preferred the silence of the petrified women, or the muteness of the beasts that could no longer call themselves men." Nostalgia and psychic pain haunt another of Smith's masterworks, *The Empire of the Necromancers*, arguably his greatest story. Mmatmuor and Sodosma, two black magicians capable of raising the dead, attempt to create their own kingdom from the deceased citizens of a city doomed by plague. The corrupt wizards succeed, filling their kingdom with a populace of resurrected skeletons and plague-scarred corpses. But the dead, longing to return to their interrupted sleep, rebel and the necromancers are given their just desserts:

Hestaiyon lifted the great sword and struck off the head of Mmatmuor and the head of Sodosma, each with a single blow. Then, as had been directed, he quartered the remains with mighty strokes. And the necromancers gave up their unclean lives, and lay supine, without movement, adding a deeper red to the rose and a brighter hue to the sad purple of their couches.

Smith had the poet's love of rare words and elaborate imagery. His best work has a narcotic, incantatory effect on the reader. "Take one step across the threshold of his stories," Ray Bradbury has written, "and you plunge into color, sound, taste, smell, and texture—into language." Smith virtually ceased writing fiction after 1937. He occupied himself with other things, including the carving of grotesque sculptures, now highly prized by collectors. He married at

Munsey's Fantastic Novels *was made up of decades-old serials originally printed in* Argosy *and All-Story. The issue for January 1941 had a cover by Virgil Finlay, best known for his interior illustrations in* Weird Tales.

the age of 61, but continued to lead a relatively isolated life in the backwoods of California, and died there in 1961. Why he gave up writing has never been explained.

ROBERT E. HOWARD, the third member of the *Weird Tales* triumvirate, wrote horror and fantastic fiction in a variety of styles, some of it clearly in homage to Lovecraft, but the majority of his work belonged to the genre of heroic fantasy, now generally referred to as sword-and-sorcery. The style derived in part from the interplanetary romances of Edgar Rice Burroughs, the exotic and supernatural-tinged adventure stories of Talbot Mundy, and the historical tales of Mongol barbarians by Harold Lamb. Howard's stories were intensely imagined, action-packed, blood-drenched epics, written in a grand, vivid muscular prose that fairly leapt off the page. He created a number of invincible, pitiless warrior-heroes: Bran Mak Morn, leader of the Caledonian Picts against the legions of ancient Rome; Solomon Kane, an Elizabethan Puritan, battling savagery and the supernatural in darkest Africa; Kull, a king in ancient Atlantis; and his most famous and successful creation, Conan, the barbarian adventurer. Conan lived in the Hyborian Age of some 12,000 years ago, a time of magic and monsters, spectacular violence, and exclusively voluptuous women. There were 17 Conan stories of various lengths published in *Weird Tales*, and Howard developed the series in non-chronological order, taking the character back and forth from youth to middle age, and through various forms of employment, including mercenary, thief, pirate, and king.

Howard claimed to have based Conan on various roughnecks he encountered in his Texas homeland, but there was psychic autobiography involved as well—in dreams Howard recurringly saw himself as an ancient barbarian—and the author's passionate belief in his material gives the Conan stories their undeniable vivacity and force. In *Queen of the Black Coast*, drifting on a dark poison river in search of a treasure-laden lost city, an unusually loquacious Conan states his life's philosophy, and defines the character's wish-fulfillment appeal:

"Let me live deep while I live: let me know the rich juices of red meat and stinging wine on my palate, the hot embrace of white arms, and the mad exultation of battle when the blue blades flame and crimson, and I am content. Let teachers and priests and philosophers brood

EDMOND HAMILTON • E. HOFFMANN PRICE • CLARK ASHTON SMITH

Weird Tales

APRIL 25¢

Golden Blood
by Jack Williamson

over questions of reality and illusion. I know this: if life is an illusion, then I am no less an illusion, and being thus, the illusion is real to me. I live. I burn with life, I love, I slay, and am content."

Robert Ervin Howard was born in 1906 in the small Texas town of Peaster. When Robert was nine, the family moved to Cross Plains, where he lived with his mother and father for the rest of his life. He had been interested in writing from a very early age and was greatly inspired by books of history and Western lore and the stories in *Adventure* magazine. *Spear and Fang*, his first sale to *Weird Tales*, was printed in the issue for July 1925, and from 1928 his byline appeared in the magazine an average of eight times a year. Although *Weird Tales* was his most sympathetic market, Howard—unlike Lovecraft or Smith—considered himself a professional pulp writer and in addition to his fantastic material he wrote and sold adventure, Western, detective, and sports stories.

Howard grew up to be a large, strong young man and indulged in the usual masculine rites of hunting, fishing, and drinking, but he clearly stood apart from the simple farmers and small-town mentalities of Cross Plains. Many considered the moody, inward writer for suspect pulp magazines to be—in one resident's term—"a weirdie." As Howard once wrote, "It is no light thing to enter into a profession absolutely foreign to the people among which one's lot is cast." His love life—or lack of it—has been the subject of much speculation, and Howard was known to have been devoted to his domineering mother to an unusual degree. He was prone to bouts of despairing self-reflection and spoke of suicide on a number of occasions. Depression did not slow his productivity, however, and from his battered Underwood flowed thousands of pages of fiction, verse, and correspondence.

In the spring of 1936, Mrs. Howard became gravely ill. On the morning of June 11, after a sleepless night at his comatose mother's bedside, Robert was informed that she would never recover. At the typewriter in his workroom he wrote some lines of poetry, then went outside to the family's '31 Chevrolet sedan. From the glove compartment,

Opposite: "What a gorgeous splash of color," wrote Weird Tales editor Farnsworth Wright of this J. Allen St. John cover painting. "The golden yellow tiger, the vivid green of Vekyra's robe and intense crimson of Malikar's garment. Allah!"

he took out a Colt .380 he had borrowed from a friend, thumbed the safety, placed the barrel in his mouth, and pulled the trigger.

Jack Scott, a young Cross Plains reporter and an acquaintance of Robert's, arrived at the Howard house a short time later. He recalled for me what happened next:

It was a news story and I was running a newspaper here and I was a stringer for Associated Press. I went down and the yard was filling with people already. Robert was sitting in the front seat of the car and he'd blown his brains out. I was standing in the yard when the JP—the Justice of the Peace—came out of the house and called me in, said, "I want to ask you something." The JP acted as a coroner in those small towns and he had to render a verdict on cause of death. He took me into Howard's room and showed me a piece of paper rolled into the typewriter with some words on it and asked me to read it. It was a little poem:

> *"All fled, all done, so lift me on the pyre;*
> *The feast is over, and the lamps expire."*

And then the JP—he was just a fine farmer, not a literary man—says, "What does 'pyre' mean?" And I told him it meant Robert had killed himself. And the JP says, "Yep," and rendered the verdict. Robert's mother died that evening and they were buried in a double funeral.

Robert Howard was 30 years old.

WEIRD TALES was not a financially reliable market for writers. The "payment on publication" policy often became "payment whenever." Regular contributors were sometimes owed for five or six published stories. Pathetic payment plans were sometimes offered. Jack Williamson, owed $600 for his serialized novel *Golden Blood*, was eventually paid off in $50-per-month installments. "They just never had any money," says Williamson. He visited the Chicago office and found the circumstances very modest. "There was a tiny anteroom and two small offices, one for Farnsworth Wright, one for Bill Sprenger, the business manager. There was no

secretary, no assistant editors." In search of another formula for success, Wright started an adventure-fantasy magazine, *Oriental Stories*. With its specialized content and *WT* stable of contributors, this was no less idiosyncratic than *Weird Tales* and no more successful. It was retooled and retitled *The Magic Carpet Magazine* after nine issues and expired after another five. *Weird Tales* was sold in 1938 and editorial offices were moved from Chicago to New York. Farnsworth Wright stayed with the magazine but was fired in late 1939. He died not long after from complications related to an experimental brain operation. The magazine lasted until September 1954, but never again attained the greatness of its first dozen years.

Only a few publications ever tried to follow in *Weird Tales*' footsteps. Clayton Publications brought out *Strange Tales* in September 1931. Editor Harry Bates lured the best *WT* writers with pay rates of two cents a word and actual paychecks as well. Lovecraft failed to measure up but Smith and Howard made several sales. Bates preferred streamlined prose and fast-paced action, exemplified by *Murgunstrumm*,

Robert E. Howard of Cross Plains, Texas.

Hugh Cave's feverish tale of vampires at the Gray Toad Inn, and Jack Williamson's swift and savage werewolf novella, *Wolves of Darkness*. Clayton ran into massive financial problems in this period and after seven issues *Strange Tales* folded along with the rest of the Clayton chain. Macfadden published *Ghost Stories*, with a narrow subject matter, mostly poor stories, and a short life. Better Publications put out a short-lived and lousy fantasy magazine called *Strange Stories*. Late in 1939, Munsey came up with an economical title, *Famous Fantastic Mysteries*, which reprinted famous as well as forgotten material from World War I–era issues of Munsey's *Argosy* and *All-Story*, including stories by A. Merritt and Ralph Milne Farley.

In March 1939, two decades after the demise of the pioneering pulp *The Thrill Book*, Street & Smith returned to the realm of the fantastic with *Unknown*, another trailblazing effort and the only magazine to bear artistic comparison with *Weird Tales*. *Unknown* was edited by John W. Campbell, the brilliant science-fiction writer and innovative editor of *Astounding Science-Fiction*. Campbell, the futurist, had a predictable disdain for what he saw as the antique tone of much of the fiction in *WT*. He wrote a note to potential contributors, disparaging his legendary rival: "*Unknown* is not going to be science fiction, nor is it going to be another *Weird Tales*. That's genuinely fact; not a boast … I do not want old-fashioned, 19th-century writing, the kind that has burdened fantasy steadily in *Weird Tales*. I do not want unpleasant gods and godlings with penchants for vivisection, and nude and beauteous maidens to be sacrificed."

What he did want and published in the pages of *Unknown* were mostly modern-dress and, by his definition, "logical" fantasy and horror stories, many with a strongly ironic perspective. Robert Bloch, for instance, began to express in *Unknown* the sardonic sense of humor he had kept largely in check at *Weird Tales*. Similarly, the heroic fantasies of Campbell discovery Fritz Leiber, Jr, featuring the adventures of the warrior Fafhrd and feisty sidekick the Gray Mouser, brought wit and fallibility to Robert E. Howard's Conan country. "Campbell didn't really want that sort of material in *Unknown*," says Leiber, the man who coined the term *sword-and-sorcery*, "but he appreciated the humor and the tone in my writing … He had a certain humorous slant on things. My story *Conjure Wife*, about housewives as modern witches, started with Campbell talking to me about all the things women kept in their handbags."

*Top: The only serious rival to
Weird Tales' supremacy in the
horror and fantasy field was
Unknown. Begun in 1939 as a
companion to* Astounding Science
Fiction, Unknown *shared
Astounding's brilliant editor, John
Campbell.*

*Above: From the publishers of
Weird Tales came the short-lived
Oriental Stories and its successor,
Magic Carpet. Both magazines
offered exotic adventure stories.*

Campbell bought from a number of *WT* veterans (Manly Wade Wellman, Seabury Quinn, C. L. Moore, Bloch), but most *Unknown* contributions came from his own *Astounding* stable (Robert Heinlein, Theodore Sturgeon, A. E. Van Vogt, Alfred Bester, etc.). Campbell had an unusually precise, detailed idea of the sort of things he wanted to buy. Typical of the high standards of his *Unknown* purchases were the stories by L. Ron Hubbard, whose *Typewriter in the Sky* was a dazzlingly clever account of a man trapped inside the pirate story being written to deadline by his pulp hack roommate. The sky booms ominously with the sound of typewriter keys as the protagonist desperately tries to alter the story's formulaic climax and avoid being murdered by a fictional buccaneer hero. The plot is all the more entertaining for Hubbard's satiric jabs at himself and other speed-demon pulp pros. Equally good, in an entirely different style, was Hubbard's gripping exercise in psychological suspense, simply titled *Fear,* in which a skeptical ethnology professor seemingly encounters a menacing collection of horrific demons. Hubbard sustains the tension and mystery almost to the last paragraph.

Unknown—or *Unknown Worlds* after a title modification—was not very successful. Brilliant as many of his editorial decisions were, John Campbell had a wide pretentious streak and tried hard to disassociate his magazines from the pulp family tree. To this end, he decided to dispense with *Unknown*'s illustrated covers in favor of a stark logo and list of contents. This "dignified" wrapper made *Unknown* look more like a medical journal than a fantasy fiction magazine; Campbell must have thought it would scare away the riffraff. *Unknown* closed down after its 39th issue.

DESPITE THE PRESENCE of brilliant writers and an overabundance of greatly entertaining stories, none of the horror and fantasy pulps were moneymakers. A large audience for this type of material simply could not be found. Two of H. P. Lovecraft's correspondents and devotees, August Derleth and Donald Wandrei, became determined to see the deceased writer's best work put into book form. No publisher was interested. Derleth and Wandrei decided to publish such a book themselves and formed Arkham House for that purpose. The Lovecraft volume, with fewer than 1,300 copies printed, took four years to sell out.

WESTE

AUG.

PIONEER
STORIES
OF THE
OLD WEST

The Rio Kid was one of several single-hero Western pulps, following the success of The Shadow, Doc Savage, and other "hero" titles.

East of Borneo, West of the Pecos

THE ADVENTURE PULPS

Sailors from ships flying all the known flags were packed several deep at the bar. Tobacco and opium smoke mingled in thick layers. The air smelled richly of sweating, unwashed humanity, of the harbor mud at low tide, of stale beer and spilled whisky, gin and arrack, and it smelled, above all, of Singapore.

—MURDERER'S PARADISE BY GEORGE F. WORTS

THERE IS BUT ONE adventure story," wrote pulp pro Henry Kuttner, "and it is laid in the South Seas. I used to see it every week ... a mysterious map, a cannibal island, a sunken treasure, a beautiful girl, a crew of Lascars ... and an octopus or two." Kuttner was kidding, more or less, although the pulps did have a fondness for tropic ports and unshaven heroes in pith helmets and white linen suits. The adventure genre actually covered a very broad domain—

every era in history from Pharaonic Egypt to Bolshevik Russia, every exotic locale from Death Valley to the Himalayas, every dangerous occupation from telephone lineman to pirate.

The vicarious adventurer could pick his thrills from a huge stack of magazines, at the bottom of which were any number of cheap Western and knockabout action titles, and at the top four eclectic-content publications—*Adventure, Argosy, Blue Book,* and *Short Stories*—considered to be the crown jewels of the pulp world. These four offered higher pay—three or four times the norm—and prestige, at least by rough-paper standards, and in return demanded "slick" quality prose and story construction, realism, and authenticity. The regular contributors to the top adventure magazines were the pulp community's elite, and many a successful pulpster would fail to ever crack this lofty market even after years of trying. "*Adventure* bounced my stories time without end," wrote E.

names in the field wrote from firsthand experience. War heroes wrote war stories, pilots wrote flying stories, sailors wrote tales of the sea, and cowboys wrote Westerns. Editors eagerly pointed out which writer had lost an eye in the battle at Belleau Wood, which one was just back from Tahiti or tiger-hunting in Kumaon. Theodore Roscoe, one of *Argosy*'s leading contributors, was a globe-trotting journalist. "I was always catching a freighter to somewhere," he recalled for me. "Europe, Africa, South America ..." Roscoe went to Haiti to investigate voodoo ceremonies, resulting in a pair of excellent *Argosy* serials, *A Grave Must Be Deep* and *Z Is for Zombie.* His Thibaut Corday series—ironic, almost Maughamesque short stories about the French Foreign Legion—grew out of a trip to French Morocco and Algeria. "I went to the Legion headquarters at Sidi bel Abbes and to a place called Biskra in the desert, listening to stories, taking notes. There was a small war with the Arabs going on but all the Legionnaires I saw

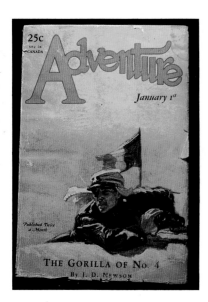

Hoffman Price, best known for his fantasy fiction in *Weird Tales,* "until came the one which was authentic, the one in which I clearly knew what I was talking about." The readership, too, logically enough, was several cuts above the average, knowledgeable about history, geography, weapons, etc, evidenced by the learned and sometimes vituperative correspondence columns. The readers read with a kind of engagement and seriousness that hardly exists today, and they were ever ready to pounce on a writer who didn't get his facts straight.

With the demand for realistic and authoritative adventure stories, it is not surprising that many of the top

were working pick and shovel, building a road. Glamorous, no. In Casablanca I met an old Legionnaire with hashmarks up to his elbow. He had been in the Legion forever and had a thousand stories. I used him as the prototype for my narrator, Corday."

For those without personal experience to fictionalize, diligent research was called for and it could mean much more than a few trips to the library. The introverted Carl Jacobi wrote dozens of convincingly detailed tales of contemporary Borneo and New Guinea without ever venturing beyond his hometown of Minneapolis. Aside from consulting the appropriate published works on the subject—

Right: Theodore Roscoe, aboard a freighter off the coast of Honduras, circa 1932.

Opposite: From the North African outposts of the French Foreign Legion to the tropic isles of the South Seas, Adventure's Writers Brigade roamed the world.

Home Life of a Borneo Head Hunter, Jungle Wallah, etc.— Jacobi solicited background info through correspondence with the same sort of pith-helmeted colonials he was writing about. His letters of inquiry to the back of beyond traveled by ocean liner, coastal freighter, river launch, and—for the final leg through the jungle—by native runner, a journey of three months' time, with another three or four months needed for Jacobi to receive his reply. The results, though, were worth it—long detailed letters from lonely traders and district officers, full of bizarre local customs and violent incidents—"Dear Mr. Jacobi ... In the middle Sepik between Origambi and the River there is a strong secret society called 'Sanguman.' They practice killing, the motive for which is not understood yet..." It then took only Jacobi's artful craftsmanship to turn this material into gems like *Spider Wires* and *East of Samarinda.*

Of the four distinguished general adventure pulps, *Argosy,* the fiction magazine that started the pulp era, had settled into an all-adventure format in the 1920s and of-

fered at least 20 years of dependably exciting—if sometimes blandly exciting—male-oriented stories. The most popular pulp writers—Edgar Rice Burroughs and Max Brand at the summit, Johnston McCulley, Luke Short, Otis Adelbert Kline, etc.—were well represented in the pages of the Munsey flagship. *Short Stories,* previously a literary journal, turned pulp in 1910 and had a long and distinguished run under the editorial guidance of Harry E. Maule. *Blue Book* had also had a pre-pulp incarnation, as a genteel, general interest periodical, before switching to rough paper and strictly masculine fare. It published many of the top names in adventure and historical writing, including Brand and other Faustian bylines, P. C. Wren of *Beau Geste* fame, Achmed Abdullah (The White Russian/Afghani author of *The Thief of Bagdad* and numerous exotic pulp tales of hatchet men and opium dens in New York's Chinatown), and the prolific H. Bedford-Jones, whose specialty was the military and warfare through the ages.

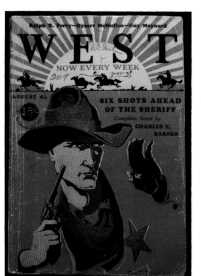

The best of the adventure magazines, and inarguably one of the handful of great pulp publications, was *Adventure*. One of many magazines put out by a division of a dress-pattern company, *Adventure* debuted with an issue dated November 1910. The first editor, Trumbull White, was an outdoorsman and explorer, and wanderlust got the better of him after less than a year. He was replaced by a magazine pro named Arthur Sullivant Hoffman. Hoffman was an "indoorsman," but he knew good stories from bad and he knew how to find them. He sought adventure fiction that would meet the high literary standards set by recent masters of the form—Rider Haggard, Robert Louis Stevenson, Kipling, Jack London. "It was slow work. The budget was very small—far too small to compete for stories of the best known writers or even for the average stories of the smooth-paper magazines. We gave our first and best attention to stories from unknown writers."

Hoffman did more than find first-rate fiction for his magazine. He made innovative use of *Adventure*'s back-matter pages, previously considered the place for expendable filler. Together with his assistant editor, Sinclair Lewis—the future winner of the Nobel Prize for literature—Hoffman devised several popular and much imitated editorial departments intended to make interactive contact between the magazine and its readers. *The Camp Fire*, ostensibly a letters column, became a rambunctious open house where editors, writers, and readers exchanged comments, critiques, and sometimes insults. *The Camp Fire* gave writers a chance to detail the biographical or factual context for their stories, and new contributors were en-

couraged to submit their resumes. "There's not much to say about me," wrote Magda Leigh, one of the magazine's few women writers. "I'm just one of those freaks. I should have been a man and wasn't. I love the sea and ships far better than anything else in the world, with the exception of my daughter.... The strange part of it all is that I've never been shipwrecked. I've been through a South American revolution (I adored it!), and any number of earthquakes, and even plague, but the sea has treated me kindly." Another back-of-the-book column was "Ask Adventure," a question-and-answer information service wherein the magazine's far-flung "staff of experts" replied to queries about everything from bicycle repair to crocodile trapping. The "Lost Trails" department allowed readers to advertise for information about missing relatives and long-lost friends. Hoffman created a veterans' "minute men" network that became the national organization The American Legion. He established and printed updated information about so-called Camp Fire Stations, scattered addresses where peripatetic readers could pick up their mail, cadge a meal or a bunk, and swap tall tales with kindred spirits. These and other practical or romantic services fostered a reader involvement and loyalty that were known to few other magazines.

While Hoffman and his editorial team were deskbound on the top floor of the Butterick Building, on Spring and Thompson in New York, far from camp fires or crocodiles, adventure sometimes came to them. On one occasion, an African chieftain in full regalia arrived at Hoffman's office, demonstrated a war dance, took umbrage at something—perhaps he had a story rejected—and began firing a rifle at random in the hallways.

Among *Adventure*'s regular contributors—Hoffman called them his Writers Brigade—were Harold Lamb, writing lusty adventures of Khlit the Cossack and various other hyperactive barbarians; Gordon Young, who wrote about hard-boiled Hurricane Williams, a nihilistic South Seas drifter; Arthur O. Friel, specializing in dangerous expeditions to the Amazon and Orinoco; W. C. Tuttle, the Mark Twain of the pulp cowboy story; Major Malcolm Wheeler-Nicholson, late of the U.S. Army cavalry, turning some of his many military exploits into ex-

10¢

THRILLING SPY STORIES

SUMMER ISSUE

A THRILLING
PUBLICATION

FEATURING
THE
STOLEN
GAS GUN

A Complete
Jeff Shannon
Spy Mystery Novel

By CAPT.
KERRY McROBERTS

ARROWS
OF DESTINY

A Complete Novelet
of Hooded Conspiracy

By WILLIAM L. HOPSON

citing fiction. (The last-named writer went on to have an injurious effect on the entire pulp industry when, in 1934, he turned entrepreneur and produced the world's first original material comic book, *New Fun*.) Another *Adventure* favorite, Anglo-Italian Rafael Sabatini, made his mark in the issue for June 3, 1921, and his first installment in the life of swashbuckling Captain Peter Blood. An Irish doctor with a sea-roving past, Blood is arrested for treating the wounds of a British traitor and packed off to the slave mart on the West Indian isle of Barbados. He escapes in a fierce revolt, commandeers a Spanish ship, and turns buccaneer. The original nine stories of Captain Blood, each subtitled *A Tale of the Brethren of the Main*, were sunscorched daydreams crowded with dazzling imagery—full-masted galleons on turquoise Caribbean, gleaming cutlasses, white sand beaches, lustrous pieces of eight—aimed straight at the pleasure centers of armchair escapists. *Adventure* later printed Sabatini's biographies of Casanova and Sir Walter Raleigh and serialized his epic novel, *The Sea Hawk*.

Of the many Western writers appearing in *Adventure* none was more popular or prolific than Walt Coburn. Beginning in 1922, he wrote more than eight hundred novelettes for *Adventure* as well as the other leading adventure and Western pulps. Coburn's prose style and plotting were often crude, but his characters, the tangential details, and the sights and smells he put into his Western stories seemed to come straight from the range. In a field full of secondhand stereotyping, Coburn enlivened cowboy fiction with quirky authenticity, as in this passage from *Town Tamer*:

Sundown fetched him into the broken country south of the Little Rockies. Long ridges spotted with scrub pines. Long draws thick with brush. It was the fall of the year and berries were ripe. Wild currants, green gooseberries turning mahogany brown. Chokecherries in clumps so thick he had to ride around them. Brice would lean from his saddle and scoop his hand full of berries. Hunger wasn't bothering him much. A cowpuncher gets accustomed to going for a day or two without grub.

Coburn was, in fact, an honest-to-God cowboy. His father had settled Last Chance Gulch, where Helena, Montana, now stands. Walt had been a wrangler on ranches all over the West (with time off to ride with Pancho Villa's

army) and claimed that many of his pulp yarns he had first heard told by old-timers in the bunkhouse. Most of his characters were unglamorous roughnecks and they drank a considerable amount of alcohol, a trait they shared with their creator. He wrote every morning, six days a week, and always with a bottle of "hooch" within arm's reach. During Prohibition, Coburn used to hide a stock of tequila in the stove of his Arizona cottage. One time a pulp editor from New York came to visit, there was a chill, and Walt thoughtlessly fired up the stove. It exploded, nearly killing the visiting tenderfoot.

Perhaps the most significant member of *Adventure's* Writers Brigade was Talbot Mundy, whose long association with the magazine began in the February 1911 issue with a non-fiction sketch, *Pig Sticking in India*, only the second piece he had ever written, and continued with scores of stories and serialized novels. He was another adventurous, larger-than-life character, as Arthur Hoffman made clear in his savory introduction to the writer's first contribution:

Shake hands with Mr. Mundy—there is only time for me to whisper these words in your ear: An Englishman, India, China, the Himalayas, Singapore, the Straits Settlements, Persian Gulf, the Boer War . . . elephant hunting, pigsticking, single-handed yachting, two campaigns against African tribes

Mundy was a colorful character, all right, but he had seriously misrepresented the facts of his early life. Far from the lordly soldier and sportsman he claimed to have been, Mundy in his India-Africa period was a con man, ivory poacher, bigamist, and deportee. In "British East", the Africans gave him a Swahili nickname, *Makundu Viazi—White Arse*. He began to write while healing from a skull-fracture he received under sordid circumstances in New York's notorious Gas House district. In America he remade himself, changed his name, put the reprobate career behind him, and became a best-selling adventure novelist and beatific Theosophist.

Mundy worked primarily in Kipling-Haggard territory—colonial India, the Northwest Frontier, East Africa. His best novels in this vein, *King—of the Khyber Rifles*, *Om*, *The Devil's Guard* (*Ramsden* in magazine form), were ex-

hilarating tales of high adventure with fascinating characters and vivid word pictures of the "exotic East." His work was further distinguished by its lack of colonial conformism, the sort of cant and racism endemic to British Empire stories. Mundy's recurring cast of Orientals—the crafty babu Chullunder Ghose, the Mata Hari—like Yasmini, the fearless warrior Narayan Singh, among them—are at least as fully and sympathetically drawn as his assorted Anglo-American Secret Service aces and White Hunters.

In the mid-'20s, he began writing historical fiction, the saga of *Tros of Samothrace*, a Greek adventurer and nemesis of Julius Caesar. The Tros series, totaling a mighty half-a-million words in *Adventure*, was as pleasurable a reading experience as any the pulps ever offered. Mundy's characterization of Caesar as "a liar, a brute, a treacherous humbug" brought forth a deluge of angry letters from history buffs and Caesarians. Printed in *The Camp Fire* in numerous issues, the letters necessitated Mundy's writing some ten thousand words—presumably unpaid for—of be-

Left: Ranch-hand-turned-writer Walt Coburn.

Right: Talbot Mundy in Jerusalem, 1920.

mused rebuttal. If nothing else, the scholarly back-and-forth illustrated the erudition of the pulp magazine's readership. Tros' exploits were also read by fledgling writers such as Robert Howard and Fritz Leiber and would influence the development of the sword-and-sorcery genre. "The Tros stories made a great impression on me as a young man," recalls Leiber. "I read and re-read them. I can still picture the ship Tros built, called the *Liafail*, a magnificent super-galley with these huge masts, built to take him around the world. It was wonderful, imaginative writing."

Mundy died in 1940, while writing the scripts for the children's radio series *Jack Armstrong, All American Boy*. His real name (William Lancaster Gribbon) and wayward early life were not known until 40 years later and the determined sleuthing of his biographer, Peter Ellis.

The mainstay of adventure pulps: brawling adventurers in exotic locales.

THE ADVENTURE PULPS followed the trend toward specialization in the 1920s and 1930s. At one time or another, there were pulps devoted entirely to tales of "darkest Africa" (*Jungle Stories, Thrills of the Jungle*), inscrutable Asia (*Far East Adventures*), pirates (*Pirate Stories*), beachcombers (*South Seas Stories*), boxing (*Fight Stories*), the ancient past (*Golden Fleece*), and the French Foreign Legion (*Foreign Legion Adventures*). The growth of aviation, memories of the spectacular dogfights of World War I, and the much-publicized exploits of Charles Lindbergh and other celebrated pilots and daredevils made a very large impact on the popular imagination and were reflected by a slew of pulps devoted to the air war and flying adventures in general: *Wings, Air Stories, War Birds, Sky Birds, Sky Fighters, Battle Aces, Zoom*. The public's short-lived interest in lighter-than-air craft inspired just one publication, *Zeppelin Stories* (by aficionados, the most cherished of all absurd pulp titles). There was not much room for plot or character development in any of the air war magazines, storylines being largely an excuse for the inevitable dogfights, with passages like the following from *Knee Deep in Krauts* by Allan R. Bosworth:

The Fokker rode down the skies, painting a trail of death with dun, acrid tracer smoke. Her bullets chipped fabric from the Ark's wings, sent splinters flying from the sturdy hull.

Tac-a-tac-a-tac!

Floorboards rattled. A slug gashed the pit coaming. Humpy Campbell swore between clenched teeth and jerked the Ark on over in a half loop. Her load suddenly lightened—the heavy body of Margo Dubois plunged out, streaked for earth in a flutter of voluminous skirts.

Tac-a-tac-a-tac!

A short burst and a bloody one. Tracer etched a sky trail straight to the pilot's pit. Screaming slugs found a mark deep in cringing flesh. The Fokker heeled, went over in a roaring power dive, and twisted toward earth.

Crash!

The most important of the adventure pulp offshoots, the Western, became the most popular of all forms of pulp literature. In the pre-pulp era, there had been two strands

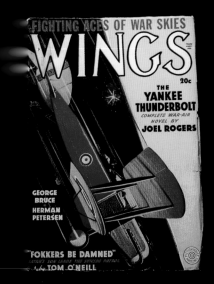

Top: Artist Rudolph Belarski was one of the brilliant workhorses of the pulps, painting hundreds of covers from the 1920s to the '40s. This fine example of his work comes from the Spring 1937 issue of Wings.

Above: A parachuting pilot was a frequent sight on the covers of pulp adventure magazines. Another aviator takes the plunge in this issue of Rapid Fire Action Stories, from 1931.

of the genre—the dime-novel hokum of Ned Buntline and his ilk, and literary stories by the likes of Mark Twain and Bret Harte. Early in the 20th century, the two strands coalesced in the romanticized but adult-oriented novels of Owen Wister (*The Virginian*) and Zane Grey (*Heritage of the West, Riders of the Purple Sage,* etc.). Grey was a discovery of Street & Smith editor Charles Agnew MacLean, and many of the writer's best-selling books were serialized in *The Popular* and other family and general-fiction pulps. He was long-winded and his prose was often as purple as the sage, but he did pack a lot of authentic frontier lore into his novels and millions swore by them. Grey's success was a crucial influence on the Western fiction boom that began just after World War I. One of the first of the specialized pulps, Street & Smith's *Western Story Magazine* took the place of *New Buffalo Bill,* one of the last of the 19th-century weeklies. It appeared on newsstands with a July 12, 1919, cover date and the subtitle *Big Clean Stories of Western Life.* Indicating the escapist direction the Western story was taking, an editorial in that first issue emphasized not the magazine's historical accuracy or range of subject matter but its quotient of wish-fulfillment:

. . . Hunched up over a desk, are you? Well, read about the life you would like to lead, and the life you will lead, just as soon as you can throw off the bonds that keep you from making a break for the woods or the rolling plains . . .

The magazine had arrived in time to feed a surging interest in the frontier life and legends of America's recent past. Perhaps the movies, with their charismatic cowboy stars and glimpses of spectacular Western scenery, had something to do with it. Or perhaps the nation had come to a nostalgic realization that its vaunted frontier spirit now belonged to the history books. In any case, the first Western pulp was a great commercial success, quickly reaching a circulation of a half-million per week. In the years ahead, the Western titles would become the most numerous and financially reliable of all pulps—*Ace Western, Big Book Western, Cowboy Stories, Crack Shot, Dime Western* (among its subscribers was Franklin Delano Roosevelt), *Double Action Western, Frontier Stories, Lariat, Nickel Western, Quick Trigger, Pete Rice, Popular Western, Riders of the Range, Six-Gun, Spicy Western, Star Western, Texas Rangers, Thrilling Western, Triple-X, West, Western Outlaws, Western Trails, Wild West Weekly*—a comprehensive list would go on for pages. In addition, the general

FIGHT STORIES

FALL 20¢

A booklength
biography
HARRY GREB—
"The HUMAN
WINDMILL"

A MILLION MEX for the DOUBLE X

Novel of slug—south of the Rio

by CUR

adventure pulps continued to publish considerable amounts of Western fiction and could afford the best of the stories by the top writers in the genre, an elite group that included Max Brand, Walt Coburn, W. C. Tuttle, Clarence Mulford, Luke Short, and Ernest Haycox.

Brand wrote myth-minded melodramas that did not so much distort the historic West as ignore it, oblivious to specifics of time or place. W. C. Tuttle, like Walt Coburn, was an authentic Westerner, son of a Montana lawman, and he spent some of his younger years punching cows and riding the range. Tuttle derided the glamorization of cowboy life: "What a job! Forty-a-month plus frostbite. Out of the sack about five o'clock in the morning, the temperature about zero in the bunkhouse; outside ten or twelve below, and a wind blowing. You shiver into frozen overalls, fight your way down to the stable, where you harness a team of frosted horses, take 'em out and hitch them to a hayrick wagon ... Man, it was romantic!" Tuttle specialized in the comic Western, some wry and folksy, some outright slapstick. He was at his best in a long-running, non-comic series about Hashknife Hartley and Sleepy Stevens, a "range detective" and his sidekick, published variously in *Adventure*, *Argosy*, and *Short Stories*. Hashknife and Sleepy were a sort of cowboy Holmes and Watson, drifting into assorted frontier towns and solving crimes. The amalgam of mystery and Western might sound contrived but Tuttle's funkily realistic atmospherics, idiosyncratic dialogue, and offhand humor made for immensely enjoyable reading.

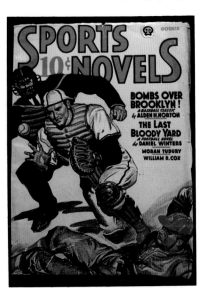

Clarence Mulford was another writer who drew an honest portrait of the West. A New York civil servant when he began writing, he took numorous research trips to the Western states and kept a 17,000-card file of Western data. His very popular stories were about the wandering trail boss of the Bar 20 ranch, Hopalong Cassidy. The fictional Hopalong was a considerably tougher, more violent character than the avuncular hero portrayed in the movies by Bill Boyd.

Luke Short (pseudonym for Frederick Glidden) and Ernest Haycox were fine writers whose stories and novels were comparable to any well-crafted, historically sound mainstream fiction. Haycox in particular had a talent for subtle characterization and poetic and vivid descriptions of Western landscape.

There were many first-rate Western writers in the pulps—Harry Olmstead, Thomas Blackburn, William Cox, Walker Tompkins, and others—great storytellers, but most of them working in the late-pulp style, speed and action at the expense of character and atmosphere.

As the number of cheap Western pulp magazines grew almost immeasurably in the 1930s, standards declined, and the historically minded or atmospherically correct writers were inevitably overwhelmed by the churn-'em-out hacks ("cowboy stories by Manhattan bellhops," as one critic disparaged the typical pulp Western). The Western fiction magazines remained in abundance until the very end of the pulp era, but the final decade was sorely lacking in originality or style. The movies remained the most expressive canvas for the Western—capable of conveying epic grandeur with a single lateral pan shot. But it must be noted that nearly every classic Western movie—from *Stagecoach* to *Red River* to *The Searchers*—was adapted from the work of veteran pulp writers.

Above: A typical sports pulp of the 1930s. Sports titles were a humble lot, unable to compete with the more imaginative and melodramatic genres.

Opposite: The long-running Fight Stories mixed hard-boiled boxing fiction with factual articles about famous fighters.

DETEC

Despite the title and
its comic book–styled
lettering, Super
Detective offered no
super-human crime
fighters, only the usual
sort of two-fisted
private eyes.

RUN

KII

Twenty Bucks a Day and Expenses

THE PRIVATE EYE PULPS

It is not a very fragrant world you live in, and certain writers with tough minds and a cool spirit of detachment can make very interesting and even amusing patterns out of it.

—RAYMOND CHANDLER

TWO MEN INVENTED the hard-boiled detective story: Carroll John Daly and Dashiell Hammett. Their inventions were published within months of each other in 1923 and in the pages of the same magazine, *Black Mask.* Both men were obscure tyros of uncertain ambition, writing for a three-year-old pulp "louse," as *Mask's* co-founder, H. L. Mencken, described it. They were hardly the sort anyone would have expected to launch a literary revolution. Daly had been an usher and projectionist and owner of a movie theater in Atlantic City, New Jersey. He was afraid of cold weather and dentists. Hammett, more pertinently, was an off-and-on operative for the Pinkerton Detective

Agency, and dying from tuberculosis. He lived, of course, much to his own surprise, for nearly 40 more years. The two men crossed paths at the *Black Mask* juncture, and for a time their careers moved along parallel lines, then moved very far apart. Hammett became an acclaimed novelist, a world-famous artist traveling in the highest circles of New York and Hollywood society. He made a million dollars and spent them all, went through one of the longest creative "dry spells" in literature, was by turns a hedonist and an ascetic, went to jail, a martyr to McCarthyism, and became the posthumous subject of novels, biographies, and movies—in short, a legend. Carroll John Daly, much more popular in their early years, would never leave the pulp ghetto, and was still writing for a few cents a word when the last detective pulps closed shop in the 1950s—a suburbanite, family man, forgotten hack.

Before Daly and Hammett, the detective story was the domain of twitty aristos and brainy, eccentric puzzle-solvers. The writing was Victorian, the murders emotionally bloodless. The times demanded something new, something stronger. America in the 1920s was a tough, wised-up place, with its veterans of the World War I trenches, its flappers and gangsters. The Volstead Act gave millions of upright but thirsty citizens their first unlawful experiences. Cynicism was in the air, crime in the headlines. Someone was bound to take mystery fiction out of the vicarage and the country home and drop it down on the turbulent mean streets, to give murder—Chandler again—"back to the kind

of people that commit it for reasons, not just to provide a corpse; and with the means at hand, not hand-wrought dueling pistols, curare or tropical fish."

Chandler was referring to Hammett, but Daly got into print first. The hard-boiled groundbreaker was his second appearance in *Black Mask. The False Burton Combs*, in December 1922, featured not a detective but a tough-talking "gentleman adventurer." The anonymous, first-person narrator is colloquial, wisecracking, violent. In the May 1923 issue of *Mask*, a similar-sounding hero, this one named Terry Mack, "Private Investigator," would complete the prototype. *Three Gun Terry* is officially the first detective story in the new hard-boiled style. The ferocious, trigger-happy hero is familiar with both sides of the law. "I play the game on the level, in my own way," says Mack. "I'm in the center of a triangle; between the crook and the police and the victim"—exactly the position to be occupied by the thousands of tough detectives that would follow. Indeed, as William F. Nolan points out in *The Black Mask Boys*, "This pioneer private-eye tale is remarkable in that almost every cliché that was to plague the genre from the 1920s into the 1980s is evident in *Three Gun Terry*."

Two weeks later, Daly's now standardized hero was renamed Race Williams for a story called *Knights of the Open Palm*. Making his debut in *Black Mask's* incredible Ku Klux Klan special issue (Daly's story was, at least, one of the *anti*-Klan entries), Race would go on to star in 70-some magazine stories and eight novels. He was an immediate sensation with readers and became the single most popular detective hero of his era. In retrospect, it may be difficult to understand Daly's impact. His hyperactive, semi-literate narrations seem shrill and phony. But compared to the prose that preceded him Daly comes off as reliably streetwise. Here is dialogue from a pre-Daly story, *The Clue from the Tempest*:

"If there is a scintilla of evidence to verify this extraordinary hunch of mine—well, I shall be at one end of a thread which has begun to disentangle itself from the whole maze."

And here is Race Williams speaking:

Above: The birthplace of the hard-boiled style was Black Mask. Dashiell Hammett, Raymond Chandler, and Horace McCoy were among the magazine's great discoveries.

Opposite: G-Men was one of several pulp titles devoted to the glorification of the F.B.I. Director J. Edgar Hoover closely monitored the contents of these magazines and occasionally contributed his byline to them.

THE FEDERALS IN ACTION

10¢

G·MEN

MAY

A THRILLING
PUBLICATION

BULLET JUSTICE
A COMPLETE NOVEL FEATURING
THE WORLD'S GREATEST
MAN-HUNTERS IN ACTION

CHINESE HOLIDAY
An Inspector McIntosh Story
By TOM CURRY

C. K. M. SCANLON • COL. WM. T. COWIN

AN INSIDE
EXPOSE
OF THE
RACKETS

In the center of the floor
lay the sprawled figure of
a man

HOTEL MURDER

By STEVE FISHER

*A room locked from the inside, a corpse shot in the back,
and three suspects—that's the problem Mike Hanlon faces!*

FOOTSTEPS padded quickly along the corridors of the Hotel Wellinglex. Crystal over-head lights shafted white beams on the red plush carpets. A room door slammed.

A shot!

The bell captain, in the hall on the twentieth floor, turned suddenly. He rushed to the door of the room from which the explosion had sounded. He tried the knob, reached for his keys; then remembering his instructions, hesitated. He waited impatiently until there was someone else in the hall.

"Get the police—quickly!"

The man in the hall ran to the bell captain.

"But—"

"I've got to stay here," the hotel employee said. "I heard a shot. Unless it's suicide, there's a killer in that room. Hurry now! Get someone!"

Mike Hanlon, of the Homicide Division, got off the elevator and came swinging up the hall. The red-faced Irish dick had a ragged cigar jammed in his mouth. His black eyes were glittering.

The bell captain was in a nervous

"You've had one look at my gun," I told them as they sneaked out. *"The next time you have cause to see it you'll see it smoking; now—beat it!"*

With his philosophy of shoot first and gather clues later, Race Williams, detective, may have had little in common with Sherlock Holmes, but he was a blood relative of Natty Bumpo, Wyatt Earp, Deadeye Dick, and other rugged individualist Americans of fact and fiction. This was a crucial aspect of the new style—the pulp detective story would henceforth emphasize action over mystery, and cases would be solved by fists and .45s, not ratiocination. As Williams comments, "There might be a hundred clues around and I'd miss them. I've got to have a target to shoot at." Daly, in any case, was not the sort of writer who would have been comfortable with the elaborate plot-puzzles and logical explications of the "classical" detective story. His storytelling was crude, repetitive, illogical, and prone to exaggeration. In fact, for all their fresh, vivid details about life in gangland, Race Williams' adventures are told with the braggadocio and hyperbole of 19th-century tall tales:

"I tickled his chin with my gat."

"I handled three of your breed last night. Come! Jump out of that night shirt or they'll bury you in it."

"No laughter in my voice then—when I'm gunning I'm a bad man—none worse!"

The colloquial narrative voice of Daly's stories was artless and inconsistent, full of bad grammar, arbitrary paragraphing, and awkward binges of stream-of-consciousness. Race Williams and Daly's other cardboard hemen were brutal and ignorant and frequently espoused the virtues of vigilantism. "The law," Daly once wrote, "is too cumbersome, too full of loopholes to be of much use."

For some or all of the above reasons, *Black Mask's* editors had little affection for Daly, despite the fact that his name on the cover meant a guaranteed increase in sales—as much as 25%. Daly once recalled how his initial entry into the magazine only came about because the chief editor was on vacation. After the stories were published, that editor, George Sutton, summoned Daly to his office for some reluctant praise: "It's like this, Daly, I am editor of this magazine to see it make money. To see the circulation go up. I don't like these stories—but the readers do. I have never received so many letters about a single character before. Write them. I won't like them. But I'll buy them and print them."

Daly never altered his style much, and by the 1940s, his gunslinging Roaring Twenties detective had finally gone out of favor. He continued writing, but mostly for secondary titles. A few years after the last pulps died in the 1950s, so did Carroll John Daly. He was 68. Oddly, while Daly was fading into obscurity after World War II, a young, rabid admirer of his named Mickey Spillane wrote a kind of updated Race Williams pastiche, *I, The Jury,* featuring a similar ignorance-is-bliss vigilante called Mike Hammer, and became an international sensation. Daly was not pleased by his disciple's success. "I'm broke," he said, "and this guy gets rich writing about my detective."

For most of his life, Daly lived quietly in White Plains, New York. The houses on his block were identical, and Daly sometimes could not find his way home. A trip to Manhattan was a major undertaking, and in winter he seldom left his carefully temperature-controlled residence. "I always felt that he used Race Williams as a means of satisfying subconscious impulses which he knew could never be gratified in real life," said Daly's friend Erle Stanley Gardner. "Daly had never had the slightest experience with actual crime or criminals, much less with bullet wounds...Daly himself wanted no part of the rough and tumble."

SAMUEL DASHIELL HAMMETT was born in Maryland, May 27, 1894. He left school at age 14 and took a series of railroad and factory jobs until in his 20th year, he answered a Help Wanted ad in a Baltimore newspaper and went to work for Pinkerton's National Detective Service. For various periods of time over the next six years, Hammett was a Pinkerton operative, crisscrossing the country on a variety of assignments from investigations to security work and strikebreaking. During a stint in the army during the First World War, he developed a case of tuberculosis, the first in a lifelong series of lung diseases. While living in San Francisco in the early 1920s, Hammett quit detective work for good and began to try his hand at writing. Hammett did not immediately recognize the potential importance of his Pinkerton experience

Opposite: Tough stuff from a mid-'30s issue of Thrilling Detective.

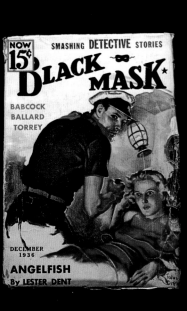

Above: The December 1936 Black Mask featured some of the last stories bought by former editor Joseph Shaw, including the second and final contribution by Lester Dent. Dent's character, Oscar Sail, was a seafaring Miami private eye.

Right: Joseph T. Shaw, editor of Black Mask, the premiere detective pulp.

as subject matter. His first fictional sale was a vignette to *The Smart Set*, a snobbishly "aristocratic" magazine created by Mencken and George Jean Nathan, the founders of *Black Mask*. His first story for *Mask*, *The Road Home*, credited to the pseudonym of Peter Collinson, was atypical, with its Conradian situation and Southeast Asian setting.

It was in his third sale to *Black Mask*, with the story titled *Arson Plus*, that Hammett would introduce the distinctive style that changed the face of American mystery writing. *Arson* featured an operative for the Continental Detective Agency in San Francisco. Like Daly's Race Williams, Hammett's hero was an urban professional detective, tough, street smart, conversant with both sides of the law. Unlike Daly's trigger-happy Narcissus, Hammett's middle-aged, paunchy private eye was cool-tempered and self-effacing—literally anonymous, he came to be known as the Continental Op for editorial and advertising purposes. The nameless protagonist, Hammett wrote to the editor at *Black Mask*, was "more or less of a type: the private detective who oftenest is successful: neither the derby-hatted and broad-toed blockhead of one school of fiction, nor the all-knowing, infallible genius of another. I've worked with several of him." The Op's first recorded case would prove to be characteristic of the stories to come: the understated, first-person narration; the terse, hard sentences; the methodical investigation. *Arson Plus*' mystery is colorful enough—an insurance fraud involving impersonation and arson—and the story ends in a car chase and shootout, but the effect of the tale is realistic, not fanciful. Hammett's writing had the ring of truth; this was how a real detective did his job.

Of course, as it turned out, Hammett had much more to offer than a laconic voice of experience. He was an artist, unique and complex, an innovative prose stylist with a profound vision of an America driven by violence and corruption. Not all of the Continental Op stories were first rate, and Hammett despaired of his solidifying identity as a writer of pulp detective fiction, but his artistry continued to grow, and in 1927 he wrote a novel featuring the nameless Op. *The Cleansing of Poisonville* appeared serially in the pages of *Black Mask* beginning with the November 1927 issue. As much a gangster epic as a detective story, *Poisonville* tells of a Montana mining town completely run by criminals and the Op's attempt to destroy them by pitting one rival gang against another. The novel contains—in the serialized version—26 murders, and writing as spare and clear as any in the history of American fiction:

The strike lasted eight months. Both sides bled plenty. The wobblies had to do their own bleeding. Old Elihu hired gunmen, strike-breakers, national guardsmen and even parts of the regular army, to do his. When the last skull had been cracked, the last rib kicked in, organized labor in Personville was a used firecracker.

As *Red Harvest*, the novel was published in book form in February 1929. In the next three years, *Black Mask* would print three more Hammett novels—*The Dain Curse*, *The Maltese Falcon*, *The Glass Key*—each one a masterpiece of the crime genre and the artistic summit of the hard-boiled style. Hammett published his last pulp story in *Black Mask* in November 1930. His fifth and final novel, *The Thin Man*, was published in 1934. He was 40 years old. Royalties and Hollywood money kept him in booze and hotel suites for another decade, but his career as a writer was essentially ended.

THE TOUGH DETECTIVE story caught on and other writers began following in Daly's or Hammett's footsteps—Erle Stanley Gardner, Nels Leroy Jorgensen, Raoul Whitfield, Frederick Nebel. Gardner was a California lawyer and ex—traveling salesman in his mid-30s when he began trying to augment his income with the sale of short fiction. His first story for *Black Mask* was, by Gardner's own admission, "dreadful ... Even the *title* was dreadful ...*The Shrieking Skeleton*." Even Gardner's less dreadful stories were closer to Daly's standards than to Hammett's. His pulp fiction is written in a fast-moving but slapdash manner (in later years, he was known to dictate all his "writings"), without style or resonance. Although, like Hammett, Gardner had firsthand knowledge of real lawmen and criminals, his early crime-writing is dependent on gimmicks and juvenile heroics. His numerous series characters—three dozen in all—for various pulps, included an amateur juggler with a pool cue for a weapon (Bob Larkin), a con-man (Paul Pry) and a skyscraper-scaling "human fly" (Speed Dash).

Gardner's output in the pulp era was phenomenal, with over five hundred mostly novelette-length stories in the 1920s and 1930s, as well as—from 1933 on—an average of three hardcover books per year. Gardner's first novel, turned down for serialization by *Black Mask*, was published by William Morrow in March 1933. *The Case of the Velvet Claws* featured a tough attorney named Perry

Mason and would go on to sell 28 million copies in its first 15 years in print. Gardner, whose no-frills, compulsively readable style of storytelling was born and bred in the pulps, came to be the most widely read and translated of all American writers.

Beginning with the November 1926 issue and for the next ten years, *Black Mask* was edited by Joseph T. Shaw. Although he did not discover Daly or Hammett or the other early tough crime writers mentioned above, Shaw was the editor responsible for defining and refining the new style of hard-boiled realism, the man most responsible for establishing hard-boiled as a literary force to be reckoned with. In his introduction to a 1946 anthology of early stories from the magazine, Shaw described the sort of mystery story he sought for *Black Mask*: "We wanted simplicity for the sake of clarity, plausibility and belief. We wanted action, but we held that action is meaningless unless it involves recognizable human character in three-dimensional form."

Shaw was as colorful as any of his writers. A former newspaper reporter and army captain (friends and associates always called him Cap), he had fought in Europe during World War I, had won an Olympic medal for fencing, and was the only man in New York licensed to carry a sword cane. Although he had never even heard of *Black Mask* before he was asked to edit it, he took the job seriously, even ponderously. Unlike the many pulp editors who were more interested in quantity than quality, Shaw maintained the highest standards in pulpdom. Stories were often returned to writers more than once for revisions, but most of the regular contributors were inspired by Shaw's detailed, serious response to their work. Raymond Chandler, a Shaw discovery, wrote that Shaw "has a great insight into writing and he can give a man a buck up when he needs it as nobody else I know can..." And in another

Below: A photo taken at a Los Angeles gathering of Black Mask *writers, January 11, 1936. Front row: Arthur Barnes, John K. Butler, W. T. Ballard, Horace McCoy, Norbert Davis. Back row: Raymond Moffat, Raymond Chandler, Herbert Stinson, Dwight Babcock, Eric Taylor, Dashiell Hammett.*

THE RED STAR NEWS COMPANY, Publisher. 280 BROADWAY, NEW YORK, N. Y.
WILLIAM T. DEWART, President THEODORE PROEHL, Treasurer
THE CONTINENTAL PUBLISHERS & DISTRIBUTORS, LTD. PARIS: HACHETTE & CIE.
2, La Belle Sauvage, Ludgate Hill, London, E.C.4 111 Rue Réaumur

Published weekly and copyright, 1939, by The Red Star News Company. Single copies 10 cents. By the year, $4.00 in United
States, its dependencies, Mexico and Cuba; in Canada, $5.00. Other countries $7.00. Remittances should be made by check,
express money order or postal money order. Currency should not be sent unless registered. Entered as second class matter
September 1, 1924, at the post office, New York, N. Y., under the Act of March 3, 1879. Title registered in U. S. Patent Office.
Copyright in Great Britain. Printed in U.S.A.
Manuscripts submitted to this magazine should be accompanied by sufficient postage for their return if found unavailable.
The publisher can accept no responsibility for return of unsolicited manuscripts.

Detective Fiction Weekly, May 13, 1939.

letter, "We wrote better for him than we could have written for anybody else."

With Cap Shaw at the helm *Black Mask*'s circulation increased throughout the late '20s and early '30s, peaking at 103,000. The Depression and increasing competition from a slew of hard-boiled imitators induced a circulation slump, and late in 1936, after a decade with the magazine, Shaw was fired. He wrote some mystery fiction (which showed no sign of approaching his editorial standards) and eventually became a moderately unsuccessful literary agent, dying at age 77 in the elevator of his Manhattan office building.

Although few would achieve anything like the success or acclaim of Dashiell Hammett, the writers in Shaw's stable were by and large a remarkably talented group, creating a rich array of effects and characters within the bounds of the hard-boiled style. Raoul Whitfield, a former silent-film actor and World War I fighter pilot and eventually a close friend of Hammett's, wrote razor-sharp detective and crime stories, including two action-packed novels serialized in *Mask: Green Ice* and *Death in a Bowl*. Even better were his stories written under the pen name of Ramon Dacolta, featuring the exotic adventures of a Philippines-based detective named Jo Gar. Having been brought up in the Far East, Whitfield did a colorful job of transplanting the tough private-eye tales from the mean streets and speakeasies of urban America to the muddy Pasig and the sweltering waterfront of tropical Manila. When Whitfield's novels began appearing, critics linked him with Hammett as the best of the new breed of crime writers—one high-minded essay labeled them the Matisse and Cezanne of modern mystery fiction. And like Hammett, Whitfield's output ended abruptly. In eight years, he wrote nine books and nearly two hundred stories, 88 in *Black Mask* alone. He then married a wealthy socialite and stopped writing. The socialite was murdered, Whitfield inherited her fortune, spent every dollar, and died, destitute, at age 46.

Other good writers mimicked the Hammett style, either by natural inclination or in calculated deference to Cap Shaw's buying patterns. Frederick Nebel wrote the popular Kennedy and MacBride series about a reporter and a police captain (with a sex change, it became the *Torchy Blaine* series at Warner Bros, starring Glenda Farrell and Barton MacLane) and authored the adventures of "Tough Dick" Donahue of the Inter-State Detective Agency, a p.i. clearly patterned after Sam Spade. W. T. Ballard placed his hard-boiled hero in the employ of a movie studio in the fast and entertaining stories about Hollywood troubleshooter Bill Lennox. Roger Torrey and John K. Butler wrote of various two-fisted gumshoes for *Mask* and assorted other private eye pulps throughout the '30s and '40s, both men masters of the tough-guy idiom, both now unjustly forgotten.

Cap Shaw discovered at least three writers who achieved the artistic heights of Dashiell Hammett. Horace McCoy was a World War I flier, a war hero awarded the *Croix de Guerre*, and a Dallas sports and crime reporter before he began writing fiction for *Mask* in late 1927. His stories about the flying Texas lawmen known as Hell's Stepsons combined the landscapes and character types of the Western with the detached tone and bloodletting of the hard-boiled detective story. At loose ends in L.A. after a fizzled attempt to break into the movies, McCoy took a job as a bouncer at a Santa Monica marathon dance contest, one of those tawdry, desperate spectacles that were the

Depression-era equivalents of bear-baiting. From this experience, and writing in the "hard, brittle" style well-known to *Black Mask* readers, McCoy produced a great American novel, *They Shoot Horses, Don't They?* His work went largely unnoticed in his own country, but in France, McCoy was acclaimed by Sartre and Gide as an important novelist and a father of existentialism.

Fast One was a cold-hearted, machine gun–paced masterpiece, published serially in five issues of *Black Mask*. A saga of gangland violence in Prohibition Los Angeles, it contains the hardest-boiled writing of them all, prose so lean and mean it makes Hammett's sentences read like the work of Rafael Sabatini. The author of *Fast One* and 12 short stories for *Black Mask* was Paul Cain, otherwise known as Peter Ruric, whose real name was George Sims. Sims liked to change his name a lot. He like to change the names of his wives and girlfriends, too. He married a cigarette girl from the Mocambo club and changed her name from Virginia to Mushel. He convinced a young dancer named Myrna Williams to call herself Myrna Loy. Not much more is known about him. To an anthologist seeking biographical information (Cap Shaw himself, who knew no more about Sims than anyone else), he sent a comical *curriculum vitae* in which he claimed to be a former Dada painter, bosun's mate, and gynecologist. As Ruric, he worked occasionally in films, scripting the bizarre and brilliant Edgar Ulmer—directed version of *The Black Cat* with Karloff and Lugosi. After the '40s, Sims dropped out of sight, report-

edly living a seedy expatriate's life on the Spanish island of Mallorca. Unpublished for decades, he died in obscurity on a Hollywood backstreet. His one novel, *Fast One*, called by the New York Times "a ceaseless welter of bloodshed and frenzy, a sustained bedlam of killing and fiendishness," is the enigmatic author's legacy, frequently republished in recent years to increasing acclaim—one of the highlights of the entire pulp era.

Shaw's third great discovery, and the only true success story, was Raymond Chandler. In 1933, Chandler was a 45-year-old failed Bloomsbury poet and fired oil-company manager when he sold his first story to *Black Mask*, a detective novelette titled *Blackmailers Don't Shoot*. From the beginning, Chandler had little in common with the fast churn-'em-out pulp pros. His first story took five months to write and in his entire pulp career Chandler never sold more than five stories in a year. But his work was crafted to last. Here is the well-known but never-tiresome opening to his story *Red Wind*:

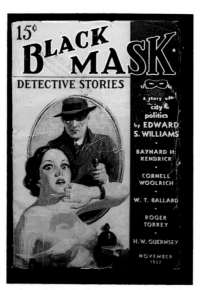

There was a hot desert wind blowing that night. It was one of those hot dry Santa Anas that come down through the mountain passes and curl your hair and make your nerves jump and your skin itch. On nights like that every booze party ends in a fight. Meek little wives feel the edge of the carving knife and study their husbands' necks. Anything can happen. You can even get a full glass of beer at a cocktail lounge.

Born in America, raised in England, Chandler received a classical education and began his adult years with effete and grand artistic ambitions. But the aspiring poet had to wait for experience and middle age and the wearying toll of life's disappointments to find his literary voice. Chandler brought a deliberately poetic style and rueful romanticism to the tough detective story. In the novels he wrote, *The Big Sleep, Farewell, My Lovely*, etc, some adapted—"cannibalized" he called it—from the pulp stories, Chandler perfected his synthesis of the lyrical and the hard-boiled. His distinctive, simile-laden prose, and his concept of the private eye as a knight errant in a corrupt world, would influence uncountable numbers of followers

All Stories Co

10¢ DOUB

DETECT

A Thrilling JIGGER MASTERS Case

DETECTIVE
FICTION
WEEKLY
Formerly Flynn's

JAN. 19
10

THE
LADY
FROM
HELL

True
Story of
a Sinister Woman
by Eugene Thomas

*Above and left: At the peak of their
popularity in the late 1930s, there
were more than 50 different pulp
detective magazines.*

in print and on film. Style cannot be copyrighted, or Chandler would have made his fortune in lawsuits. In any case, a zillion plagiarists, idolators, and satirists later, Chandler's best work remains unsurpassed.

Private-eye and crime pulps proliferated throughout the 1930s. More than 150 new titles were launched in the years following *Black Mask*'s success. Some lasted only a few issues, while others stayed in business for decades: *Ace-High Detective, Action Detective, All Star Detective Stories, All Story Detective, Best Detective, Black Aces, Candid Detective, Clues, Crack Detective Stories, Detective Book, Detective Classics, Detective Tales, Detective Trails, Dime Detective, Double-Action Detective, Double Detective, Exciting Detective, Fifteen Detective Stories, Fifteen-Story Detective, Five Detective Novels, Gold Seal Detective, Hollywood Detective, Nickel Detective, Popular Detective, Private Detective Stories, Red Star Detective, Romantic Detective, Speed Detective, Super Detective, Sure-Fire Detective, Ten Detective Aces, Thrilling Detective, Top Notch Detective, Variety Detective* ... and so on. What had been innovations in *Black Mask* became familiar formula, a pulpwood logjam of tough, wisecracking detectives, curvy secretaries, shabby offices with the requisite bottle of booze in the desk drawer, wary police inspectors, greasy nightclub-owning mobsters, their sap-wielding gorillas, and a seemingly endless supply of mysterious blonde clients. Only the gunslinging cowboy and the Wild West rivaled the private eye and his urban world as the predominant popculture mythology of 1930s America.

THE APPETITE for stereotypical hard-boiled detective stories may have been inexhaustible, but in the pulps' expansive heyday there was always enough rough paper left to try any and all variations on a theme. Big city gangsters grabbed the headlines during Prohibition, and several pulps, including *Gangster Stories, The Underworld, Gang World,* and *Gun Molls,* dealt with crime from the criminal's perspective, although the stories often featured the gangster protagonists in a commendable and highly unlikely collaboration with the police. The gangster pulps produced no works comparable to the great gangster films being made in Hollywood in this period.

Below: Street & Smith's Detective Story *magazine was the first all-detective fiction pulp. The March 5, 1932, cover featured the most common setting for Prohibition-era crime fiction, the speakeasy.*

Opposite: No figure was more emblematic of the pulp era than the hard-boiled private eye.

Despite many of them being habitués of mob-run speakeasies, the gangster pulp hacks evidenced little knowledge of the criminal milieu. An exception was Armitage Trail. The author of hundreds of underworld stories, published under an assortment of pseudonyms, Trail—real name Maurice Coons—was a gangster groupie. For years, he cultivated friendships with Chicago's top racketeers and killers. He eventually wrote a novel about Capone, *Scarface*—dedicated, as a matter of fact, to pulp editor Leo Margulies—and sold the film rights to Howard Hughes. Trail/Coons went out to California with the book, got himself a chauffeur and a butler, put on a lot of weight, and dropped dead in Grauman's Chinese Theatre at age 28. Anyway—

Another hard-boiled subgenre covered the good deeds of J. Edgar Hoover's much-publicized minions at the Federal Bureau of Investigation. In 1935, following the lead of a hit Jimmy Cagney movie called *G-Men* and the *Crashing G-Man* stories by Dwight Babcock in *Black Mask,* Standard Publications launched *G-Men* magazine. Subtitled *The Federals in Action,* it featured not only F.B.I. agents but two-fisted heroes from other—less legendary—branches of the government, such as Rush Blackwell, Postal Inspector. *G-Men* was followed by *Public Enemy* (later changed to *Federal Agent*), *The Feds,* and *Ace G-Man Stories.* Although endorsed by Hoover in the form of letters to the editors and reprints of his speeches to chambers of commerce and the like ("It is my personal opinion that the time will come when every honest man will be glad to have his

fingerprints on file"), the G-Man pulps were not big on authenticity. As Harry Steeger, publisher of *Ace G-Man Stories*, observed, "I don't think many real F.B.I. agents ever saw the kind of action we had in our stories." An understatement: Steeger's most popular G-Men characters belonged to a highly fictional clique called the Suicide Squad.

While the "classic" hard-boiled P.I. never lost his precedence, every detective pulp offered variant crime-fighting types, some of them believable, some silly, and a few that were utterly absurd. The most frequent—and certainly the most logical—line of work for non-professional sleuths was journalism. The 1920s and 1930s were the years of the crime-obsessed tabloids, when tough reporters rubbed elbows with big-time gangsters and were frequently investigating very violent events, and many pulp writers were themselves former or presently working newspapermen. Among the popular pulp journalists were Theodore Tinsley's creation, "Broadway wiseguy" Jerry Tracy of the *New York Daily Planet*, George Harmon Coxe's Flashgun Casey, Fred MacIssac's Rambler Murphy, and William

Writer Richard Sale, in Hollywood, with actress Barbara Bates, 1950.

Barrett's Dean Culver, author of a Winchellesque column on crime, *The Blue Barrel*. The best newspaper-based series featured Joe "Daffy" Dill (with spinoff stories about Dill's Weegee-like pal, photographer Candid Jones), published by *Detective Fiction Weekly* and written by pulp wordsmith extraordinaire Richard Sale. "I had some newspaper experience on a couple of papers," he told me. "I knew the background and knew some colorful characters. Those were the days when you had a dozen or so newspapers in New York. A lot of the tabloids were pretty wild." The Dill stories are told in a wisecracking, vernacular voice and move at a lightning pace.

"Garbo," I snapped, "get a grip on yourself. This is the finish. Call an ambulance and get that kid to a hospital. Call Poppa Hanley at H.Q. and tell him to come running. We've got the Pendleton killer. Then call the Old Man and break the yarn. I'll be back" And I tore out and down the stairs.

Up until the final crime-solving shootouts, nearly all of Dill's narration and dialogue is slangy sarcasm—he even answers the phone with a bantering, "Your nickel!" This was the sort of thing that was done to death in the detective pulps, but Sale's brash skill kept the Dill stories fresh and funny. Like many of the younger pulp veterans, Sale moved on to Hollywood. His first novel, *Not Too Narrow, Not Too Deep*, was turned into the MGM Devil's Island drama *Strange Cargo*, starring Clark Gable and Joan Crawford, and Sale eventually became a successful screenwriter and then director of motion pictures.

If newspapermen won hands down as the most believable of the detective-variants, the competition for *least* likely sleuth was stiff. Professions represented among the legion of amateur pulp detectives included magician, inventor, bookie, acrobat, tattoo artist, and mortician. The latter two were featured in *Dime Detective*. William E. Barrett's Needle Mike was a gray-haired, gold-toothed, jaundiced sleazeball practicing his tattoo trade in a ratty office building otherwise occupied by shyster lawyers and mail-order tricksters. In reality, Mike is young Ken McNally, the son of a St. Louis millionaire, who occasionally drops out of polite society and, heavily disguised, assumes his grubby alternate identity.

He looked into the mirror . . . The face that stared out at him was the tough, uncompromising face of Needle Mike,

Right: Street & Smith's
Detective Story, *the first
detective pulp.*

KEEN-EYED DETECTIVES *Match Wits with* CLEVER CRIMINALS

Street & Smith's **Detective Story Magazine**

TWICE A MONTH

15¢

AT ALL NEWS STANDS

the character that he had created to be his other self—the self that went adventuring into the grim fringes of the underworld when life amid luxury became too boring to be endured.

Barrett told *Dime Detective* readers, "I met several needle wielders and, although I haven't a single blue mark on my hide, the guild has fascinated me ever since." These lower depths adventures were never mentioned on Barrett's resume in later years, when he became the acclaimed author of religious-themed works such as his biography of Pope Paul VI and the novel *The Lilies of the Field.*

J. Paul Suter wrote ten stories for *Dime Detective* about funeral director and reluctant detective Horatio Humberton. The murder cases he works on are not nearly as intriguing as the brief, deadpan glimpses of Humberton practicing his vocation:

He could not devote all his time to criminology. Some of it had to be spent in earning a living. That morning he had a ticklish embalming job—one with diabetic complications . . . Still later, he skipped supper to do a plastic on a drunk driver, who otherwise would have to be buried without a face. He grabbed a midnight lunch from an owl wagon and hurried to police headquarters.

Perhaps the most unpromising of the amateur detectives was a character thought up by writer Lawrence Treat. "He was an advertising agency executive," Treat recalled. When I asked him—not having located the stories—how an advertising exec would possibly become involved in solving crimes, Treat took a long, perplexed pause before answering, "I don't have any idea! We tried everything back then." The police in those days, said Treat, "used to make fun of a lot of our stuff. They preferred the 'true crime' magazines, with the real murder cases and the photos of the corpses." Treat's crime-writing became more authentic after he befriended a San Diego homicide cop. "I went out with homicide detail for two weeks, and found out how little I knew." Treat would go on to become the "father" of the police procedural novel.

In the mid-'30s, the hard-as-nails school of mystery writing—a revolution ten years earlier—had become the standard, and perhaps a bit passé. Coinciding with Cap Shaw's dismissal from *Black Mask,* there came to prominence several writers who would take the hard-boiled style in new directions. Cornell Woolrich had been a promising young Fitzgeraldian novelist in the Jazz Age. By the time of the Depression, he was a broke, despairing recluse living with his mother at the Hotel Marseilles on 103rd Street and Broadway (Absolutely Fireproof was the hotel's utilitarian motto). In early 1934, he wrote his first crime story, *Death Sits in the Dentist's Chair,* and sold it to *Detective Fiction Weekly* for $110. It was a clever story about a murderous oral surgeon, and the narrator's race to save himself from the effects of a deadly cyanide filling. His second story, *Walls That Hear You,* was even better. A man's brother is found with his tongue and fingers cut off. The man tracks down the assailant, an insane abortionist, and the story climaxes in a grueling mix of anger, suspense, and dread. Woolrich, in these and over a hundred other stories in the next half-decade, gave mystery fiction an intensely emotional and psychological dimension. His typical stories, set in the grimy, low-rung Manhattan of cramped tenement buildings, subways, and dime-a-dance halls, are tales of torment and dark passion. Woolrich's word magic could draw a reader so deeply into his protagonist's dilemma that one finished the best of the stories in a state of almost unbearable anxiety. This was a long way from the cool toughness of Hammett.

Steve Fisher was another writer at this time who gave emotions to the hard-boiled style. A young ex-navy man, Fisher called his style "tough but tender." He sold *Black Mask's* new editor, Fanny Ellsworth, an unusual story titled *Wait for Me,* about a White Russian whore in Shanghai and the American sailor who loves her. The ending is tragic and haunting. The more emotionally charged style caught on and was featured in a number of detective pulps. A Popular Publications title, *Detective Tales,* became devoted to non-series and "off-trail" crime stories. Steve Fisher complained that the magazine "missed the whole point" of his and Woolrich's innovations. "I suppose what [editor Rogers Terrill] heard was 'emotion is in,' and to him emotion was having the hero's sister brutally murdered, or a sweetheart kidnapped … the weeping and wailing ladled on. It was embarrassing." Perhaps Terrill didn't give Fisher enough work. In fact *Detective Tales* published many outstanding stories, in-cluding notable and distinctly unformulaic work by Day Keene, Dane Gregory (Rob Robbins), and Fredric Brown. Another innovative approach to hard-boiled came from Norbert Davis, a skilled, highly entertaining writer who brought a touch of screwball comedy to the tough-detective story in his *Dime Detective* series about Max Latin. Latin's office is a booth in a noisy restaurant, surrounded by rude waiters and a blustering chef.

The ultimate subversion of Dashiell Hammett's standard of realism came in 1938, with *Dime Mystery's* short-lived devotion to the so-called "defective detective." This magazine, previously concerned with stories of "Weird Menace" (see chapter 7), suddenly turned itself over to the exploits of private eyes suffering from one or another disease or birth defect. Calvin Kane had deformed legs and was forced to crawl along the floor like a crab. Nicholas Street was a detective who suffered from amnesia—he could solve a case for you but don't ask him where he was born. The husband-wife team of Edith and Ejler Jacobson detailed the activities of Nat Perry, "the Bleeder," a detective suffering from hemophilia who could bleed to death from the slightest scratch. Journalist and biographer John Kobler wrote about private eye Peter Quest, who suffered from incurable glaucoma and was attacked by seizures of total blindness during moments of crisis. Further distinguishing him, Quest had a death wish and hoped one of his violent encounters with criminals would end his ocular suffering. "I plagiarized the idea of the blind detective from some old stories about an English detective named Max Carrados," says Kobler, 50-some years later. "The concept for the magazine was Rog Terrill's, I guess. I really don't remember a thing about it. The whole thing sounds kind of odd, doesn't it?"

The detective story managed to survive this aberration. As in every other pulp genre there was room for excellence and room for junk. Great crime writers continued to be nurtured by the rough-paper magazines right up until their demise. Hard-boiled classicists such as William Campbell Gault and John D. MacDonald were among the first-rate latecomers; they carried the tradition of Hammett and Chandler from the pulps into the paperback era to come. And before that, pulp genius Cornell Woolrich, moving on to novel-writing in the 1940s, took mystery fiction to its next creative plateau after hard-boiled—the shadowy, doom-haunted landscape of *noir.*

Right: Second only to Black Mask *in the quality of its crime stories was* Dime Detective, *from Popular Publications.*

10¢

ALL STORIES COMPLETE

OCTOBER

DIME DETECTIVE MAGAZINE

DEATH IN THE RAW
A CARDIGAN STORY
By FREDERICK NEBEL

T. T. FLYNN
WILLIAM E. BARRETT
FREDERICK C. DAVIS

LOV

10¢

NOV.

ALL STORIES
COMPLETE!

THE

By

*A typical romance pulp featured
not only love stories but a variety
of features from lovelorn columns
to etiquette advice to "love
astrology."*

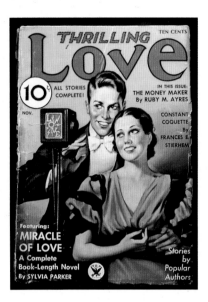

Popular Love

ROMANCE AND SEX PULPS

I glued my glims on her blonde loveliness; couldn't help

myself. The covers had skidded down from her gorgeous

shoulders; I could see plenty of delishful shemale epidermis.

Layna had the face of an angel, the curves of a scenic railway.

—FROM SPICY DETECTIVE STORIES

T HE PULPS WERE AIMED at the readers' emotions. Inevitably, some publishers targeted those emotions emanating from the heart and the groin. The romance pulps featured tales of idealized love, and made up the only rough-paper category aimed specifically at women. The sex—or "Spicy"—pulps featured ... well, idealized sex, and had an almost exclusively adult male readership, although no accurate statistics were kept on the number of American boys who sneaked a look at their fathers' back-drawer stash of Spicys. Every big pulp house had its assortment of sweet romance titles, and some of these were perpetually top moneymakers. The major houses could have made a fortune

on "hot" titles too, but there were certain things respectable, even semi-respectable, publishers didn't do in the 1920s and 1930s, and it was left to the fringe, independent outfits to supply man's *baser* magazine needs.

WHEN STREET & SMITH created the first successful romance pulp, *Love Story*, in 1921, it had already had great success with female-oriented romantic fiction. In the 19th century, their novels by the unromantically pen-named Bertha M. Clay were best-sellers. There were many slick-paper magazines for women, but these were generally upper middle-class in orientation and more than a little hoity-toity. Publisher Ormond Smith believed there was a huge untapped female market for the more egalitarian style of the pulps. The first attempt, *Women's Stories*, failed, but in May of '21, Street & Smith tried again and this time they had a winner. Under the editorial guidance of the ladylike Amita Fairgrieve, *Love Story* became a charming mixture of beauty tips, poems, and stories about modern girls—but not *too* modern—and how they fall in love forever and ever. In an early issue, Ms. Fairgrieve printed a boldly bombastic statement of policy:

LOVE STORY MAGAZINE
has recently made its appearance.
Its contents are, as its name implies,
based on the greatest thing in the
world: Love!

Love Story is not just another of those
sex-problem magazines, which have
done incalculable harm.

Love Story is clean at heart, and its love stories are
written around the love of the one man for the one woman.

Civilization has been built upon this sort of love—all the
great accomplishments of mankind have been inspired by
good women who were greatly loved.

"She was a sweet woman, Amita Fairgrieve, very sweet," recalls writer Jean Francis Webb. "She was a kind person and looked out for you, and if you were one of her favorites she really bought a lot of stuff from you. But then she got to where she didn't want anyone to think they were taking advantage of her, so she would reject every *third* story. It wasn't that there was something wrong with the third story, but that was her way of showing she wouldn't accept just anything. It got so I would show her each third story just to get it over with and then take it right over to sell to another magazine editor."

Under Fairgrieve, *Love Story* was an immediate success, with a circulation of over 100,000. In 1929, when an ex–dress model named Daisy Bacon took the editorial helm, it became a phenomenon, with sales of more than 600,000, the most popular pulp of all time. A thoroughly modern 1920s woman herself, Daisy Bacon believed her magazine's stories might be sweet and sentimental but they were not "old-fashioned." The heroines of *Love Story* represented the emancipated females who now had the *freedom* to seek true love. "She doesn't have to marry to get somebody to support her—she can do that herself," Bacon said in a newspaper interview. "And so she considers other things besides a man's money-making abilities. She looks for charm, companionship, and other intangibles in marriage today, where formerly she had to consider whether or not a man was likely to be a good provider ... Why, women are just beginning to know what romance is all about, and how to go out after it."

A successful pulp spawned imitators, and *Love Story* was followed by *True Love, Real Love, New Love, Thrilling Love, Popular Love, Sweetheart Stories,* and *Cupid's Diary,* to name but a few. There were, as well, the offshoots—love pulps with a Western background became

Opposite: Hounded off the newsstands by bluenoses, the Spicy line became the "speed" line and dropped entirely the erotic theme that kept the Spicys going.

Spicy MYSTERY ★

25c

JULY

by
Lew
Merrill

VAMPIRE

SPICY DETECTIVE STORIES *is published by*
the CULTURE PUBLICATIONS, INC., 900 *Mar-*
ket Street, Wilmington, Delaware. The
publisher assumes no responsibility for re-
turn of unsolicited manuscripts.

Contents page for the August '36 Spicy Detective Stories.

a major romance subdivision, with such titles as *Rangeland Love Stories, Romantic Range, Ranch Romances, Western Romances,* and *Thrilling Ranch Stories.* Less successful was an attempt to bring "love's compelling call" to the heartless denizens of the criminal underworld. In the waning years of Prohibition, Popular Publications launched *Underworld Romances.* Jean Mithoefer was the very young associate editor of the magazine. "The publisher just thought, love stories were doing good and crime stories were doing good, let's combine them. But that magazine lasted just three issues, as I remember, because we couldn't get any good stories. The women love story writers wrote kind of silly gangsters, and we had

some pretty tough crime writers who didn't know how to make their criminals act romantic. I don't know who the readers for that magazine would have been...maybe the wives of gangsters..."

Most pulp love stories were formulaic tales of flirtation and courtship, some light and frothy, some emotionally charged and full of heartbreak (although never containing the masochistic suffering of the "confession" story, another genre entirely). The stories might, depending on the editor and the year, be provocative, even racy at times—a girl might, for instance, fall into the New York harbor and be fished out by a young yachtsman who proceeds to strip her of all her wet clothes.

A faint smile flickered in his eyes. *"The crew are, naturally, men. Chinks, at that. What would you have had me do? Let you die of exposure? Besides, I—I didn't look. At least—" his flush matched her own—"I tried not to"*

Most often, though, the nature of pulp love was cloyingly sweet. And while the heroine could be a debutante or an heiress or even a movie star, she was likely to be a more modestly endowed, middle-class American female, not unlike the love pulps' primary readership of shopgirls and schoolgirls and secretaries and young married women. The story formula these readers responded to was a simple one: girl meets boy, girl marries boy. Of course, the road to romantic happiness could be a bumpy one, full of obstacles such as meddling relatives, tempting lotharios with pencil-thin moustaches, and even a girl's own foolish pride, but nothing is ever allowed to alter the course of true pulp love, and each and every fictional romance was mandated to end happily, the heroine and her dreamboat pledged to each other in eternal devotion:

"Oh, Kyle! Oh, Kyle—"

Gently, he took her in his arms. Tenderly he kissed the tears from her cheeks, kissed the long black lashes closed, kissed finally her lips.

"Love me?"

"Love you, Kyle!"

And so on: 4,950 words of coquetry and conflict, followed by 50 of rapturous climax. Most pulps offered a short factual column or two and a page for readers' responses, but the love pulps gave significant space to back-of-the-book non-fictional material. These features included beauty pointers ("It seems to me that only the slim, tapering finger can stand the long, pointed nail"), pen-pal ads ("I am a girl of fifteen who loves to have a good time . .."), advice to the lovelorn ("You are undoubtedly in a very trying situation, my dear"), advice from astrologists ("June children are usually filled with unrest, and therefore it is not strange that you are doubtful whether to begin the life of a school teacher or a seed specialist"), and advice that is just not categorizable:

Before retiring, take a hot bath and a drink of cold water.

Secure some picture representing romance and place it on the night-table . . . As soon as you settle yourself in bed lie several moments on your left side to slow up your heart action. Start taking deep breaths. With all your heart desire a romantic dream. Don't leave either arm outstretched . . .

Although they were enormously popular in their day, when the love pulps eventually disappeared, they left behind no trace of their existence. No great writers or continuing series characters were born in their pages, and it appears likely that no pulp romance story has ever been reprinted anywhere.

"I did some of the sexy stuff when I was starting out," recalls Jean Webb. "*Breezy Stories* and a couple of others. These were stories of what they used to call 'hot love,' as opposed to the 'clean love' stories I did for the romantic pulps. They were not at all explicit, you couldn't use any dirty words, but they were considered a bit shocking. I didn't enjoy writing them, either. I thought it was sordid. I remember my grandmother didn't want them anywhere in her house, she was so afraid someone might see them

Exotic foreign females provided the titillation in the typical Spicy Adventure story.

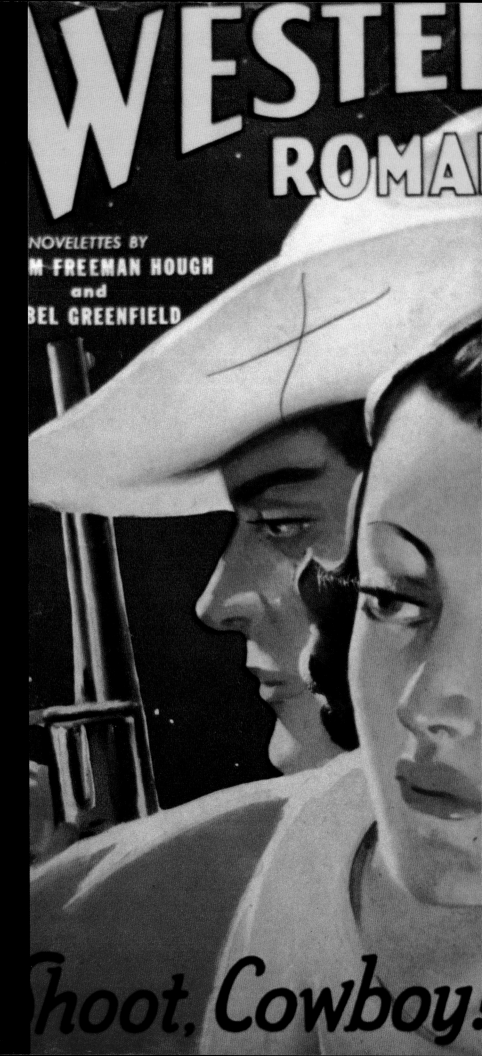

LOVE STORIES OF THE REAL WEST

RANCH ROMANCES

The Challenge at Crescent Peak
A Story of Cowgirl Courage
By MARIE de NERVAUD

20c

Second
October
Number

Above and right: Western-themed
romance pulps were nearly a
category unto themselves. Most major
rough-paper publishers had at least
one Western-love title.

WESTE
ROMA

NOVELETTES BY
M FREEMAN HOUGH
and
BEL GREENFIELD

Shoot, Cowboy

there." William Campbell Gault, best known for his excellent detective fiction and juvenile sports stories, made his first pulp sales to a pair of fringe sex magazines, *Paris Nights* and *Scarlet Adventuress*. The latter was an oversized pulp devoted to tales of "the woman adventuress," the sort, according to the editorial guidelines for contributors, "who has a definite goal—love, money, power, or revenge—toward which she steadily forges, using the allure of her body ..." Says Gault: "They were published in Pennsylvania somewhere, and paid a third of a cent a word. They bought anything as long as you made all the female characters voluptuous. I guess men read them like they read *Playboy* today. They were supposed to be hot stuff, but the stories were about as sexy as church."

America before World War II could be a fanatically puritanical place, and the various local and state blue laws regarding sexual literature were strictly enforced in many areas. For purposes of decorum and minimizing risk, the sexy pulps were rarely displayed openly but sold "under the counter" and had to be requested, even in a supposedly adult male bastion like the cigar store. Since many of the sex pulps came from oddball independent publishing companies, they were often irregular in appearance compared to the uniform product of the mainstream publishers. The dimensions varied—some sex pulps were saddle stitched, and some contained slick-paper inserts, six or twelve pages usually reserved for black-and-white photos of naked women. When the Spicy titles came along, they included comic strips as a regular feature—the adventures of Sally the Sleuth, Diana Daw, and Polly of the Plains, tough, luscious heroines fighting bad guys and losing their clothes in the process.

The first wave of sex pulps was tied to the *Zeitgeist* of the Roaring Twenties, a decade perceived to be made up of equal parts *joie de vivre* and moral turpitude. The stories detailed—or more often teasingly *implied*—incidents of premarital sex, extramarital sex, even wife-swapping, all activities fueled by plenitudes of bootleg gin. Free-spirited young flappers, with their short skirts and open minds, made perfect heroines for prurient literature. In *The Emancipation of Arabelle* in the November 1928

Below: French Night Life Stories *documented the revelry in* Gay Paree. *It was, in fact, one of many Gallic-set sex pulps.*

issue of *Ginger Stories*, the titular character is a saucy 18-year-old who, as the story begins, has succumbed to the latest frivolous flapper craze: "Half of the twenty-dollar gold piece her father had given her ... had been spent in having her legs, just above the knees, painted with pictures of the world's most famous bachelors ...Colonel Bindburgh [*sic*] and the Prince of Wales." Arabelle reveals her thigh-portraits after imbibing too much "pre-Volstead punch," raising her skirt while dancing the Charleston on a tabletop for an assortment of lascivious men. The flapper's unseemly behavior leads to two richly documented spankings before the story's ironic conclusion.

Americans of the 1920s and 1930s—particularly those interested in reading "hot" stories—were well aware that their nation paled by comparison, sexually speaking, to *la belle France*, the global capital of naughty activities. And the sex pulps fed this perception with a slew of Gallic titles: *Parisian Life, Gay Parisienne, Paris Nights, French Night Life,* and *French Scandals*, each offering up a selection of erotica with a continental air. Pulp *Pa-ree* was an insouciant place populated entirely by roués and their mistresses, horny *apache* dancers, and hornier rich nymphomaniacs, where the leading form of employment was nude figure modeling. If he could man-

age to get through the idiomatic dialogue ("*Mon Dieu*, me, I weel be less decent in one small moment eef you haf your way!") the reader of the French sex pulps could consider himself a true man of the world.

APRIL 1934 was a significant date in the history of under-the-counter literature. It marked the debut of the line of erotic fiction magazines known to legend as the Spicys. "I hope nobody minds my making love in public," S. J. Perelman effused in the pages of *The New Yorker*, "but if Culture Publications, Inc, of 900 Market Street, Wilmington, Delaware, will have me, I'd love to marry them...call it a schoolboy crush, puppy love, the senseless infatuation of a callow youth for a middle-aged, worldly-wise publishing house...I love them because they are the publishers of not only *Spicy Detective* but also *Spicy Western*, *Spicy Mystery*, and *Spicy Adventure*." And in these feelings, Perelman was not alone—well, perhaps at *The New Yorker* he *was*, but not elsewhere in red-blooded America. The Spicys, brain-children of publishers Harry Donenfeld and Frank Armer, were both daring and innovative, raunchier than previous sex pulps, and more accessible to a mainstream readership. While the *Gay Parisienne*–type publications affected an ersatz sophistication and used sex and seduction as subject matter, the Spicys took up the popular action genres—Western, private eye, high adventure—and infused them with blunt and often highly gratuitous passages of eroticism.

In the Spicys, the narrator's lechery needed no context—a woman merely bending over to tie her shoe was sufficient to provoke four or five sentences of salacious description. No matter how tense or action-packed a story might become, there was always time to stop and examine the attributes of every passing female:

Her creamy legs and sculptured thighs were the answer to a celibate's dream. Her hips were boyish and yet feminine: her waist slender and inviting. The flat plateau of her stomach swelled northward into two taut, milky-white breasts of flawless nubility. Just to glimpse those cone-shaped hillocks through the brassiere made Dan breathe faster . . .

* * *

Around her luscious silver-etched hips clings a torn piece of pale silk scarcely large enough to disguise the loveliness of her body. One arm is doubled under her back in such a manner that her breasts, large and firm like mounds of moon-lit snow, lift their proud swells into the cool night . . .

* * *

Naked to the waist, she picked up a longthonged whip and flexed it. Her full, tawny breasts undulated and swayed under their covering as she drew back her arm— Crack!

These are what were known as the "hot parts," calculated to quicken the pulse of impressionable Depression-era males. Some surviving copies of the Spicys show that discriminating readers often carefully underlined or encircled said hot parts for easy reference. Culture Publications knew what they were doing: the inclusion of concupiscent passages in otherwise conventional detective and adventure stories enabled them to charge 15 cents more than the price of the "decent" competition. And suc-

Writer Hugh Cave in 1932.

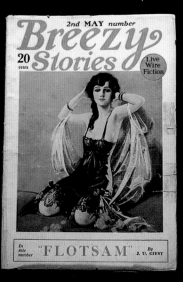

Top: A Spicy heroine may lose her clothes but she keeps a tight hold of her .38.

Above: Early sex pulps like this issue of Breezy Stories from May 2, 1929, usually suggested much more than they delivered.

Right: The male love objects in romance pulp illustrations were often more delicately featured than the females.

cess at the higher price allowed them to pay writers top-of-the-line rates. Although most felt the need to adopt pseudonyms, a number of notable pulp pros did write for the disreputable Spicys. Norvell Page was a contributor, as were E. Hoffman Price, Henry Kuttner, Steve Fisher, and Hugh Cave. Cave told me, "It was a good market. They paid three cents a word and sometimes more, and anytime I needed a quick check I could sit down and write one of those stories in an afternoon. They paid right away, on acceptance, unlike some of the more 'respectable' magazines. I never went to their offices, never met any editors. It was all done through my agent, Lurton Blassingame. It was fun. I wrote a series character, a roguish fellow called 'the Eel'— he was an imitation of a Damon Runyon character, told his own stories in the first person. I was reading Runyon at the time and so was everyone else. I didn't put my own name on the Spicy stories because I was trying to sell to the slick magazines then and it just would not have been a good idea for my real name to be plastered all over the cover of those Spicys. I invented a pen name for myself: Justin Case."

Robert E. Howard, famed for his Conan series in *Weird Tales*, wrote at least five pseudonymous stories for *Spicy Adventure*—brawling exploits of sailor Wild Bill Clanton. He discussed the new market in a letter to his pen pal H. P. Lovecraft, advising him to take a crack at it: "Just write up one of your own sex adventures, altered to fit the plot." The notion of the sickly, reclusive, and puritanical Lovecraft doing an autobiographical "sex adventure" for one of the *Spicy* magazines is more harrowing than any of his horror stories. The great Lovecraft did not follow Howard's suggestion.

NOV.

25¢

SPICY-ADVENTURE STORIES

HASHISH *from* HOSHEPUR
by Carl Moore

BITTER VENGEANCE
by
Willis Vachell Keith

There may have been other well-known writers in the Spicy pages, their pseudonymous bylines never to be exposed. Indeed, it is likely that many a Spicy detective and adventure story was a reject from the straight markets, recycled with a few hastily added sex scenes. There was really only one distinctive writer for whom Culture Publications was not a quick-buck or shameful secondary market—for whom, in fact, Culture provided the *only* forum for expressing his singular, goofball artistry. That writer was Robert Leslie Bellem, the Shakespeare of the Spicys. Bellem, an ex-reporter, had been selling to the pulps for several years when the Spicys came into being. He was one of the speed demons, capable of churning out a roomful of copy every day of the week, and he often wrote whole issues of minor pulps, using his own and an assortment of pen names. Most of his work was no better than competent and he would be one more obscure hack today if not for his creation of a horny, Hollywood-based private eye named Dan Turner. Turner first appeared in the June 1934 issue of *Spicy Detective* and quickly became the Spicys' most popular offering. Eventually, the character would have his own personal pulp, *Hollywood Detective*, and Turner's adventures, all penned by Bellem, would number in the hundreds.

What distinguished the Turner stories, and earned them the rabid admiration of readers like Perelman, was their wacky colloquial voice, a version of the simile-and-slang-laden hard-boiled style exaggerated to the point of delirious ridiculousness. A gun, for instance, never fired; rather, a "roscoe" "belched *Chow-chow*," "coughed *Ka-Chow*," "sneezed *Ker-choob!*" If P. G. Wodehouse had decided to make his Bertie Wooster a violent and salacious hard-boiled gumshoe, the result night have sounded something like Dan Turner. "Will you come along willingly," the detective typically says to a guilty party, "or do I bunt you over the crumpet till your sneezer leaks buttermilk?"

Turner's first home being a Spicy, there were naturally many occasions for lechery, and Bellem was a master of dippy sex talk. He was particularly creative in his euphemisms for a women's breasts, known variously as "white woman's melons," "creamy bon-bons," "firm little tiddlywinks," "perky pretty-pretties," and "gorgeous whatchacallems." Unlike most of his Culture Publications co-workers, who tended to merely impose a little sex on an ordinary action plot, Bellem knew how to conceive a story with organic erotic content. In *The Corpse in the Cabinet*, for instance, Dan Turner is in a Turkish bathhouse ("having a gallon of Scotch steamed out of my carcass...") when a scream comes from across a partition. Dan bursts in on the crowded ladies' section of the bath, finds a dead body, and for several pages proceeds to interrogate a lineup of sweating, stark-naked female murder suspects.

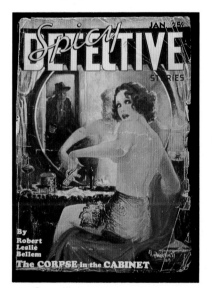

FROM THE BEGINNING the Spicys had enemies in high places. The Post Office and various local governments were continually scheming to put them out of business. The Spicys had their editorial offices in Manhattan, but the publishers felt the need to use a Delaware maildrop address on the masthead in order to confuse the bluenosed New York authorities. There were plenty of problems with distribution. In some cities, the Spicys were banned or had their front covers removed before sales were permitted. By the late '30s, Culture was forced to scale back the sex content and eventually gave up the Spicy line altogether. The tamer "Speed" line took its place. By then, publisher Harry Donenfeld had found a much less troublesome and more profitable form of publishing—comic books. Culture's head man had taken over DC Comics, the enormously successful home of Superman and Batman.

Above: The Corpse in the Cabinet *was the featured story in the January 1935 issue of* Spicy Detective Stories. *Author Robert Leslie Bellem, creator of concupiscent Hollywood detective Dan Turner, was the prolific "Shakespeare of the Spicys."*

Opposite: The Spicys owed a good deal of their success to the larger-than-life cover girls painted by H. J. Ward.

The Shadow was the first and
most successful of the pulp
super-heroes

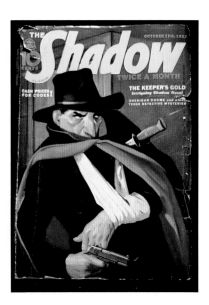

Shadows and Supermen

THE HERO PULPS

"Well," said Doc Savage, ill at ease, "I guess you would call our profession righting wrongs and punishing evildoers, going to the far corners of the earth if necessary."

"That sounds silly," said Fiesta.

The bronze man made no reply to that.

—"The Flaming Falcons",
Doc Savage Magazine

I N THE FALL OF 1930, a mentally unstable radio writer named Harry Charlot—murdered a few years later in a Bowery flophouse—thought up an identity for the previously anonymous narrator of "The Detective Story Hour." He called him The Shadow. The radio program was a cheap promotional showcase for Street & Smith Publishers' *Detective Story Magazine.* Each week an actor named James LaCurto read over the airwaves a story from the magazine's

current issue. Now the programs began with LaCurto doing a hammy, scarifying laugh and intoning the words, "The Shadow knows..." This newly characterized narrator became a hit with the listeners, and Street & Smith began hearing of repeated requests for "the magazine with that Shadow guy ..." There was no such magazine, of course, only *Detective Story*, with its mostly humdrum private-eye and mystery fiction. But news of the public passion for the creepily cackling radio Shadow came to the attention of the S & S circulation chief, Henry Ralston. A veteran of more than 30 years in the cheap thrills business, Ralston clung to some old, outmoded enthusiasms. He had never forgotten the pleasures—and the profits—once generated by the dime novels with their larger-than-life heroes, Nick Carter, Buffalo Bill, and the rest. The response to The Shadow gave Ralston the excuse he was looking for to revive a single-character publication. It could be done just like in the old days: target a young male audience, create a house name byline to retain all creative control. Ralston even found an ancient unpublished Nick Carter manuscript that could be rewritten for the new character. He dumped the project on the desk of *Detective Story* editor Frank Blackwell and told him to put out a magazine, fast, while the radio show was still causing excitement.

Blackwell may not have thought much of the idea—after all, even the low-caste pulps looked down on the embarrassing dime novels—because he did not give the assignment to one of his regular writers but instead offered it to a relatively unknown Philadelphia magician and author named Walter Gibson, who happened to be stopping by the office that particular day in December 1930.

Gibson, 33 years old, had been a reporter, one of the first composers of crossword puzzles, and a ghostwriter for the world-famous magician Harry Blackstone. Gibson and Blackwell decided to toss the Nick Carter manuscript and start fresh, and Gibson began writing on the train ride back to Philadelphia—the book-length story had to be completed at once, the premiere issue of *The Shadow* scheduled to hit the newsstands in a little over two months' time.

With an April 1931 cover date, the first issue of *The Shadow*, went on sale right on schedule. The novel opens on a scene thick with tension, mystery, and despair. On a New York bridge clouded by a black mist, a young man prepares to commit suicide. He leans above the distant dark waters and his fingers loosen their hold on the rail. Suddenly, while "balanced between life and death," he is gripped by an iron force. Someone drags him back, someone with an irresistible power. The would-be corpse sees a frightening figure before him, "a tall black-cloaked figure that might have represented death itself . . . The stranger's face was entirely obscured by a broad-brimmed felt hat bent downward over his features; and the long, black cloak looked like part of the thickening fog." Hauled into the back of a chauffeured limousine, the dazed man hears the mysterious stranger's offer of a new lease on life. "I shall improve it ... I shall make it useful. But I shall risk it, too. Perhaps I shall lose it, for I have lost lives, just as I have saved them." A few paragraphs later, the young man has sworn his allegiance, a hold-up man has been shot dead, and the stranger has vanished—"like a shadow!"

And so begins the first issue of the first single-character pulp, the beginning of the great epoch of pulp heroes and superheroes. *The Shadow* was a sensation, moving quickly from quarterly issuance to monthly to biweekly. The character would make Street & Smith several fortunes in licensing fees and royalties, and the magazine would last for nearly two decades. Old Henry Ralston had been right, the old dime novel formula could be repackaged and made to work again.

The Shadow himself, a Victorian wraith with his black cloak and sinister cackle, might have felt right at home in a 19th-century story paper. He also owed something to the flamboyant pulp heroes of the pre-1920 pe-

Above: Street & Smith's The Wizard *was a short-lived hero pulp about "Cash" Gorman, a financier. The magazine, subtitled* Adventures in Money Making *did not catch on.*

Opposite: As this Rudolph Belarski painting for March '38 shows, the streets aren't safe even for a man in a diving helmet.

The PHANTOM DETECTIVE

MAR.

10¢

A THRILLING PUBLICATION

BIG
CASH
PRIZES

THE MASTER OF DEATH
A FULL-LENGTH NOVEL FEATURING
THE WORLD'S GREATEST SLEUTH

ALSO IN THIS ISSUE: AVIN H. JOHNSTON
ROBERT WALLACE • EARLE DOW

riod, Johnston McCulley's masked swordsman of Old Capistrano, Zorro, and Frank Packard's Jimmie Dale, a.k.a. The Gray Seal. The Shadow may have actually seemed startlingly fresh in the 1930s, when crime-fighting heroics had become the exclusive province of the hard-boiled, bluntly realistic private eye. The setting, too, although ostensibly contemporary, had little in common with the mean streets realism of most pulp crime fiction of that time. Filtered through Walter Gibson's theatrical imagination, The Shadow existed somewhere near the foggy gaslit world of Sherlock Holmes and Count Dracula.

In the first novels, The Shadow is an almost peripheral character, making sudden, decisive appearances at critical points in the narrative. The Shadow prefers to use an informal army of recruits and lieutenants to do his groundwork, investigating incipient crimes, setting the traps that will thwart the hordes of evil; then, when the time is right, and from some unknown sanctum, he arrives, a being in black, striking swiftly with blazing automatics. The ending is invariable—the foe vanquished, crime for the time being stilled, and the midnight victory announced by the creepy peals of The Shadow's mighty laugh (that radio actor's improvisation becoming the literary

Shadow's permanent and most famous characteristic). For a time, The Shadow was so mysterious that no one involved in his creation had a clear idea what he looked like. The definitive depiction of the character was the belated work of cover artist George Rozen, who took over the job when the previous painter, his twin brother, Jerome, was injured in an auto accident. George had one initial difficulty, a blind spot about the description of The Shadow's nose as "hawklike." He was finally told to copy the nose of the assistant art director. As the series went on, readers gradually came to know more about their hero. The Shadow acquired familiar props—his twin .45s, an autogyro—and his true identity was revealed. Known only to a pair of close-mouthed Xinca Indians (and, implicitly, to millions of trustworthy readers), The Shadow was actually Kent Allard, the famous aviator (Lamont Cranston was merely one of The Shadow's many impersonations—the revised radio series, starring Orson Welles, got that all wrong).

Street & Smith maintained a close proprietary watch over their breadwinner throughout most of his existence. Individual plots and general developments in the series had to pass through an unusual committee system. Writer Walter Gibson would work out a detailed synopsis for the next novel and then take it to overseer Henry Ralston and new editor John Nanovic for approval or amendment. New gimmicks, settings, characters were kicked around by the three during committee meetings. Gibson welcomed the guidance since his standing assignment was the production of two 60,000- to 70,000-word novels per month. It was a grueling task, but Gibson seemed to relish it. "To meet *The Shadow*'s schedule, I had to hit 5,000 words or more per day," Gibson once recalled, "I made 10,000 words my goal and found I could reach it. Some stories I wrote in four days each … On these occasions, I averaged 15,000 words a day, or nearly 60 typewritten pages, a pace of four to five pages an hour for 12 to 15 hours. By living, thinking, even dreaming the story in one continued process, I found ideas came faster and faster." Gibson typed so furiously that his fingers bled. Incredibly, he maintained this pace—and a generally high standard of storytelling—for more than a decade, producing a total of 282 Shadow novels.

Blackwell's original, arbitrary choice of Gibson could not, as it turned out, have been more inspired. It was the perfect matchup of author and character. As a magician and as a historian of magic, Gibson brought to The Shadow a

On Sale First and Third Friday

Vol. XXIII THE **Shadow** REG.U.S.PAT.OFF. Yearly Subscription $2.00
Number 4 **Shadow** Six Months $1.00
October 15, 1937 TWICE A MONTH Single Copy 10 Cents

The entire contents of this magazine are protected by copyright, and must not be reprinted without the publishers' permission.

CONTENTS

The Keeper's Gold
Complete Shadow Novel
From the Shadow's Private Annals
As told to
Maxwell Grant

STARTS ON PAGE 10

Thrilling Stories and Features

MURDER IN THE CARDS Robert Arthur 88
Fortune telling was mysterious business to the law, but getting a murderer wasn't!

CODES Henry Lysing 99
Interesting information concerning Codes, Ciphers, Cryptograms and Secret Inks.

DEATH IN THE RAIN Stephen Gould 102
Sheridan Doome, crack Naval Intelligence ace, walks the streets of Wash-

The Shadow, October 15, 1937.

unique perspective. The stories were the literary equivalent of a master illusionist's stage act, full of tricks, threats of sudden death, and mysterioso atmospherics. Despite his output, Gibson was no hack. He felt an intense dedication to the series and the character he had largely created. Each novel had to top the last in plot twists, trickery, surprise ending. His one frustration with the assignment that would take up so much of his life was its enforced anonymity. Street & Smith never wavered from its policy regarding *The Shadow's* byline—all of Gibson's novels would be credited to the house name of Maxwell Grant. As the magazine soared to prominence, and the new radio series and motion picture adaptations followed, Gibson's crucial contribution to it all remained unknown outside pulp circles. Only in his old age did Gibson get to enjoy public acclaim from the legions of *Shadow* readers around the world.

IT TOOK MORE than a year for publishers to try and emulate *The Shadow's* great success, but from early 1933 the imitators began to arrive, an assortment of single-character pulps featuring mysterious avengers and larger-than-life enemies of evil. The first to hit the stands was Standard's *The Phantom Detective.* Created, with a minimum of ingenuity, by editorial head Leo Margulies, The Phantom was the crime-fighting alter ego of Richard Curtis Van Loan, a Park Avenue playboy. The Phantom was a master of disguise, although his most frequent disguise was a rather unmasterful Lone Ranger–type mask and a derby hat. The cases that caused Van Loan to abandon his polo ponies and don his mask and bowler were the ones too big for the entire New York police force. The Phantom's foes were usually megalomaniacal conquerors like The Mad Red, a Communist with a fiendish plan for world domination. *Phantom Detective* stories tended to be bloody nonsense. Margulies assigned them to a stable of hacks (Anatole Feldman, D. L. Champion, Laurence Donovan, Norman Daniels, etc.), all writing under the house names of G. Waymon Jones or Robert Wallace, and through the years there was little consistency regarding the tone or the scope of the series or the precise personality of The Phantom Detective himself. With no sympathetic biographer like The Shadow's Gibson, the character remained lifeless. Still, the series contained enough outlandish villainy and blood-and-thunder action to maintain moderate sales and keep The Phantom in business for 20 years.

JIMMY CHRISTOPHER

Jimmy Christopher was Operator #5, "America's secret service ace."

A month after *The Phantom Detective's* debut, Street & Smith issued their own follow-ups to *The Shadow.* Not surprisingly, considering his enthusiasm for the dime novel heroes of the past, Henry Ralston decided to put Nick Carter back on the newsstands. Of course, the character had to be modernized: instead of the dippy Rover Boy of the 1890s, the new Nick was a tough private investigator, tackling crime syndicates and such. Of course, this being a juvenile hero pulp and not *Black Mask,* Nick's investigations involved spectacular props such as his bomb-carrying private airplane with a floor that could convert into a giant magnifying glass. The public showed little interest in the character and the face-lifted Nick was re-retired.

The second hero pulp Street & Smith launched that same month—March 1933—was considerably more successful. *Doc Savage Magazine* would last for 17 years, 181 issues, and come to be regarded as one of the supreme achievements in the history of the pulps. Once again, the initial idea came from Henry Ralston. He conceived of a single-character magazine that could be the high-adventure equivalent of *The Shadow* mysteries. John Nanovic, the young editor who had been working on *The Shadow* since the fourth issue, took Ralston's rough concept and

wrote a detailed outline and character genesis for the proposed pulp. Clark Savage, Jr., is a brawny genius, a surgeon, mineralogist, engineer, inventor, and master of languages, as well as being the Supreme Adventurer. His skin color is a glowing bronze ("bespeaking of long years spent beneath tropic suns and northern skies"), his hair is a matching hue, and so are his set-well-apart, magnetic-like gold-flake-resembling eyes—not for nothing is he known as the Man of Bronze. Headquartered in a Manhattan skyscraper, Doc is the leader of an almost equally colorful group of five other adventurers: Renny, another brawny giant and a world-renowned engineer; Long Tom, a skinny electronics genius; Johnny, scrawny, studious-looking, a geologist, and "the greatest physicist of the land"; Monk, chemist of genius with the body of a gorilla; and Ham, sardonic, nattily dressed, Harvard-educated lawyer, wielding a sword cane with a drug-laced tip. Financed by gold reserves from a hidden Central American mine, Doc and gang begin their spectacular task:

. . . to go here and there, from one end of the world to the other, looking for excitement and adventure; striving to help those who need help; to punish those who deserve it . . . People, tribes and nations would gain their help when sore pressed. Industry would be served by them. Art and science would profit by their daring . . .

It was an exciting enough declaration of intent, but there was no initial guarantee that Doc Savage would fare any better with the readers than the reincarnated Nick

Carter. The Nanovic-penned outline lacked spirit and its gold-mine plot was plain dull. Doc's future became assured only when Ralston and Nanovic chose as his amanuensis a man by the name of Lester Dent, a 28-year-old Missouri writer with a limitless imagination, a devious sense of humor, and a flair for gadgetry and science—all hallmarks of the series to come.

Only a few years before he was picked for the monthly Savage assignment, Lester Dent had been a $125-

a-month "brass pounder"—a telegrapher—at the Associated Press office in Tulsa, Oklahoma, attempting to write adventure stories during the midnight-to-eight graveyard shift. In December 1930, he received an amazing, inexplicable telegram from Richard Martinsen at Dell Publishing: "If you make less than $100 a week on your present job, advise you to quit. Come to New York and be taken under our wing with a $500-a-month drawing account." Dent was soon living in Manhattan, writing the entire contents of two Dell pulps, *Scotland Yard* and *Sky Riders*. He made $1,500 the first month. Both pulps folded a few issues later and Dent was left to his own devices.

One of the stories he sold while freelancing was a gaudy action tale titled *The Sinister Ray*, featuring a brilliant "scientific detective" named Lynn Lash. This was likely the story that brought Dent to the attention of Henry Ralston. Even more than Walter Gibson and his Shadow, Dent and Doc Savage were the perfect symbiosis of creator and creation. "He put a lot of himself into that character," his widow, Norma, told me. "A lot of his writer friends used to call him 'Doc' because he was so much like Doc Savage." Strange but true, the telegrapher/hack from Missouri and the bronze Supreme Adventurer had much in common. Physically, both were prepossessing figures. Dent was a huge man, six foot two and over two hundred pounds, and a flamboyant dresser, affecting for a time needle-point mustachios or full beard. Like Doc, Dent easily mastered a variety of technical skills. He was a pilot, electrician, radio operator, plumber, and architect. "He designed our entire house from scratch," said Norma. "Taught himself how to do it, drew up the blueprints and everything." And Dent shared with Savage a yearning for adventure. He prospected for gold in the Mojave and for three years sailed the Caribbean on his yacht *Albatross*, searching for sunken Spanish treasure. "He had a treasure map he bought from someone," Mrs. Dent recalled, "and there was supposed to be a big gold table worth millions of dollars sunk out there. We never found it but someone else did many years later. He would dive for treasure during the day and then sit on the deck and write his Doc Savage story all night."

Certainly Dent's productivity as a writer qualified him for superhuman status. He could write around the clock, putting himself as much as a year ahead of schedule when he wanted time off, and he often worked on three different stories at once, moving from typewriter to typewriter to keep from getting bored.

*Above: Lester Dent, author of the
Doc Savage novels.*

*Opposite: Pictured, the emblem for
the Doc Savage Club. Most of the
single-character "hero pulps,"
aimed at a juvenile readership,
had similar organizations.
Membership dues from the
youngsters were a good source of
income for hero-pulp publishers.*

Although Street & Smith required
the use of a house name (Kenneth
Robeson) for all issues of the
magazine, the majority of the Doc
Savage stories were written by an
inventive Missouri wordsmith named
Lester Dent. Seen here, the April
'39 issue made timely use of the
New York World's Fair.

A firm believer in fiction formulas and "master plots" for pulp writing, Dent referred to the bulk of his output as "salable crap," but if his *Savage* work was mechanical, he disguised it well with an endless supply of dazzling distractions. Particularly in the wild and wooly early years, Dent really delivered the goods: great villains (The Mystic Mullah; The Sargasso Ogre; the dreadful John Sunlight; the tittering "Tibetan" Mo-Gwei; the piano-playing—"always a prelude of unpleasantness for somebody"—sadist Count Ramadanoff; the speedy 131-year-old Dan Thunden); great gadgets (600-shot-per-minute handgun; oxygen pills for breathing underwater; rocket-propelled dirigible; hollow false teeth containing explosive chemicals and tiny tools; a banjo rifle, bullets fired by plucking a string; a platinum suit for deflecting certain death rays); great threats (genetically mutating monsters; exploding "terror falcons"; flesh-eating ants; mind-freezing radiation); and great *buildings* even (Doc's icelike Arctic refuge, the Fortress of Solitude, guarded by a tribe of Eskimos; his privately owned "college" where evildoers are sent for brainwashing).

Dent was a recklessly generous storyteller, providing each issue of *Doc Savage* with enough imaginative material to supply a year's worth of competing hero pulps. One typically over-the-top narrative, September 1933's *The Lost Oasis*, involves a hijacked zeppelin, a gorgeous English aviatrix, trained vampire bats in New York harbor, a pair of Middle Eastern bad guys, a desert prison camp, Doc and gang in an autogyro dogfight, jewel-bearing vultures, car chases, man-eating plants, a slave revolt, and a lost African diamond mine. Although the inventions and science-fictional elements were a strong part of the series' appeal, the stories themselves transcended categorization, roaming freely from science fiction to supernatural horror to whizbang action to lost world adventure à la Burroughs or Rider Haggard. With Dent behind the typewriter, *Doc Savage Magazine* became a crazily exhilarating reading experience, a monthly ten-cent hallucinogen for 14-year-old boys of all ages.

L ATE IN 1933, that most eventful year for the superhero, Popular Publications weighed in with two memorable titles. *The Spider* reshuffled established ingredients—The Phantom Detective's mask and day job (New York millionaire), old-timer Jimmie Dale's calling cards, and The Shadow's black duds. Known only to his girlfriend, Nita Van Sloan, and his Hindu manservant, Ram Singh, Richard Wentworth's secret identity is The Spider, "Master of Men," a ruthless crime fighter who stamps the corpses of his numerous victims with a vermilion, spider-shaped seal. "We saw how very successful *The Shadow* was and we wanted to do something like it," said *The Spider*'s creator, Henry Steeger. "And I think we improved on it."

The first two issues were stodgily written by R. T. M. Scott, a Canadian ex-army major. He was replaced by wild-eyed, hard-boiled hack Norvell Page, using the pen name of Grant Stockbridge. In this same period, Steeger had begun his notoriously sadistic "shudder pulps"—to which Page contributed numerous lurid stories—and *The Spider* would take a similarly intense approach to violence and sex. From the first, Page's Spider novels have a harsh, visceral power. In *Wings of the Black Death*, Richard Wentworth battles a cruel, blackmailing criminal who threatens New York with bubonic plague ("'I think it best,' he said, 'that Ram Singh drive you back to town at once. The man who just phoned declared that he was about to loose the Black Death upon all of us!'"), the effects of which are described in sickening detail:

Works' head sagged forward. Breath rasped more harshly in his throat. He belched. Blood poured from his jaws. It tore a muffled scream of agony from him.

"Quick, man!" Wentworth shot at him. "Do you know who the blackmailer was?"

Suddenly Works convulsed, reared back in his chair with clutching hands digging into his throat.

"Speak, man, speak!" Wentworth cried.

The purple lips opened, suffocation blackened his face. Blood gushed out. Sound issued from that ghastly mouth. But it was sound that was translatable into no word. It was the death rattle.

In *The Spider*, for once, the viciousness of the criminals was matched by the hero. None of Doc Savage's anesthetic "mercy bullets" or reprogramming seminars for the opponents of Richard Wentworth. Justice for them is sudden and final:

But the Spider's bullet had sped true. A round blue hole gaped in the forehead of John Harper.

DOC SAVAGE

MAGAZINE

REG. U.S. PAT. OFF.

10 CENTS

"LAND OF LONG JUJU"
—And of Danger And
Death to the Unwary
Complete Novel

For an instant he sat straight up in his chair, a surprised look upon his face. Then he slumped forward, his head spilling blood on the stolen jewels over which he had gloated. His life of greedy crime was ended.

* * *

The Spider sprang upon him, slammed home his fist. The head rolled limply over. The larynx had been crushed in, closing the windpipe and killing him instantly.

* * *

In the end, the Black Death was a coward and died a coward's death, with terror in his eyes, with The Spider's fingers crushing the life slowly out of him.

As for sex, both Wentworth and the lovely Nita continually encounter the sort of lasciviousness that would have sent Doc Savage fleeing to his Fortress of Solitude and bolting the door. There are orgies, threats of rape, sexual torture:

They lifted her bodily from the floor, stretched arms and legs to the great thick spokes of the wheel and bound them there, ripped off her clothing with rough hands. Even before the task was finished, a gnout whistled through the air to lay its streaks of torn red across her white body.

Temptresses:

Her body was alive and warm and urgent and she raised herself up against him, and her lips found his with a kiss so passionately abandoned that it burned like something annealed in a white-hot oven.

It was another effective innovation from Henry Steeger, pulp publishing's Young Turk: a superhero book aimed at an adult sensibility. The stories grew larger and more fantastic as they went on, and author Norvell Page

Opposite: The hero of 181 issues of Doc Savage Magazine *was Clark Savage, Jr., surgeon, inventor, aviator, engineer, brawny punisher of evildoers, the Man of Bronze, the Supreme Adventurer.*

came increasingly to identify with his creation. "Some have said Norvell Page was a bit eccentric," said Henry Steeger. "He used to wear a black cape and a large black hat like The Spider, and he may have thought he was that character. Talented man, though." True. Although lacking Lester Dent's relentless inventiveness, Page wrote prose that grabbed you by the collar and didn't let go.

The other hero pulp Popular brought out in October 1933 was equally distinguished and captured an immediate and loyal readership. *G-8 and His Battle Aces* was the creation of Robert J. Hogan, a 36-year-old minister's son from Buskirk, New York. Hogan had learned to fly during World War I, and had been a salesman and aircraft demonstrator for Curtiss-Wright at the Syracuse airport. He lost the job in the Depression and began writing stories for the vast array of aviation magazines. He came to Steeger with an idea for a hero pulp with an air war background. G-8 would be a World War I flying spy, his persona and experiences inspired by a real-life pilot of Hogan's acquaintance, Harold Nevin. Steeger went for it, but hedged his bet by including the title and typeface of his first successful pulp, *Battle Aces*. These were not going to be your average air ace stories, as evidenced by the first of Frederick Blakeslee's many stunning G-8 cover paintings, a moonlit view of two Spads chasing a giant bat, the hero strapped to one of the rodent's wings. With the outlandishness the pulps had become noted for, G-8 combined flying fiction with science fiction and frequent doses of horror-fantasy.

In the opening adventure, *The Bat Staffel*, the young American spy is cooling his heels in the dungeon of Freiburg Castle, stooped over in an old codger disguise and about to be executed. He wangles a meeting with the man who would become his most frequent adversary in the issues ahead, *Der* evil *Herr Doktor* Krueger, and in the time-honored tradition of criminal masterminds, *Herr Doktor* feels compelled to reveal his top secret plans to G-8 before killing him. The Germans, it seems, are about to unleash the "poison breath" of the great bats of the Jura caves, a breath so deadly that a few canned drops—as Krueger demonstrates—shrink a guinea pig to dust. Now, with this info to relay, G-8 *must* escape, using the *doktor* as a shield and heaving the cannister of bat breath at the guards.

"Gott im Himmel"

Aided in his escape by two passing fliers—future Battle Aces Nippy Weston and Bull Martin—G-8 returns to Paris headquarters, gets General Pershing's new man-

date ("You may take matters entirely in your own hands") and sets off to destroy the Bat Staffel, and a total of 109 other gaudy opponents to come. Mercifully, few of our fighting men in World War I knew of the terrifying experimental weaponry in the hands of the German enemy: the bat halitosis, the skeleton ray, the dragon, the lightning machine, the chemical that turns men into mummies, the zombies, robots, wolf-men, hawk-men, tiger-men, Martians, and more. But superspy G-8 knew and each month he and his devil-may-care flying buddies, Nippy and Bull, did what it took to intercept the Kaiser's bizarre arsenal.

For a time, the air was crowded with flying hero pulps. *The Lone Eagle* from Better Publications featured conventional heroics, while another Popular title, *Dusty Ayres and His Battle Birds*, was even more fanciful than G-8. Dreamed up during a possibly liquid lunch between Henry Steeger and writer Robert Sidney Bowen (a World War I vet and former Royal Air Force ace), *Dusty* was to take place in the near-future, during a spectacular war between the U.S. and an imaginary Central Asian country ruled by a merciless, masked dictator known as Fire Eyes, Emperor of the World. Having conquered all of Asia and Europe, Fire Eyes' fierce armies invade America—one cover shows a

BOOK ONE OF
KA-ZAR OF THE BEASTS

Pearl Harbor–like air attack on New York City. Street & Smith's *Bill Barnes Air Adventure,* had a contemporary setting and was aimed at very young boys of an earnest disposition. It resembled a hobbyist publication, with its non-violent covers depicting customized aircraft (superbly rendered by Frank Tinsley, an aviation specialist), and pages of model airplane diagrams. The novels were credited to George L. Eaton, a house name, but most were written by a young Canadian named Charles Spain Verral. "The editor, F. Orlin Tremaine, offered him the job after the first writer didn't work out," recalls his wife, Jean Mithoefer Verral. "We were in a little trouble, very broke, and I had been quite ill and confined to bed ... we didn't know what we were going to do. Then Street & Smith accepted the *Bill Barnes* story and gave him a check for $500. He cashed it in all small bills and he came home and threw them all over me in the bed. Oh, it rained money!"

Terence X. O'Leary's War Birds, from Dell, was an obvious derivative of both *G-8* and *Dusty Ayres.* There were futuristic air ships, ray guns, and invasions of America by imaginary evil empires. The magazine's titular character had taken a peculiar route to superherodom. Originally, in the pages of *War Stories* in the early '20s, he was a lowly World War I trench soldier and a caricature of a vaudeville Irishman. A few years later, he had become slightly less obnoxious in Fawcett's *Battle Stories.* Then, without warning in March 1933, he resurfaced as "the world's greatest hero" and the "dyno-blasting" star of his own magazine. *Terence X. O'Leary's War Birds* lasted for three issues. Author Arthur Empey was a dreadful writer and a radical right-winger. A world war vet and author of the best-seller *Over the Top,* Empey lived in Hollywood in the 1930s and co-founded—with movie star Gary Cooper—a blackshirts-type private army, the Hollywood Hussars, which aspired to military political power in the name of "Americanism."

Perhaps Empey would have enjoyed reading *Operator #5,* the righteous and xenophobic adventures of Jimmy Christopher, "ace undercover agent of the United States Government," and chief opponent of various hordes of rampaging, blood-maddened foreigners. The paintings by cover artist John Howitt were often feverish, Goyaesque images of desperate, anguished Americans manning the barricades. Far from escapist entertainment, *Operator #5* had an ugly timeliness, exploiting the lingering air of anger and social upheaval caused by the Depression and the increasingly bellicose atmosphere in Europe and Asia.

Top: *Each cover of* Bill Barnes, Air Adventurer *featured a different, customized aircraft, created by illustrator Frank Tinsley.*

Above: Operator #5 *was a violent, apocalyptic pulp. The* Purple Invasion *issues detailed the takeover of America by brutal foreign armies.*

Opposite: *Ka-Zar, October 1936.*

Another creation of Henry Steeger, *Operator #5* was initially written by talented workhorse Frederick C. Davis.

The magazine reached its apogee in the issues devoted to the "Purple Invasion." In these stories, a "woefully unprepared" America is invaded by the powerful, multi-national armies of Rudolph I, Emperor of the Purple Empire. Everywhere is devastation, death, torture, Purple encampments protected with living walls of American youths hung upon crosses. It is a violent, paranoid pulp, and amazingly premonitory of the holocaustic world that lay just a few years away.

New single-character hero pulps appeared throughout the decade. A few thrived; many expired after the first sales figures wheezed in. Among the characters featured in homonymous magazines there were cowboys (Pete Rice, The Masked Rider, The Rio Kid), secret agents (Secret Agent X), aspiring Tarzans (Ka-Zar), and, of course, many more masked, cowled, costumed, dual-identity crime-fighters (The Ghost, The Whisperer, The Avenger, Captain Satan). Some oddities came and went. Street & Smith's *The Wizard* was about a superhero of finance, "Cash" Gorman. Plots dealt with corporate takeovers and union beefs. Actually, it was an intelligent, interestingly detailed magazine; it lasted four issues. There were even a few super-*villain* pulps. For a few months Dell offered *Doctor Death*, about a white-haired mad scientist. Popular came up with *The Mysterious Wu Fang*, concerning the misdeeds of a Fu Manchu type as reported by the industrious Robert Hogan. After seven appearances, *Wu Fang* mysteriously disappeared, replaced on the newsstands by the remarkably similar *Dr. Yen Sin*. Two other madmen, The Octopus and The Scorpion, completed the very short-lived super-villain cycle.

The heyday of the hero pulps ended as the 1940s began. Many titles were canceled, while others such as *The Shadow* and *Doc Savage* were toned down, losing much of the ripe melodrama and outrageousness that had distinguished them. Tastes were changing. The juvenile readers had turned to comic books, and to the science-fiction magazines. The first generation of hero pulp readers, the devoted teenagers who had known irrational joy with the arrival of each new adventure of Doc and G-8 and the rest, were young men in the 1940s, going into uniform and having their own dangerous adventures in exotic places.

But the great pulp heroes did not die, despite what the publishers' ledgers said to the contrary. They lived on in the memories of boys grown old, stars in a lost adolescent universe.

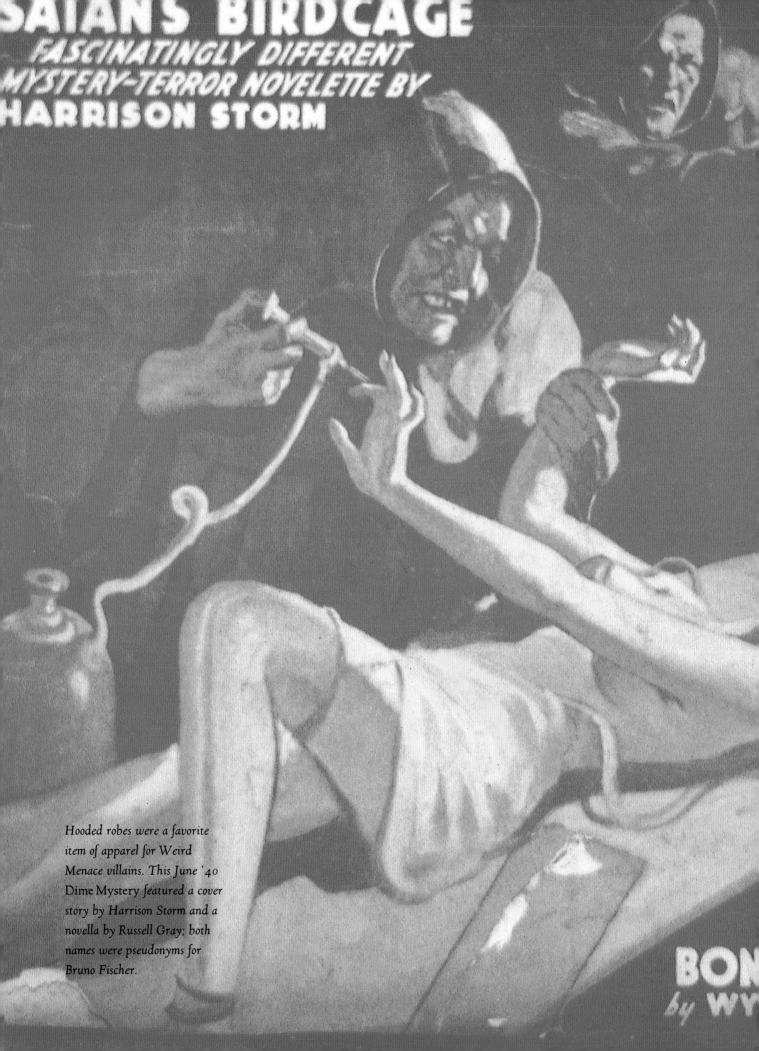

SATAN'S BIRDCAGE

FASCINATINGLY DIFFERENT MYSTERY-TERROR NOVELETTE BY HARRISON STORM

Hooded robes were a favorite item of apparel for Weird Menace villains. This June '40 Dime Mystery featured a cover story by Harrison Storm and a novella by Russell Gray; both names were pseudonyms for Bruno Fischer.

BON
by WY

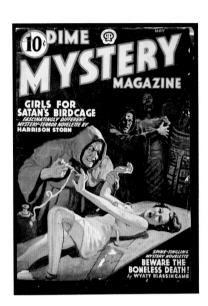

When the Blood-God Ruled

TALES OF WEIRD MENACE

They say there is nothing more ghastly than to witness the torturing of a fellow human being. I say there is! I say it is a thousand times more ghastly to know that such horror is going on and yet be blinded to it, seeing it only through the lurid workings of a fever-warped imagination!

—"Death Tolls the Bell"
Terror Tales, 1935

THE OCTOBER 1933 ISSUE of *Dime Mystery Magazine* launched what would prove to be the most depraved and blood-soaked chapter in the annals of American publishing. It was in the October issue that Popular Publications premiered the new format for its faltering, year-old magazine. *Dime Detective* had been a huge hit for Popular, but the mystery companion had never found an audience. In those days, new pulps were quickly dispatched if they

didn't turn a fast profit. Easier to tempt the consumer with a brand-new title than to tinker with a lemon. But Popular was committed to its *Dime* generic titles and so they decided to try a revised format, something sufficiently startling to give *Mystery* a second chance. Instead of crime detection, the magazine would now offer an odd mixture of Gothic atmosphere, grotesque threats, and vicious villains. From here on, stories would address what an early editorial called "a primitive, age-old urge in the heart of every red-blooded human, the keen desire to know fear. . . ."

The "Terror" or "Weird Menace" stories, as they came to be known, had many of the trappings of the horror genre, but there were distinct differences. Unlike the traditional scary story, the new form eschewed the supernatural. All activities, no matter how bizarre, would be given a natural—if not necessarily logical—explanation by story's end. This self-imposed restriction meant that new concepts and faces of horror had to be invented. No ghosts or vampires or black magicians, but equally creepy types out of real life, the mutilated and the psychotic, renegade scientists and crackpot cult leaders. Plots would revolve around earthly motivations like greed, revenge, or insanity.

The other distinguishing aspect of the new form was its intensity, a calculated assault on the reader's nervous system. Editor Roger Terrill defined the difference between terror and the older fright style: "Horror is what a girl would feel if, from a safe distance, she watched the ghoul practice diabolical rites upon a victim. Terror is what the girl would feel if, on a dark night, she . . . knew she was marked for the next victim." To ef-

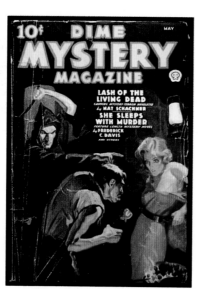

fect this more involving perspective, the horrific elements of each story were described with an unprecedented savagery, an attention to detail that, as the genre developed, included heavy dollops of Sadean sexuality.

Like a flash, it battened itself upon the corpse's breasts, clinging with all four clawing hands, the sharp nails digging demoniacally into dead pliant flesh. . . . Its fanged slash of a mouth fastened on the girl's gory, torn throat. Then, while Travis Brant watched in nauseated fascination, it began to suck the dead woman's clotting, congealing blood.

* * *

I stopped to spin around as Helen's moans rang again. Someone had brought a bridle and jammed the steel bar between her teeth. They forced her down on her hands and knees and they were driving her like a horse, flogging her and sawing her reins till the foam on her lips dripped crimson.

The creator of Weird Menace was Popular's resourceful president, Henry Steeger. "I got the idea during a trip to Paris. They had the Grand Guignol Theatre there, with these violent situations, and the audience was very enthusiastic. I thought, 'We could do a magazine like that, with the same sort of emphasis.'" The theatre was a notorious Parisian nightspot where audiences were treated to the sight of on-stage whippings, gougings, and all variety of simulated gore. Steeger may also have had an eye on such contemporaneous movies as *Island of Lost Souls*, *Mystery of the Wax Museum*, and *Freaks*, each offering similar modern-dress horrors—vivisectionists, deformed maniacs, denizens of the carnival sideshow, all staples of the Weird Menace world.

Dime Mystery's metamorphosis was a success, and as reader interest grew, Steeger started two more gory pulps, *Terror Tales*, debuting in September 1934, and *Horror Stories*, four months later. For these two, readers had to pay 15 cents, a nickel premium for an increased dosage of blood, no doubt. The new titles also did well, and by 1935

Above: Dime Mystery Magazine *inaugurated the strange and bloody pulp subgenre known to infamy as Weird Menace.*

Opposite: No matter how far-fetched the activities depicted kin a Weird Menace story, they were all expected to have a "logical" explanation. This scene is from the Dime Mystery for July 1938.

10¢

DIME MYSTERY MAGAZINE

JULY

THE WEREWOLF OF WALL STREET

A SMASHING STORY
OF
EERIE MYSTERY
AND TERROR
by
EDITH &
EJLER
JACOBSON

GODDESS OF THE
HALF-WORLD BROOD
by HENRY T. SPERRY

other pulp houses were jumping on the Terror band-wagon. Subsequent titles included *Thrilling Mystery, Eerie Mysteries, Eerie Stories, Sinister Stories, Ace Mystery, Spicy Mystery, Strange Detective Mysteries, Startling Mystery,* and *Uncanny Tales.*

At their most effective, Weird Menace stories had a visceral power and nihilistic sensibility that anticipates *The Texas Chainsaw Massacre* and other "splatter" films and books of the 1970s and 1980s. Weird Menace was a negative utopia of non-stop unpleasantness. The thrills these tales induced were of the sort one might obtain from an upside-down roller coaster ride through a slaughter-house—fine, if you like that sort of thing. The titles alone were enough to set the stomach churning: *Flesh for the Swamp Men, The Tongueless Horror, Coming of the Rat Men, Revolt of the Circus Freaks, Hosts of the Leper King, Meat for Satan's Locker.* Each story could be depended on for its share of blood-letting and putrefaction, told in a sensuous, hothouse prose on the verge of hysteria from the very first paragraph.

Usually, the out-of-control tone was entirely justified by the events unfolding, as in this passage from *Corpses on Parade:*

In hideous nudity she advanced one step toward me. Her breasts, her hips, seemed half-decomposed. And the smell! It was like the fumes that might arise from a city's garbage lying for hours under an August sun Then—I've read about lips melting in an embrace, but I'll never read it again without being sick. For that was exactly what Thea's lips did. They squashed, with the same plosh of rotten fruit that had marked the disintegration of Kitty's hand . . . I didn't turn to look. I ran. My mouth felt ghoulishly filthy, as though I were a cannibal epicure.

At other times, the unrelentingly oppressive atmosphere could make a narrator a tad jumpy, as in the hero's hopped-up reaction to a vague, shadowy figure he notices in a scene from *Satan's Workshop:*

SATAN CALLS THE STRIKE

A Pulse-Jolting Novel of Mystery and Menace

By ARTHUR LEO ZAGAT

(Author of "Satan Calls His Children," etc.)

Death, Famine, and destructive Lust came, that hot summer, to the little town of Galeton—came in the forms of a sightless, cadaverous old man, a starved child of Satan, and an evilly voluptuous, blood-thirsting woman. No man could say whence came this hell-spawned trio; but their arrival turned a peaceful village into a town of terror and sudden, awful death.

NO ONE ever discovered how the first of the terrible three came to Galeton.

The Raunt Silk Mill, where seven-eighths of the town worked, had been shut down for a week-end overhaul, and the [...] layoff had extended through that Monday. In consequence there were more than the usual number of loungers at the depot, but none of them saw the grey man alight from a passenger train or come up out of the freight yard by the only feasible [...]

wards of a whirlpool of dust that drifted past her gate in the grey and brooding dusk. Such a miniature cyclone it was, she said, as a fitful wind sometimes sucks up, or as dances in the wake of a speeding truck. She was puzzled by it because not the slightest breeze relieved the sultry Indian Summer heat, and there was no truck. For this reason she watched the whirling dust jet as it whispered between the slattern fences of her millworker neighbors, breasting the little rise in the road there, till it vanished over the crest where the Turnpike becomes Galeton's Main Street.

the company houses, that line Boston Turnpike at each end of Galeton, recalled his entering the village.

Someone else might have passed the loungers or the women unobserved, but not Astaris. Not unless they were all suddenly struck blind as [...]

Sonia swore that jus[...] slope hid it, it took [...]

Right: Bruno Fischer in 1940.

Opposite: The horror stories in the Weird Menace magazines took place in ordinary, contemporary settings.

For all I knew, it might be a bloated, rotting corpse risen from an unhallowed tomb, a fiend from Hell sent by the Devil on some unholy errand! If I had been certain that it had a material body like my own, I would have gone out and fought with it. I would have gloried in battering it to a crimson pulp with my fists, in letting its blood spray over me in a scarlet torrent! But I wasn't sure . . .

Villains, when they did materialize, were a mix of scheming psychopaths—mad scientists, religious cultists, vengeful old crones—and their repellant assistants—gnarled dwarves, brainless mutants, horny hunchbacks. They invariably came equipped with a panoply of elaborate devices for torture and slow death, bubbling vats, buzz saws, iron maidens, branding irons, or flame throwers. Both male and female protagonists suffered from the villains' bloodlust, but the worst sort of unsavory endurance tests were reserved for beautiful, helpless young women. Once captured, the leading ladies were quickly reduced to a wardrobe of tattered lingerie or less, then hung from basement rafters, strapped to a surgeon's table, dipped in boiling chemicals, or put through some other equally uncomfortable regimen.

Motivation for all this villainy was not the Terror pulps' strong suit. Very often a couple—usually on their honeymoon—has the misfortune to stumble into the wrong Old Dark House. If the homeowner is of a scientific bent, he will undoubtedly need the heroine's naked body for his latest crackpot experiment:

"I'm going to transfer your wife's personality—soul—will—whatever you call it, to one of these fish. Which shall it be? That slimy eel? The sting ray? No, I think the octopus would make you a better wife. Think of being embraced

by eight sucking arms and nibbled, perhaps by that huge beak!"

Even when the mad doctor's goals are less grotesque, his methods remain painful in the extreme. In *Beauty Born in Hell*, he turns ordinary-looking women into literally raving beauties with a caustic program of beatings, cosmetic surgery, and mind control. "You see, it makes very little difference to me whether I get good raw material to start with," says the owner of the world's strangest salon. "Let them be fat or thin—as ugly as you please, I'll turn out beauties in the end—and as alike as two peas in a pod ..." Once the women have undergone their excruciating makeover, the doctor puts them all on stage in a dancing chorus line.

When not compelled by science or aesthetics, Terror villains fell back on more selfish motives. Simple lust was often enough to get the ball rolling. The vicious antagonist would feel an instant passion for the passing heroine, or have an outdated attachment to *le droit de seigneur*: "I am the law here!" snarls the lord of the manor in *Death's Bridal Night*, "and the first night of every bride in my domain is mine by right ... *jus primae noctis*—the law of the first night." Much weird menacing was done by greedy or vengeful relatives or business partners, desiring a greater share of an inheritance or company profits, or paying back some crushing insult from years past. These motives usually became evident only in the final paragraphs of the story after pages of elaboration and unlikely action, and the writers sometimes had a lot of explaining to do in a few sentences:

"I've got the whole story," snapped Purcell, "if you're man enough to listen. The Calder girl spilled it. Chandra Lal saw Elise on the street once, desired her, checked up on her, found you, bribed the Calder girl to help him. They took their time. The Calder girl practised until she could imitate the voice of your wife. She was well paid, but not enough to justify the murder of Bergstrom, for which she must pay the penalty as an accomplice. Edna Calder suggested Chandra Lal to Elise. He wasn't a Hindu. He just made up for the part. He has a record at headquarters a mile long. For crimes, and attempted crimes, of passion"

Many times the reader was left feeling like the hero at the conclusion of *The Horror in His Bed*:

"I know it was some kind of family grudge," Peters said, "but I still don't understand just what his motive was."

Terror writers seemed to take the attitude (not unknown throughout the pulp field) that the thrill was in the ride, not in the destination. So what if the ending was lame or made no sense, as long as everything up to then scared the hell out of you. The proscription against the supernatural explanation was supposed to intensify plot credibility, but it often worked the other way around.

Nevertheless, there were any number of stories that met the Weird Menace ideal of a naturalistic horror story, making creative use of terrors to be found in modern 1930s America. *Children of Murder* takes a honeymooning couple slumming on New York City's Lower East Side. There, they find twisted, "leprous-looking" tenements where the sunlight never penetrates, an "overpowering smell of decay, of stagnant bilge," and horrid street urchins "with weazened faces and all-knowing eyes" who go on a pyromaniacal rampage, setting fire to derelicts. In Nat

DEATH CAME CALLING

By RUSSELL GRAY
(Author of "The Maid and the Mummy," etc.)

Joseph Wilson knew the boundless horror of those who are beloved by the dead. . . .

THE MAN who stumbled into the police station looked as if he had just come from a slaughter house. Blood spattered his trousers and streaked his face. The front of his shirt looked as which the lieutenant sat and just stood there, saying nothing. His eyes to his right hand, and we noticed that it was tightly clenched. The hand was covered with blood and bits of gore.

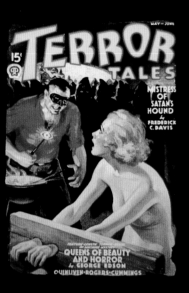

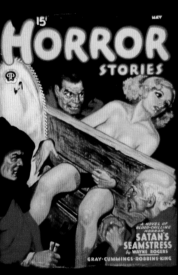

Top and Above: Terror Tales was
Popular Publications' second Weird
Menace title. It debuted in September '34 and four months later was
joined by Horror Stories.

Opposite: Gruesome doings in Death
Came Calling by Russell Gray,
a.k.a. Bruno Fischer.

Schachner's *Lash of the Living Dead*, hell on earth is the Stygian depths of a Pennsylvania coal mine, where entombed immigrant miners become the "legions of the damned." Even better is *Furnaces of the Damned*, by Francis James (one of his 40-odd contributions to the genre). Dubbed a "Novelette of Horrible Revolt," *Furnaces* was set in and around a town's nightmarish steel mill, known unaffectionately as Little Hell, and not merely for the "tongues of crimson" leaping from the roaring furnaces:

Every steel mill has its quota of unfortunate occurrences, men burned or caught and mangled in whirling machines. But Halstead had many more such cases than it should normally have had, ghastly catastrophes, unparalleled in their hideous tortures.

Up and down the streets of the little village, they were never out of one's sight—misshapen and crippled forms of men whose arms or legs had been crushed in gears or trapped in spewing molten masses from a tapped cupola furnace.

No walk through the town of Halstead is complete without a startling encounter with a maimed ex—steel worker. Newlyweds Tom and Margaret stumble upon one during an evening stroll. In the light of a flaming chimney mouth they see "a face—half of a face, for one side of the man's countenance had been swept clean from the grinning bones as though torn by the raking of giant hooks. And his bloated torso waddled on legs that had been cut off at the knees. Revulsion stabbing me, I turned back to Margaret. 'It's only another one of those cripples out of the works,' I muttered. '... The place is full of them.'"

The young bride comes to believe that the swarms of maimed mill workers are following her, " ... dogging my steps on my way home. Trailing me everywhere, trying to touch me!" The husband scoffs, but does concede a recent rash of strange disappearances from the village, half a dozen girls missing in the last few weeks. Could it be that the town's half-human creatures were making away with the girls, "taking them where and for what heinous purpose no one could guess"? In a word, yes. When Margaret is inevitably abducted, the horrified husband trails her kidnappers to the steel mill, where a fiendish, mutilated mob has gathered for a fiery ceremony. There, among towering vats and "gaudy-hued vapors," the narrator sees his

10¢

JULY

DIME MYSTERY MAGAZINE

"THE WEIRDEST STORIES EVER TOLD"

DARK MELODY OF MADNESS
SPINE-TINGLING MYSTERY-TERROR NOVEL
by CORNELL WOOLRICH

THE PRIESTESS OF SHAME
GRIPPING TERROR NOVELETTE
by ARTHUR J. BURKS

JOHN H. KNOX
F. B. MIDDLETON
PAUL ERNST

wife and a dozen other missing young women. "Stark naked they were, and with them the cripples were playing. Playing—God!"

In a scene out of American management's worst nightmares, the crowd of vicious laborers listen to rabble-rousing speeches by Hans, a renegade foreman, and his mysterious masked partner. Stirred into a frenzy of hate and destruction, the mob begins tossing sacrifices into rivers of lavalike liquid. The hero can take no more, and springs into action: "Into the midst of those creatures I stormed, jabbing and slashing, and I took them by surprise. Satanic, hate-knotted faces whipped around in amaze." The "creatures" disperse; the hero pushes Hans into the furnace and unmasks the masked man. Hardly the satanic union organizer he pretends to be, it is none other than Rodney Halstead, wastrel son of the mill's owner. Desperate for cash, Rodney had inspired the wounded workers' "horrible revolt" to make his family sell the steel mill to his creditors "for a song." Young Halstead is arrested, and the furnaces get back on schedule, but the newlyweds have had enough. "We got out of that town," concludes the narrator, "and I found a job elsewhere."

OVER A HUNDRED WRITERS contributed to the two-hundred-odd issues comprising the entire Terror *oeuvre*, although the great majority of the stories were written by a mere handful of highly productive pros. Men such as Arthur J. Burks, Hugh Cave, Arthur Leo Zagat, Paul Ernst, and a few others practically cornered the market in Weird Menace, each one selling dozens of stories. Some would have two or three stories in a single issue. When publishers used more than one of a writer's stories at a time, it was common practice to put a different byline on each contribution—readers demanded a fair complement of authors for their dime. Among Weird Menace writers, pseudonyms were sometimes adopted for more personal reasons. Baynard Kendrick, mystery novelist and cofounder of the Mystery Writers of America, explaining his own Weird Menace modesty, said, "One of my stories that made quite a hit was one where they burned the panties off the girls with a blowtorch ... Hell, you don't think I'd put my own name on a thing like that?"

Bruno Fischer, author of such sociopathic classics as *School for Satan's Show Girls*, *Models for the Pain Sculpture*, and *White Flesh Must Rot*, published all of his 55 Terror stories under his pen names, Russell Gray and Harrison Storm. "I was a little ... I wouldn't say *embarrassed*," he recalled for me, "but it was the thing to do, to use a pseudonym for these magazines ..." Fischer is a notable figure in the Weird Menace saga, not only for being one of the most popular and productive writers, but because he made his pulp debut in Weird Menace and specialized in it almost exclusively until the genre's demise. "At the time I started selling to the pulps I was the editor of the *Socialist Call*, the official weekly magazine of the Socialist party. I was getting $25 a week—when I got it. I'd been married for about a year, and even then, 1935–1936, in the midst of the Depression, you could just get along on $25. So—I was thinking about ways to make some money on the side. And I was talking to another guy over some drinks and he told me that he had written pulp stories in Chicago. I don't think I had ever read a pulp at that time. So, on the way home I bought a few of them and read them. And when my wife got home I told her, 'All our troubles are over!'"

Attracted to the Terror titles—"I thought that was right up my alley"—Fischer turned out a six-thousand-word story that weekend and sent it to Rogers Terrill at Popular Publications, home of the "Big 3" terror pulps. "About ten days or two weeks later I got a check for $60. Wow! That was real money. A cent a word. So I sat down and wrote a ten-thousand-word story. I got a raise to a cent-and-a-quarter for that one, $125. Well, that would be like getting a couple thousand dollars today. So I kept writing pulp, and after awhile I dropped my

Opposite: Suspense master Cornell Woolrich wrote only a few Weird Menace tales, although his ability to convey terror and paranoia was perfectly suited to the genre. His brilliant short novel, Dark Melody of Madness *was printed in the July '35* Dime Mystery.

The Pain Master's Bride

Edmund Neymores felt chill horror at sight of Fulton Xavier's sensational statue of a man in pain. But Neymores did not know real horror until he saw the ghastly torment of a helpless girl as she posed for a newer masterpiece.

Left: Brides and newlyweds were frequently the subjects of painful scientific experiments in the Weird Menace pulps.

Opposite: Weird Menace villains were always having "mad desires" of one sort or another, and most had easy access to a blowtorch.

job at the *Socialist Call* and became a full-time writer."

Fischer became one of Popular's most reliable producers. Many of the stories were written to order, on the basis of artwork that was already in-house. "The covers were supposed to illustrate a story; however, the covers were sometimes printed in advance, before there *was* a story. So what the editor did was show me the cover or a drawing—it was usually a picture of a half-naked woman and someone stripping the rest of the clothes off her. And on that basis I wrote dozens of stories." When family and friends found out what Fischer was writing, the reaction was mixed. "A few people would go, 'Oh my!' you know," he remembers. "Or to my wife, 'Woo, what Bruno wrote! How can you let him write something like that? And it was such mild stuff, believe me. But my father was so proud that he used to carry these pulps

with the monsters and the naked women on the cover and show them to people"

One writer whose style and temperament would seem to have been perfectly suited for the Terrors, Cornell Woolrich—literature's future master of suspense and founding father of the *noir* sensibility with such works as *Phantom Lady, The Bride Wore Black,* and *Rear Window,* and a prodigious story salesman in this period—contributed only four stories to these pulps. *Vampire's Honeymoon,* written for *Horror Stories,* is a straight supernatural tale, and poorly told. *Baal's Daughter,* published in the January 1936 *Thrilling Mystery,* is unadulterated Weird Menace, with whippings, strippings, torture by fire and hot oil injections, and a tongueless goon. It is also, in the words of Woolrich scholar Francis M. Nevins, "so overloaded with

stupid inconsistencies and grotesque twaddle, that to claw one's way through its pages is an act of masochism." The two other Woolrich stories in this style, however, are among the few genuine masterpieces of the genre.

Dark Melody of Madness (Dime Mystery, July 1935), is a poetic and intricately structured evocation of fear and fate. At four in the morning, a man staggers dazedly into a New Orleans police station and confesses a murder. It is Eddie Bloch, celebrated jazz bandleader. Cops listen to his weird confession. In need of a new musical direction for his band, Eddie finds it at a bloody secret voodoo ceremony. He steals the ceremonial rhythms for a hit record, and the voodoo high priest, Papa Benjamin, puts a curse on him. When his drummer dies, Eddie begins to take the curse seriously, loses lots of weight, and becomes a hysterical wreck. Ultimately, he is driven to insanity by the harassment of the voodoo cult and feels compelled to commit murder. There are a half-dozen climactic twists before the last haunting line: "All she says is: 'Stand close to me, boys—real close to me, I'm afraid of the dark.'"

Graves for the Living (Dime Mystery, June 1937), is typically Weird Menace in its outrageous plot and tone of hysteria, but otherwise avoids the standard sex and torture spectacle for a more psychological brand of terror, a tour de force of sustained anxiety. Woolrich's hero is haunted by an understandable fear of premature burial. As a child, he witnessed the disinterment of his father's corpse, the gruesome occupant of the coffin showing obvious signs of post-funerary life: "The eyes were open and staring, dilated with

horror, stretched to their uttermost width ... There were dried brown spots all about the white quilting that lined the lower half of the coffin, that had been blood-spots flung from his flailing, gashed fingertips." With this image never far from the hero's mind, he becomes a habitué of graveyards and during one such visit, stumbles upon a strange religious cult, the Friends of Death. The cult purports to bring the dead back to life, but it is actually a scam involving poisons and aerated gravesites. When the hero betrays the sacred order,

he finds they are an unforgiving and omniscient bunch, evil minions wherever he turns. In dramatizing the state of paranoia, Woolrich has no peers. *Graves* ends after a gut-wrenching race against time, the hero's fiancée buried alive while he frantically searches for her grave, exhuming coffin after coffin with his bare hands.

THE OCTOBER 1938 ISSUE of *Dime Mystery* signaled the beginning of the end for Weird Menace. Exactly five years after it inaugurated the Terror format, *Mystery* went in a new and even more eccentric direction. Instead of Weird Menace, all stories would now feature weird heroes, crime fighters with strange quirks and afflictions—the so-called defective detectives. It was an idea that had actually been hatched in one of Popular's minor weird publications, *Strange Detective Mysteries,* and now the weird flagship would be given over entirely to private eyes with deformities.

Mystery's sister publications at Popular and the rivals at other houses continued to offer terror and torture as before. If anything, stories, titles, and cover illustrations hit a new peak of depravity. Cover girls showed an increase in voluptuousness and a decrease in wardrobe. As the decade ended, an inevitable backlash set in. Articles and editorials attacking the Weird Menace pulps had been coming for some time. Typical were the fulminations in an issue of *American Mercury:* "This month, as every month, 1,508,000 copies of terror magazines, known to the trade as the shudder group, will be sold throughout the nation. They will contain enough illustrated sex perversion to give Krafft-Ebing the unholy jitters."

As would happen to comic books and Communists in the 1950s, the Terror pulps became the object of disaffection and witch-hunts by outraged moralists and political opportunists such as New York's Mayor LaGuardia. Magazines were threatened with confiscation. Popular toned down the sex and sadism in its Terror titles, sales began to sink, and the magazines limped through the first year of the new decade. Bruno Fischer, whose sole income at the time came from the Weird Menace pulps, recalls, "In 1940 I was living in Florida with my family when the whole terror-horror market collapsed. There was a lot of government pressure, Congress was investigating and all that ... And one day I got a letter saying the magazines had folded, and all my unpublished stories were returned. They just stopped, just like that. It was a shock. Just one day the market was gone."

Pulp's bloody reign of terror was over.

WOND

ST

15¢

JUNE

Thrilling Wonder Stories *was*
home to countless alien villains,
known affectionately as bug-eyed
monsters or BEMs. These classic
specimens are from the June
1939 issue.

Worlds of Tomorrow

SCIENCE FICTION PULPS

Both my wife and myself are regular readers of your

Wonder Stories, and naturally there are lots of stories we

read that call for discussion. I contend that it is impossible

that in the future "time traveling" machines will be invented

that will transport one through time to the future, say

1,000 years—and my wife says that it will be possible to do

so. Who is correct?

—Letter to the Editor, 1931

DEPENDING ON your definition of terms, the science fiction story can be traced back to Homer's *Odyssey*, and prototypical S-F themes were explored centuries ago in such works as Thomas More's *Utopia* (published in 1515), Cyrano de Bergerac's *Voyage to the Moon* (1650), and Mary W. Shelley's *Frankenstein* (1818). In the late 19th century, Jules Verne and H. G. Wells were brilliant popularizers of scientific and speculative fiction,

as was "the American Jules Verne," Luis Senarens, author of hundreds of "invention stories" for the cheap weeklies and dime novels. The "scientific romances" of Edgar Rice Burroughs and A. Merritt electrified readers of the early general-interest pulps in the teens of the 20th century. But all these efforts were haphazardly produced and published, belonging to no clearly defined category or tradition. It awaited the specialty pulps of the 1920s and 1930s to give the various strands of S-F material a common name, a home, and a set of guiding principles that would mark the foundation of a distinguished and enduring form of literature. The pulps alone discovered and nurtured the entire generation of writers responsible for the maturation and so-called golden age of science fiction, and it all happened in less than 20 years.

The first magazine devoted to science fiction—*Amazing Stories*—was the creation of a Luxembourg emigrant named Hugo Gernsback. When he was nine, Gernsback read a German translation of a book by an American astronomer, *Mars as the Abode of Life*. Reading the book affected young Hugo so strongly that he developed a fever and became delirious. The boy had found a calling. He came to the United States in 1904, when he was 20, an expert in telephonics and electronics and a fledgling inventor. In the next decade, he would invent and market the world's first home radio set, the Telimco Wireless, begin publishing the world's first radio magazine, open the first store to sell radios, and coin the term *television*. In 1922, he had some blank pages to fill in an issue of his periodical *Modern Electronics* and so he wrote the initial installment of a serial titled *Ralph 124C41+ . . . A Romance of the Year 2660*. Written with all the style and verve of a technical manual, the serial was a remarkable feat of prophecy, describing such inventions-to-be as tape recorders, synthetics, radar, fluorescent lighting, plastics, microfilm, night baseball, and jukeboxes. Gernsback's magazine—the title changed to *Electrical Experimenter* and then *Science and Invention*—began to publish more and more futuristic stories grounded in science. The response to these was strong enough that Gernsback decided to launch a nearly all fiction magazine, and *Amazing Stories* made its debut with an April 1926 cover date. It was an immediate success, selling over 100,000 copies per issue. Gernsback had tapped into a kind of underground of science-oriented-fiction enthusiasts, readers delighted to find a single source for material they previously had had to search for in random issues of *Argosy*, *All-Story*, *Weird Tales*, and others. There had not even been a generally accepted name for these types of stories. Publishers variously referred to them as "off-trail," "impossible," "pseudo-scientific," "weird-scientific," "science fantasy," "scientific romance," and "different." Gernsback once again took the matter in hand. He first created the term *scientifiction*, tinkered with it, and finally settled on a less whimsical two-word term, *science fiction*.

The *Amazing* staff had little in common with that of any other pulp magazine. Besides Gernsback himself, the monocle-wearing Luxembourger genius and prophet, there was assistant editor C. A. Brandt (a German chemist and the man who introduced the calculating machine to America) and managing editor Dr. T. O'Conor Sloane (a 75-year-old inventor, author of the 1892 tome *Electric Toy Making for Amateurs*, and the son-in-law of Thomas A. Edison). Even *Amazing*'s regular cover artist, Austrian-born Frank R. Paul (brilliant on machinery and architecture, but his human figures all looked like ancient Mughals) apparently had an appropriate gift for scientific prophecy. According to Arthur C. Clarke, Paul's depiction of Jupiter, for example, had fine details that were supposedly not known to earthlings before the Voyager space-probes of a half-century later. With wise staff and eager audience in place, the only thing left

Above: Astounding Stories, from Clayton, was the first science-fiction magazine to be published by a major pulp publisher. When Clayton went bankrupt, the title was revived by Street & Smith and thrived in one form or another for several decades.

Opposite: Starting in 1945, Amazing Stories courted controversy by publishing the "non-fiction" of Richard Shaver, a Pennsylvania welder who believed the earth had been invaded by a race of malevolent creatures turning humans into degenerate zombies.

AMAZING
STORIES

DECEMBER 25¢

IN CANADA 30¢

THE LAND OF KUI *by* RICHARD S. SHAVER

Above and left: Austrian-born
Frank R. Paul, the regular cover
artist for Wonder Stories and other
Gernsback publications, was
excellent with machines and aliens
but his renderings of human beings
often left something to be desired.

was to find enough good stories. The scientific standards and extremely low pay scale at *Amazing* pretty much excluded the participation of the usual pulp pros-for-hire. Gernsback filled the early issues with reprints by the old masters—Verne, Wells, Poe—and new fiction by fledgling young writers, many with a strong, even obsessive interest in the brave new world of scientific possibilities.

"I grew up secluded, poor, on a ranch in New Mexico, and without many prospects," says Jack Williamson, one of Hugo Gernsback's earliest "discoveries." "I became fascinated with science, the prospects that seemed unlimited. For people of school age in the 1920s, science seemed like a sort of wonderland that would be a means of changing the world and making things perfect. And this was a feeling shared by many of us who were drawn to writing science fiction in that period. I was fascinated with these stories and with the first issue of *Amazing* that I read. When my first story was printed in the magazine, I was thrilled and delighted." Williamson's first sale, *The Metal Man*, appeared in the December 1928 issue. A blurb compared it to Merritt's *The Moon Pool* and raved: "Unless we are very much mistaken, this story will be hailed with delight by every scientifiction fan. We hope Mr. Williamson can be induced to write a number of stories in a similar vein." As it happened, Williamson could be induced, and was still writing distinguished science fiction 63 years later. Other Gernsback discoveries included the satirical Stanton Coblentz; Philip Francis Nowlan, creator of Buck Rogers, a pulp hero long before he became a star in comic strips; David H. Keller, M.D., who made his debut with the intriguing *Revolt of the Pedestrians*, about a future where humans are the abused playthings of the ruling automobiles; Raymond Z. Gallun, a pioneer in the "modern" phase of SF; and E. E. "Doc" Smith, the most popular and influential of all *Amazing* writers.

Possessor of a doctorate in chemical engineering ("Ph.D." was proudly attached to all his pulp bylines), Smith was a chemist in a Michigan donut factory when he began working on a novel of outer space adventure. Unsure of himself with characterizations and "love interest," he asked for assistance from a woman named Mrs. Lee Hawkins Garby. Smith spent four years writing his mas-

Below: In the pulps, female space-women generally dressed more like showgirls, as in this September 1948 issue of Startling Stories.

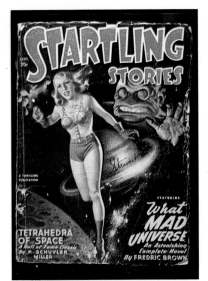

sive novel and another eight years unsuccessfully marketing it before Gernsback bought it for *Amazing*. *The Skylark of Space* caused a sensation among science fiction readers and writers.

The prototype for what would be known as "space opera," Smith's novel was an action epic of genuinely cosmic scope and jaw-droppingly spectacular technology. *Skylark's* characterizations were primitive, the love triangle was laughable (Mrs. Garby had failed in her appointed task), and the plot was in essence a very long chase scene as noble scientist Richard Seaton pursued the evil space pirate "Blacky" Duquesne across the galaxies. But if Smith lacked subtlety and complexity, he had a compensatingly abundant imagination and audacity. Smith's dynamic use of scientific principles, his vivid, sweeping action scenes, and his breathtakingly spacious canvas at once made all the previous forms of outer-space fiction seem paltry and old-fashioned by comparison. Smith, with his epic-scientific style, would become for a time the major influence on younger S-F writers, replacing Merritt and Edgar Rice Burroughs. Gernsback, however, understood Burroughs' continuing popularity with readers and for a special *Amazing Stories Annual* he commissioned the pulp superstar to write a new novel, *The Master Mind of Mars*. At a hefty and unprecedented cover price of 50 cents, the magazine was a near-sellout.

By 1929, Gernsback had a growing media empire. Besides *Amazing* and *Amazing Annual*, he had technical, health, and risque-joke magazines, a radio station, and pos-

sibly the world's first regularly transmitting television station. Then, apparently as a result of an opaque feud with the far more powerful publishing mogul Bernarr Macfadden—the two lived in the same apartment building at 527 Riverside Drive—Gernsback was forced into bankruptcy. Another company took over *Amazing*, while Gernsback immediately established a new company and a new S-F magazine, *Science Wonder Stories*. Since he had illicitly grabbed most of the manuscripts that had been submitted to *Amazing*, there was a good deal of continuity between the two periodicals. Gernsback followed *Science Wonder* with *Air Wonder Stories*, *Scientific Detective Monthly*, and *Science Wonder Quarterly*. The Great Depression had a grave impact on sales, and the various wondrous magazines had to be merged as a single S-F publication, *Wonder Stories*. Sales never picked up, and in 1936 Gernsback unloaded the title on Ned Pines.

Hugo Gernsback is seen today as a Moses-like figure in the history of science fiction, the great visionary and virtual founder of the formal genre. But he did have his

Left: An ad for the upcoming issue of Amazing Stories.

Opposite: Pictured here are participants at one of the first science-fiction conventions. Front row: Otto Binder, Manly Wade Wellman, Julius Schwartz. Back row: Jack Williamson, L. Sprague de Camp, Dr. John Clark, Frank Belknap Long, Mort Weisinger, Edmond Hamilton, and Otis Adelbert Kline.

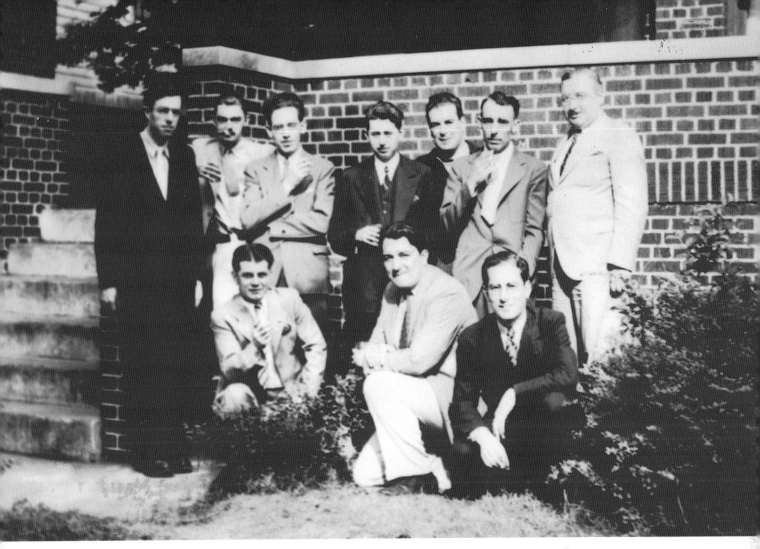

flaws, including a notable—even for pulp publishers—penchant for exploiting his writers. Although he was taking a salary of around $1,000 a week from his magazines, Gernsback paid writers as little—and as seldom—as possible. He gave Lovecraft $25 for the brilliant *The Colour Out of Space.* "Doc" Smith earned a less-than-whopping $125 for his huge *Skylark* novel. Many writers were finally forced to get lawyers and sue Gernsback for the meager amounts he owed them but refused to pay. It has left decidedly mixed feelings about the great pioneer among the survivors who actually wrote for him. "I was not particularly impressed by him," says Raymond Z. Gallun, whose first two stories, *The Crystal Ray* and *The Space Dwellers*, appeared respectively in the November 1929 issues of *Air Wonder Stories* and *Science Wonder Stories.* "He was pretty much of a crank and would revise your story without reason or permission. And he hung onto a nickel like no one else and he knew it. He once sent out a Christmas card referring to himself as 'The Deadbeat Philanthropist.' He wouldn't pay for the stories he published and I was living in Wisconsin and had to find an attorney in New York. Ultimately she got the money out of him." Says Jack

Williamson: "I owe Gernsback a great debt of gratitude for printing my work, accepting me as a writer, and so forth, but I became disappointed with him. He was slow and reluctant in the matter of payment for material when it was unnecessary. He would print a story without even telling the writer he was using it. I finally got an attorney to collect for various stories, and paid a 20% commission. But you couldn't cross him off the list because he was one of the few available markets for science fiction."

The first non-Gernsback-created science fiction magazine—and the first to be produced by a large, mainstream pulp publisher—was Clayton's imposingly named *Astounding Stories of Super-Science,* arriving on newsstands late in 1929 with a January 1930 cover date. A luridly exciting scene from a Victor Rousseau story, *The Beetle Horde,* was depicted on the cover—somewhere in Antarctica, a crashed aviator and a distressed damsel in a fur coat battle a sharp-toothed giant insect. Inside, the magazine's intentions were trumpeted by editor Harry Bates:

To-morrow . . . astounding things are going to happen.
Your children—or their children—are going to take a trip

ADVENTURES OF FUTURE SCIENCE

1933 *November*

WONDER
Stories

HUGO GERNSBACK Editor

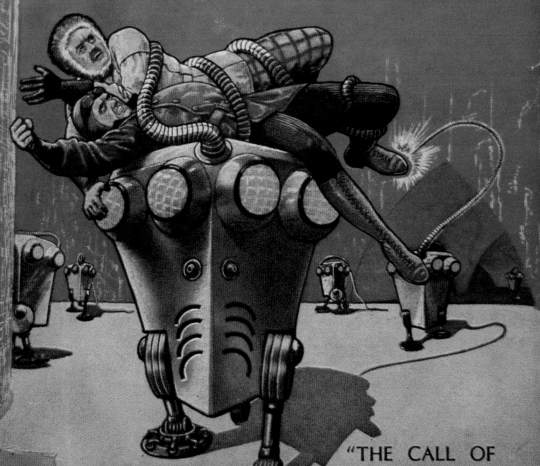

"THE CALL OF
THE MECH-MEN"
by Laurence Manning

25¢

to the moon. They will be able to render themselves invisible—a problem that has already been partly solved. They will be able to disintegrate their bodies in New York and reintegrate them in China—and in a matter of seconds.

Astounding? Indeed, yes.

Impossible? Well—television would have been impossible, almost unthinkable, ten years ago.

Now you will see the kind of magazine that it is our pleasure to offer you beginning with this, the first number of Astounding Stories.

It is a magazine whose stories will anticipate the super-scientific achievements of To-morrow—whose stories will not only be strictly accurate in their science but will be vividly, dramatically and thrillingly told.

Bates' claims of strict accuracy were not strictly followed, as evidenced by that first cover story. A crash-landed expedition at the South Pole is captured by man-sized beetles and taken to Submundia, a civilization beneath the earth's crust ruled by a drug-crazed archaeologist. The madman plans to turn his human-devouring beetles loose on the outside world, vengeance on those who once ridiculed his radical scientific theories. The heroes destroy the bugs with incendiary bombs, but the dying villain confesses his back-up plan: "'Invasion by—new species of—monotremes,' he croaked. 'Deep down in the—Earth.' Monotremes—egg-laying platypus as big as an elephant—existing long before the Pleistocene Epoch ...'"

Astounding offered escapist entertainment in the classic pulp tradition. Editor Bates was not averse to intriguing scientific premises or technical data, so long as they didn't interfere with a steady flow of pulse-racing action. "Doc" Smith—style space opera predominated, intergalactic adventures full of ray guns, fiendish aliens, and dueling spaceships.

Opposite: **Wonder Stories** *was the last major science-fiction pulp created* **by Hugo Gernsback.**

Bates was a talented and amusing man. "He had a cynical sense of humor," recalls Jack Williamson. "He sent me a check for a story and attached a three-word message: 'God Is Love.' He thought Gernsback's fiction was boring. He wanted believable science but it had to support a good, entertaining story. He didn't give a lot of advice but what he did tell you made sense. I learned a lot from him. Bates has been neglected in the histories of science fiction, but I think he made a genuine contribution in those early days." When the whole Clayton chain folded in 1933, Bates was out of a job. Street & Smith bought the *Astounding* title and revived it after a seven-month coma, but a new editor was hired. Bates turned to writing full-time and sold a number of science fiction stories to the magazine he had helped create. His novelette *Farewell to the Master* (*Astounding*, October 1940), about the arrival of an alien spaceship in Washington, D.C, was turned into the classic 1951 film *The Day the Earth Stood Still*. The movie version altered the original ending, losing the surprise and stunning impact of the final line of dialogue, spoken by Gnut, the giant robot: "You misunderstand ... I am the Master."

Harry Bates' fortunes declined in the 1940s. He lived by himself in a tiny room near the Street & Smith building on 7th Avenue and 14th Street. "He was a loner and just gradually went to seed," says a writer acquaintance. "He didn't take care of himself at all and there were emotional problems." He died in 1981, his final years spent in destitution on the streets of lower Manhattan.

At S & S, the man chosen to edit the revived *Astounding* was F. Orlin Tremaine. A journeyman editor, he had worked on all sorts of magazines, and the hardcore science fiction readers may not have been expecting much from him. But Tremaine was inspired by the job. He deliberately sought science fiction stories that were utterly new in concept and treatment—he called them "thought variant." Typical of his exciting purchases for the magazine were *Rebirth* by Thomas Calvert McClary, a story of the results of universal amnesia; *Ancestral Voices* by Nathan Schachner, in which a man travels back in time, kills an ancestor, and thereby destroys his own future; and Raymond Gallun's *Old Faithful*, about a "sensitive" Martian's doomed attempt to make contact with Earth. Says Gallun, "Sloane at *Amazing Stories* had rejected it. I mentioned it in passing to Orlin Tremaine and said that no editor would want it—it didn't follow the formulas. And he sent me a note right away telling me about the new 'thought variant' policy and that he didn't want to see any

March

WRNY STATION

25 Cents

AMAZING STORIES

HUGO GERNSBACK
EDITOR

Stories by
H. G. Wells
Jules Verne
Geoffrey Hewelcke

EXPERIMENTER PUBLISHING COMPANY, NEW YORK, PUBLISHERS OF
RADIO NEWS · SCIENCE & INVENTION · FRENCH HUMOR · RADIO LISTENERS' GUIDE

Right: Christmas in Ganymede *in the January '42* Startling Stories, *was an early work by Isaac Asimov. Asimov was already selling regularly to the pulps at the age of 22.*

Opposite: Although it was not readily apparent what was going on in this cover painting by Paul, it was certainly amazing. Editor/publisher Hugo Gernsback gave his radio station WRNY a rather gratuitous plug at the center-top of this cover from March 1928.

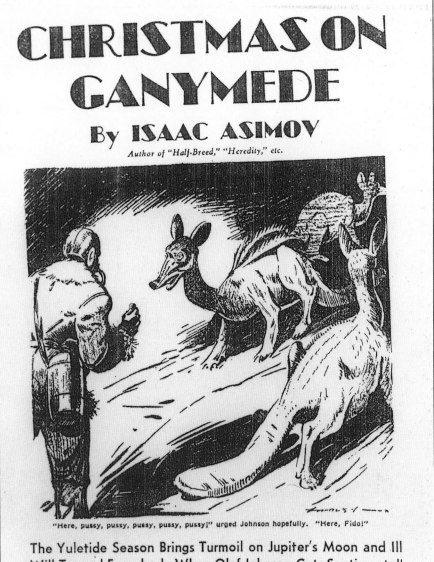

CHRISTMAS ON GANYMEDE
By ISAAC ASIMOV
Author of "Half-Breed," "Heredity," etc.

"Here, pussy, pussy, pussy, pussy, pussy!" urged Johnson hopefully. "Here, Fido!"

The Yuletide Season Brings Turmoil on Jupiter's Moon and Ill Will Toward Everybody When Olaf Johnson Gets Sentimental!

formula stories." Published in the December 1934 *Astounding, Old Faithful* was one of the first stories to present a sympathetic alien, not anthropomorphized exactly, but a thinking and feeling creature.

Another approach was taken by a Milwaukee writer whose first published story, *A Martian Odyssey* (*Wonder Stories,* July 1934), created a nearly unprecedented sensation in the science fiction community. Stanley Weinbaum's extra-terrestrials were truly *alien* aliens, conceived without any reference to humankind, but so brilliantly delineated that entirely imagined life-forms became "real." Weinbaum followed *Odyssey* with *Valley of Dreams,* and then *Wonder Stories* lost him to *Astounding.* By the time *Parasite Planet* appeared in the March 1935 *Astounding,*

Weinbaum was widely regarded as the most innovative science fiction writer in the world. But Stanley Weinbaum's career proved to be meteoric, lasting just 15 months. In December 1935, at the age of 33, he died of throat cancer.

One of the most memorable of the "thought-variant" stories Tremaine bought for *Astounding* was *Twilight,* a plotless, elegiac rumination on the jaded, passive state of the human race some seven million years in the future. The story was bylined "Don A. Stuart," but this was a pseudonym for John W. Campbell, an S-F writer of growing repute in the mid-'30s. In 1938, he replaced F. Orlin Tremaine as the editor of *Astounding Stories,* a move that would usher science fiction into its mature and intellectu-

ally rigorous golden age.

Born in Newark, New Jersey, in 1910, Campbell attended M.I.T., but failed to graduate due to an inability to master a foreign language. Even as a writer and editor, his primary interest was science, not literature. Although Campbell-the-writer had been responsible for some of the best action-packed space operas, Campbell-the-editor had no interest in buying any more of these shallow adventure stories. He made Astounding a vehicle for his vision of a technological, philosophical, iconoclastic, and idea-obsessed science fiction. Campbell consciously tried to take his magazine out of the pulp orbit. With the March 1938 issue, he changed the title to Astounding Science-Fiction, dropping "Stories," a word supposedly stigmatized by pulpy associations. He would eventually get rid of "garish" cover art in favor of more "mature" illustrations. More critical was his determination to make Astounding off-limits to the journeymen professionals who supplied materials to all the other pulp magazines. Instead, Campbell filled the magazine's pages with the work of new writers who had a serious understanding of technology and hard science. Among Campbell's discoveries were such S-F luminaries as Isaac Asimov, Robert Heinlein, Theodore Sturgeon, L. Sprague de Camp, A. E. van Vogt, Arthur C. Clarke, and many more.

Campbell encouraged writers—new and established—with an enthusiasm that bordered on the fanatical. "He was a superb and provocative teacher of science and of fiction," wrote Theodore Sturgeon. "He would return a story because it turned upon the fission of light metals or a compound of argon, and would explain to you in five or six or seven single-spaced pages why this was not possible—and give you something which would really work, and which in some cases, as with our nuclear energy technology, ultimately did."

One of the few pulp "pros" who made the grade with Campbell was L. Ron Hubbard. Hubbard had been a highly successful author of Western and adventure fiction from the age of 20. He was a well-known figure in the New York pulp community in the late '30s—well-known but not necessarily well-loved. Some of his fellow writers found him to be an egomaniac and a liar. "It was part of his character," says Jack Williamson. "He was a liar but a creative and successful one. When one lie was exposed, he could invent another one right away." A fast and skilled writer, Hubbard, along with Arthur J. Burks, was summoned to the Street & Smith headquarters for a meeting with the "top brass." According to Hubbard, he and Burks, two of the pulps' top-line professionals—"either of our names would send the circulation rates skyrocketing"—were asked to contribute science fiction stories to Astounding. Initially ignorant of the genre, Hubbard quickly became one of the stars of both Astounding and its companion fantasy magazine, Unknown.

In the late '40s, after a decade of writing often brilliant science fiction and fantasy, Hubbard came up with something different—a treatise for a brand-new form of mental-health therapy he called "Dianetics," and he convinced Campbell to publish it in Astounding. Campbell became, for a time, a convert to Hubbard's "mental health movement" after Dianetic therapy relieved him of a chronic sinus condition. The Astounding editor joined the board of directors of the Hubbard Dianetic Research Foundation established in Elizabeth, New Jersey. Eventually, Hubbard's movement developed into the Church of Scientology, with tens of thousands of followers and estimated assets of $1 billion, and the one-time hack writer of Foreign Legion and cowboy stories became a figure of international notoriety—certainly the only pulp writer to be the subject of a biography with the subtitle Messiah or Madman? Sam Moskowitz, the capo di tutti of science fiction historians, tells of the time in 1947 when L. Ron spoke to a gathering of the Eastern Science Fiction Association:

Hubbard spoke . . . I don't recall his exact words, but, in effect, he told us that writing science fiction for a penny a word was no way to make a living. If you really want to make a million, he said the quickest way is to start your own religion.

While Astounding cornered the market in adult, intellectual science fiction, other magazines thrived with offerings of more juvenile or fanciful S-F—rocketships, ray guns, and bug-eyed monsters (known affectionately as BEMs) aplenty. The late 1930s were the boom years for science-fiction periodicals. In '37, there were just three magazines specializing in science fiction. By 1939, that number had quadrupled. Ned Pines, with editorial chief Leo Margulies, had taken over Gernsback's Wonder Stories and changed the title—not unexpectedly—to Thrilling Wonder Stories. Other Standard Publications S-F pulps fol-

Opposite: Contents page, Startling Stories, January 1942.

⋆ THE BEST IN SCIENTIFICTION ⋆

STARTLING STORIES

Vol. 7, No. 1 CONTENTS January, 1942

A Complete Book-Length Scientifiction Novel

DEVIL'S PLANET

By MANLY WADE WELLMAN

Other Unusual Stories

Special Features

Cover Painting by Rudolph Belarski—Illustrating DEVIL'S PLANET

STARTLING STORIES, published every other month by Better Publications, Inc., N. L. Pines, President, at 4600 Diversey Ave., Chicago, Ill. Editorial and executive offices, 10 East 40th St., New York, N. Y. Entered as second class matter September 29, 1938, at the post office at Chicago, Illinois, under the act of March 3, 1879. Copyright, 1941, by Better Publications, Inc. Yearly $.90, single copies $.15; foreign and Canadian postage extra. Manuscripts will not be returned unless accompanied by self-addressed stamped envelope and are submitted at the author's risk. Names of all characters used in stories and semi-fiction articles are fictitious. If a name of any living person or existing institution is used, it is a coincidence.

Companion magazines: Thrilling Wonder Stories, Captain Future, Popular Western, Thrilling Mystery, Thrilling Western, Thrilling Detective, Thrilling Adventures, Thrilling Love, The Phantom Detective, The American Eagle, RAF Aces, Sky Fighters, Popular Detective, Thrilling Ranch Stories, Thrilling Sports, Popular Sports Magazine, Range Riders Western, Texas Rangers, Everyday Astrology, G-Men Detective, Detective Novels Magazine, Black Book Detective, Popular Love, Masked Rider Western, Rio Kid Western, Air War, The Masked Detective, Exciting Detective, Exciting Western, Exciting Love, Popular Football, Thrilling Football, Exciting Football and West. PRINTED IN THE U. S. A.

Top: This issue of Thrilling Wonder Stories, from the tail end of the pulp era (August 1949), contained stories by past and future masters of science fiction. John D. MacDonald, a dabbler in SF, would achieve fame in the crime genre.

Above: Planet Stories specialized in space opera and interplanetary adventure.

Right: Ray Bradbury in Los Angeles, 1940.

lowed—*Startling Stories*, featuring a full-length novel per issue (there was virtually no book publication of new science fiction in this period), and *Captain Future*, the first S-F hero pulp. The juvenile but highly entertaining adventures of the Captain were written by Edmond "World Saver" Hamilton, nickname derived from his penchant for saving entire planets in each of his stories. When *Captain Future* made its first appearance with a Fall 1939 cover date, Hamilton was one of the big names in science fiction, still a young man but a ranking veteran in the field, his Interstellar Patrol series in *Weird Tales* having done much to popularize the genre back in the 1920s. Captain Future—real name Curt Newton—was a kind of 21st-century Doc Savage, with colorful sidekicks and exotic gadgets, chasing evil super-villains back and forth across the solar system.

Other new titles to appear in that booming 1938–1939 period included Red Circle's spiced-up *Marvel Science Stories*, Fiction House's *Planet Stories*, Blue Ribbon's *Science Fiction* and *Future Fiction*. In 1940, Fictioneers (the budget division of Popular) weighed in with *Astonishing Stories* and *Super Science Stories*, while H-K Publications' *Comet Stories* marked the return of F. Orlin Tremaine to S-F editing. The latter magazine didn't last long, Tremaine quitting in the face of the company's shifty business practices.

Planet Stories was devoted exclusively to stories of interplanetary adventure. It became the regular home for the work of two of the best non-"hard" science fiction writers, Leigh Brackett and Ray Bradbury. Most of Brackett's stories were exuberant sword-and-sorcery swashbucklers, influenced by Edgar Rice Burroughs, Robert Howard, and C.L. Moore. She set them on familiar planets but these were fantasy locales, without atmospheric or geographic realities. The editors at *Planet* didn't care much about such things. One time they found they had put a Brackett story, *The Dragon Queen of Venus*, in the same issue with another Venutian piece. Some quick copy-editing saved the day, turning Brackett's story into *The Dragon Queen of Jupiter*. Unfortunately, it was sloppily edited and not all the original Martian references were removed, making the published story appear to be happening on two planets simultaneously.

Brackett also wrote tough private detective novels and some of her science fiction echoes this hard-boiled style, as in the Raymond Chandler—like opening paragraphs of *Lorelei of the Mist* (*Planet Stories*, Summer 1946):

The Company dicks were good. They were plenty good. Hugh Starke began to think maybe this time he wasn't going to get away with it.

His small stringy body hunched over the control bank, nursing the last ounce of power out of the Kallman. The hot night sky of Venus fled past the ports in tattered veils of indigo. Starke wasn't sure where he was anymore. Venus was a frontier planet, and still mostly a big X, except to the Venutians—who weren't sending out any maps.

Brackett's hard-boiled writing caught the eye of producer-director Howard Hawks, and he hired her to work on a screen adaptation of Chandler's *The Big Sleep*. Her collaborator on the script was William Faulkner. The wife of Edmund Hamilton, Brackett in the years ahead divided her time between writing science fiction and fantasy novels and screenplays, most of them for Hawks (*Rio Bravo, Hatari, El Dorado*, etc.). Her last film work before she died in 1977 was the script for George Lucas' *The Empire Strikes Back*.

Born in 1920, Ray Bradbury made his first pulp sale, *Pendulum*, to *Super Science Stories* in 1941. In the pages of *Planet Stories*, he began to develop his characteristic themes and poetic prose style. *Planet* published such early Bradbury classics as *Morgue Ship* and *Lazarus, Come Forth*, and in the Summer 1946 issue, *The Million Year Picnic*, the first of the stories that would make up the acclaimed and highly successful collection *The Martian Chronicles*. Bradbury, unlike so many of the science-obsessed S-F writers, expressed a rueful, anti-technology viewpoint in his story of an ordinary family that has fled to Mars just before Earth's inevitable self-destruction:

Science ran too far ahead of us too quickly, and the people got lost in a mechanical wilderness, like children making over pretty things, gadgets, helicopters, rockets, emphasizing the wrong items, emphasizing machines instead of how to run the machines. Wars got bigger and bigger and finally killed Earth . . . that way of life proved wrong and strangled itself with its own hands . . .

Before he began selling his work to professional publications, Bradbury had been a science fiction fan and an

Beings of the Ooze

By JOHN M. TAYLOR

Screaming, they glowed with a phosphorescent blue light!

Spence Burkly dared to enter the forbidden city of the ancient frog-men— dared to desecrate the sacred ground of Mount Dukai! From out of the past comes the awful vengeance of a race long dead—an unspeak- able doom to those who would boldly disregard the Curse!

Left: "Science fiction" in the pulps covered everything from "hard science" and speculative stories to "space opera" adventures and interplanetary fantasies.

Opposite: Leigh Brackett, circa 1939.

acquaintance of many established writers in the field, and for a time he published his own amateur S-F magazine. In this, he was representative of a phenomenon that was unique in the history of commercial publishing, the close interrelationship between the readers and the writers of science fiction. From the beginning, the genre inspired cultlike devotion from its fans, and their numbers in-creased with the arrival of each new magazine and land-mark story. Gernsback had started it all by encouraging networking among readers, printing full names and ad-dresses in *Amazing*'s letter-to-the-editor pages. Fan clubs and organizations, such as the Science Fiction League and the feuding Futurian Society and New Fandom, prolifer-ated in the 1930s, and on July 2, 1939, hundreds of fans met in New York for a historic gathering, the First World Science Fiction Convention. Other pulp genres had their

devoted readers, but only science fiction inspired such an all-consuming passion. Pulp hack Frank Gruber's nasty claim that he could pick out a science fiction fan in a crowd (it mostly involved the presence of eyeglasses and buck teeth) was an exaggeration, but there is no doubt that the S-F fans were a breed apart.

Many readers of *Amazing* and succeeding magazines became science fiction writers, and Gernsback further closed the gap between professional and amateur when, in 1933, he hired 17-year-old Charles Hornig, publisher of the mimeographed *Fantasy Fan*, to be editor of *Wonder Stories*. Twenty-year-old fan and science fiction activist Mort Weisinger was hired by Leo Margulies as editor of Standard's S-F titles, *Thrilling Wonder, Startling, Captain Future.* When Ziff-Davis bought *Amazing Stories* from Teck Publications (and fired 86-year-old editor T. O'Conor

Sloane), they handed the editorial post to another active fan, Raymond A. Palmer, who had once written a prize-winning essay on the topic "What I Have Done to Spread Science Fiction."

Hunchbacked and the size of a child as a result of being hit by a truck when he was seven, Palmer had a hard shell and a sardonic view of humanity. He exploited science fiction's lunatic fringe with a series of "non-fiction" stories known collectively as *The Shaver Mystery*. Richard S. Shaver was a Pennsylvania welder and long-time science fiction fan who began sending long, crackpot letters to the *Amazing* editors. Beginning with *I Remember Lemuria* in the June 1945 issue, Shaver warned the world of a race of malevolent creatures living in caverns beneath the Earth, using their occult powers to turn human beings into degenerate zombies known as "deros." Palmer emphasized that this was a *true* story and expected to drum up a little excitement, but *Lemuria* sparked a phenomenon. Not only did many of *Amazing*'s readers believe Shaver's stories, many sent in breathless accounts of their own encounters with the same cavern-dwelling monster race and vicious dero legions. *Amazing* became the house organ for occult conspiracy theorists, mental patients, and other distinctive fans. While circulation was boosted by the erupting controversy, the coherent S-F fans were alienated or repulsed. Many thought the concept of a prehuman race of evil gods waiting to grab power on Earth was suspiciously similar to the fictional Cthulhu Mythos of H. P. Lovecraft. Palmer's motive in all this was pretty clear—he had also endorsed the veracity of a geriatric hoaxer who claimed to be a 120-year-old Jesse James. But Richard Shaver was a true believer, genuinely disturbed. Shortly before his death in 1975, long after the controversy had faded, Shaver wrote to science fiction historian Mike Ashley that " S-F fans never seemed to get the point because of mind-control from dero sources, I believe … the fans only saw the stim and the sex orgy and the sensationalism in the *Amazing* magazine set-up, never what I wanted them to see and absorb … the nature of evil and how to do something about it with magnetic control devices which alter the flow of thought into a better pattern than the 'norm' …"

IN 1944, some U.S. military intelligence agents burst into the office of *Astounding Science-Fiction* editor John Campbell. They carried with them a copy of the story *Deadline* by Cleve Cartmill, published in the March issue, and demanded to know the source for atomic energy "secrets" revealed in the story. Campbell patriotically explained that, far from indicating a leak at the Manhattan Project, the ideas in the story belonged to a *tradition* of scientific prophecy practiced in the science fiction pulps since their inception. The encounter would prove to be illustrative of the greater attention and respect science fiction would receive in the post-war world.

In the 20 years between the first issue of *Amazing Stories* and the end of World War II, science fiction had come a long way, steadily increasing in size, quality, and impact. For those first 20 years, the pulps alone had supported this growth. Science fiction in book form, in the slick magazines, on the radio, or in the movies was virtually nonexistent. The war—with its rockets, high-tech genocide, atomic bombs, the revealed potential for total global destruction—would change this situation, provoking widespread interest in the literature of technological and sociological speculation. Science fiction would thereafter reach a mass audience beyond the far-sighted readership of the pulps, an audience eager to comprehend its fragile and dangerous future.

Bates shook his head slowly and sighed. Jerking his mind back to business, he darted to the bureau, slipped the car key, the license folder and the money-crammed pocketbook into his pockets.

At any moment Mabel or Bessie might wake up. Irene might recover her senses and pound on the bathroom floor.

Moving swiftly, silently, the detective eased to the side of the bed and slipped the automatic from Bessie's pillow. His own forty-five automatic was jammed into his coat pocket. He left the bed, started across the floor, and Irene came to life in the bathroom, banged on the floor.

Bessie and Mabel shot erect in the bed, Mabel staring at him with green, sleep-dulled eyes. The big blonde took one look at the gun in his hand, then clawed frantically through the bed covers, hunting her automatic.

"I've got it, Bessie, darling," Bates said grimly. "Irene's locked in the bathroom and her banging

backed toward the
three escaped pri
Atlanta pen will gi
gency some nifty pul
turn you in, but bu
ss and pleasure is—
"Well, the three o
ave killed me event
no guns, so—" P
Hubert Bates grasp
behind him.

serve *your copy*

of

ollywood

Detective

TODAY!

Final Issue

THE END OF AN ERA

*It is in the very nature of ephemeral literature that the
people will weary of it in time, that they will demand a new
thing, at least in appearance if not in substance.*

—Mary Noel

A S THE 1940S BEGAN, no one could have guessed
that the pulps were dying. Indeed, it was not until
the following decade that the last rites would be performed.
But by 1940, the seeds of destruction were in place. Only five
years before, original-material comic books had been only an
idea in the mind of pulp-adventure-writer Major Malcolm
Wheeler-Nicholson. By the early '40s, the combined monthly
sales of comic books was in the tens of millions. Two titles
alone—*Action Comics* and *Superman*—sold over two million
copies per month. By the end of the war, the circulation of
comic books was four times that of the pulps. And it was late

*Above: Frederick Faust, better known as Max Brand, in the
1940s.*

in 1938 that a man named Robert DeGraff and three executives from the publishing firm of Simon & Schuster test-marketed a two-thousand-copy softcover, "pocket-sized" edition of Pearl Buck's *The Good Earth*. With copies placed at random in stores in midtown Manhattan, the edition was a near sellout on the first day. Pocket Books, the first American company to publish paperback books on a large scale, was officially launched in 1939 with the release of ten titles, each printed in an edition of ten thousand copies. By the mid-'40s, dozens of companies had entered the paperback field, and editions of one million were not uncommon. Paperbacks as a format had been given a huge boost by the coming of war. They were popular with the troops overseas, and family members were encouraged to send the conveniently packaged books to the relatives in uniforms. Pocket Books even set up a Prisoner-of-War Service just for people who wanted to send books to captured Americans. The Red Cross and various other do-gooders organized drives for the purchase of paperback books for soldiers. No such groups were likely to encourage the sending of "sordid" pulp magazines. By the end of the war, a large number of Americans had become used to buying and reading softcover books. In post-war America, paperbacks, along with comic books, would be grabbing much of the newsstand space that had previously belonged to the pulps. And then there was television—in its infancy, of course, in the early '40s, but by the end of the decade, well on its way to changing America's habits forever.

The war was a mixed blessing for the publishers of pulp magazines. Anxiety on the home front meant an increased demand for escape reading, but market expansion was curtailed by restricted resources. "We sold everything we put out," Henry Steeger of Popular recalls. "The percentages for most of our titles were the highest they had ever been. We could have sold even more but it was impossible to get more paper because of the war." The wartime paper restrictions would do more than just put a cap on overall circulation. Pulp publishers responded to the shortage by canceling all of the marginal magazines so as to give more of their paper allotment to the proven moneymakers. This meant the end for the quirky, fringe-appeal titles that had give the pulps of the 1920s and 1930s so much of their dazzle and crackpot charm. And fewer magazines meant, of course, fewer stories would be bought and fewer writers would be needed to write them. The colorful subspecies known as Pulp Writer was on its way toward extinction.

face and lay still with the knife driven up to its very hilt. She had been slain accidentally by one of her own brutal allies.

Monty took advantage of these few tense seconds to reclaim his automatic from the floor. He swung its muzzle toward the man who had thrown the knife.

"You see what you've done," he said harshly. "Make another move and I'll fire."

The man stayed still now, cowed by the threat in Monty Wills' voice and by the sight of that unwavering gun. Monty flung a question at the girl. He felt he had a right to now.

"What's it all about?" he said.

The girl was staring at the dead woman with fascinated eyes. Then words came to her pale lips.

"It's terrible, but she deserved it. She would have stood by and seen us both murdered if there had been no other way. She was like that always —full of greed and brutality. Those

Many of the notables had already moved on. Lovecraft, Robert Howard, and Talbot Mundy were dead. Dashiell Hammett, Erle Stanley Gardner, Raymond Chandler, and Cornell Woolrich were successful and acclaimed novelists. Fred Nebel and others had "graduated" to the slicks, where they earned ten and twenty times the word rate at the pulps. Quite a number of pulp writers—Horace McCoy, Steve Fisher, Leigh Brackett, Borden Chase, Richard Sale, Frank Gruber—found more remunerative work as screenwriters in Hollywood. Robert Leslie Bellem, the man of a thousand pseudonyms and king of the Spicys, became a television writer, scripting numerous series including *The F.B.I.* and *Superman*. Jack Williamson took a lengthy leave of absence from writing and became a university professor, teaching one of the first academic courses in the art of science fiction. Norvell Page, the man who used to dress up like his avenging character, The Spider, went into mysterious government work in Washington. Arthur Burks, the pulps' legendary "speed merchant," author of thousands

of pulp stories of all sorts, finally got tired of writing. He disappeared from New York, and his pulp pals lost track of him. One evening many years later, an old pro and former friend of Burks named Ryerson Johnson ran into him in Chicago. The ex-Marine, ex—pulp hack was now a spiritualist called "Professor" Burks and giving psychic "life readings" for a substantial fee. Under his breath, he asked Johnson not to give him away, for old time's sake. A lot of writers whose bylines had meant something once simply faded from the scene, never to be heard from again. And there were writers who had done good work in the pulps, made names for themselves, and then burnt out or lost their touch. The publishers stopped buying from Fred MacIsaac, a one-time very popular and successful contributor to countless magazines, and one day in his Chelsea Hotel room he killed himself. Norbert Davis, highly talented contributor to *Black Mask, Argosy, Dime Detective,* and others, had a similar streak of bad luck and despair and took his own life; he was 40 years old.

As World War II raged, a curious thing occurred. Two men who were both well along in years and had little or no experience with war or with war reporting pulled the necessary strings and got themselves accredited as combat correspondents. They were Frederick Faust, better known as Max Brand, and Edgar Rice Burroughs, two men who, more than any others, were responsible for setting the standards for excitement and color in popular fiction in this century. It was as if, in old age, the two famous writers had finally determined to experience firsthand the adventure and danger they had written about for so many years. Burroughs came home from his adventure and died of a heart condition at the age of 75. Faust, the "titan of popular literature," was assigned to cover the Italian campaign. Accompanying a platoon of infantrymen into battle against an enemy stronghold, facing a heavy artillery barrage, Faust was hit in the chest with shell fragments and died on the battlefield.

In the post-war years, the pulps declined steadily in sales and in quality. By the end of the decade, nearly all the remaining publications were detective, science fiction, or Western. New titles in these categories were still appearing but without impact or distinction. Forces within and without were plotting the pulps' destruction. One of the major periodical distributors decided it did not want to handle any more of the cheap fiction magazines. Street & Smith decided to fold all of its pulps with the exception of *Astounding,* which continued in digest form. Things happened slowly and then all at once. Detective story writer Richard Deming once told of a visit he made to New York in late 1950, picking up assignments from a half-dozen different pulp editors. A month later all six were out of jobs and their magazines were out of business. "We tried to hold on," says Henry Steeger, "and thought the conditions might change. But by 1954 it was all over. The readers had gone on to other things. They looked at the pulps as something from the 'old days,' you know?"

The writers mostly had mixed feelings about the passing of the pulps. Many felt that those days were best forgotten. They had outgrown the pulps, gone on to more mature work. The pulps seemed like a youthful indiscretion. Some writers could only remember the hard work, the endless days hunched over the Remington, pounding words onto paper until the clanging of the metal keys was ringing in the ears. But there had been good work, too, and the camaraderie, and the creative challenge. Mixed feelings. "I had gotten away from the pulps and was writing for the slicks and writing books," says Hugh Cave. "And I didn't really think about the pulps anymore. But I kept copies of every pulp in which I had stories printed, hundreds of them. I kept them stowed away in boxes in the garden house because there wasn't any room in my office. And one day the garden house caught fire and the boxes with all my stories burned. I lost all traces of my work from that period in my life. Gone up in smoke. And that was what happened to the pulps. Nobody cared about them, they weren't reprinted, they were a totally dead thing. It was as if that whole era had never happened."

And so the pulps died. A huge, unprecedented outpouring of stories—good, bad, terrible, and brilliant—had disappeared, quickly forgotten. Copies of older pulps, including the most popular titles, were already scarce even in the early '50s. The cheaply made magazines carried a gene of self-destruction—they disintegrated after a time under normal conditions—and, anyway, most had been thrown away a week or two after their purchase. Gone up in smoke. It was as it had been intended.

"We just tried to entertain people," said Henry Steeger, whose Popular Publications had been the liveliest and busiest pulp house of them all, "to make them forget their troubles for awhile...to get lost for an hour in a good story or two. That was all we were trying to do . . . But, you know, in those days, the Depression, terrible conditions, a lot of people were down, and to give people some good stories to read was not such a bad thing. . . ."

IT was some time later when I said: "Okay, baby. Now you know I'm your friend. Maybe you'll answer a couple of questions, huh?"

"Such as what?" she asked me.

I said: "Well, for one thing, how long had Billy Sanston been intimate with

She went white and damned if she didn't faint.

your mistress, Kitty Calvert? How long had he been coming to visit her?"

"A—a long time. Almost a year. N-now let me go, please—!"

"Not yet. Tell me something else. Did Kitty know Billy's wife?"

"Y-yes. Just slightly. They weren't good friends. Sometimes I got the im-

pression that Mrs. Sanston suspected her husband of being in love with Miss Calvert. Of course I wasn't sure. Now

please let me get away—before the police come!"

Outside, in the distance, I heard sirens moaning. I said: "Sure, kiddo. Put on a coat to cover yourself. Then scram out the window."

She got a coat and I held it for her.

Appendix

COLLECTING PULPS

A safe—if unscientific—guess would be that only a tiny fraction of one percent of all the pulps ever published still exist in any form today. The number of these in very good or better condition is even smaller. For the various reasons cited elsewhere in this volume, the pulps were never intended to outlast the dates on their front covers. Their ephemeral nature consigned the majority to the trash can, and unstable physical ingredients eliminated most of the rest. In their own day, the lowly pulp magazines were not likely to be collected by any conventional archive, and by the time libraries and universities woke up to the literary and historical importance of certain pulp titles, such as *Black Mask* and *Weird Tales*, it was already too late. Even the narrowly specialized academic collections, like the *Black Mask* file at U.C.L.A., remain incomplete. The survival of pulps in good condition is in large part due to the enthusiasm and care of the private collectors.

Because of the pulps' relative scarcity, they have never attracted the kind of mass, frenzied attention visited upon comic books, baseball cards, and other twentieth-century American artifacts. While certain golden age comic books have sold for upwards of $20,000 in recent years, the scarcest or most-sought-after pulps have seldom traded hands for more than three figures. The pulps have remained mercifully free of the "corrupting", price-raising influence of price guides and auction houses, and free of the mirthless speculators who lock their paper treasures away in bank vaults, knowing more about price than about value. The typical pulp collector is a reader and dreamer, not an investor.

It is still not difficult to start a pulp collection, but one must know where to look. The days when stacks of medium condition pulps filled a back shelf at every used book and magazine store, and sold for a dime apiece, are over. Nearly all such copies have been scooped up by collectors or dealers, or have crumbled into oblivion on the shelf. And time is increasingly against the odds of finding

many more boxed cachés of "virgin" editions in attics and basements—Grandpa's forgotten collections of *Doc Savage* or *G-8 and His Battle Aces*. When pulps are found these days in vintage magazine stores or flea markets they tend to be the less-collectable western and romance titles, or copies from the very tail end of the pulp era, and in poor condition, selling for an average of $1 to $5. More select material is often found for sale in specialty bookstores devoted to science fiction, mysteries, or comic books. Such a store might offer a high-priced ($50 or more), one-of-a-kind item featuring a story by a popular or collected author—Raymond Chandler or Cornell Woolrich in *Dime Detective*, L. Ron Hubbard in *Astounding*, and so forth. While these shops may put a fair price on truly scarce items, they tend to overprice many of the less valuable magazines.

The best selection and fairest prices for pulps are found among those dealers who specialize in this genre. Most pulp dealers are themselves dedicated collectors and fans. They regularly buy from one another for their own collections and so have a vested interest in avoiding price gouging.

The value of a particular pulp depends, as with any collectable, on a variety of factors. Certain titles continue to be much in demand, including the most legendary pulps such as *Black Mask*, *Weird Tales*, and the major science fiction titles, *Astounding* and *Amazing Stories*. The so-called "hero pulps" have perhaps the greatest number of serious collectors. *The Shadow* and *Doc Savage* are the traditional favorites, and *G-8* and *The Spider* have their rabid adherents, but all hero pulps are collected and valuable. Among pulpophiles, there is a great demand for esoterica, those titles and categories peculiar—in every sense—to the pulps alone. High prices are paid for prime examples of the "weird menace" subgenre of the 1930s, featured in *Dime Mystery*, *Terror Tales*, *Horror Stories*, and a number of other titles offering outrageous crimes and painful punishments. Similarly "outre" and in demand are the notorious "Spicys" with their voluptuous cover girls and titillating prose. Also highly sought-after are the pulp obscurities and oddities, one-shots or short-lived titles whose strange specificity of subject matter tends to make the jaw drop, such as *Zeppelin Stories*, *Ozark Stories*, *Underworld Romances*, or *Dr. Yen Sin*.

The value of a particular copy of any pulp is further affected by the content. An issue featuring a story by the most collected authors—Burroughs, Lovecraft, Chandler, Hammett, and another couple dozen others—can double to sextuple the price of that magazine. Some people col-

Opposite: Seen here, an interior illustration for one of R. L. Bellem's many Spicy Adventure stories.

lect the works of a particular cover artist, such as Baumhofer, Rozen, or Tinsley, and notable cover art will raise the selling price.

Condition, particularly in the case of the poorly manufactured pulp, is a crucial factor in pricing. The brightest intact covers, and whitest, least brittle pages command the highest prices within a category. Many pulps had their covers removed long ago by used-magazine dealers, and these "reading copies" are sold for a fraction of the price of an intact copy. Most dealers and collectors now tend to keep all pulps in special plastic bags and away from light and moisture, hoping to forestall any further deterioration of the venerable magazines.

While any information about prices is subject to change, an idea of the current range may be of interest. Generally, an average generic pulp from the 1930s, with no outstanding cover art or contributor, can be found for $5 to $10. Better examples of the same may sell for around $20. The hotly collected titles are available for anywhere from $30 to several hundred dollars for important and mint condition copies. *Spicy Detective, Horror Stories*, and other esoterica begin in the $50 range and go up from there. As in any field of collecting, the value of an item depends on how much someone is willing to pay for it. If someone has a copy of, say, *Vice Squad Detective*, and someone else cannot live without it, the sky is the limit.

More information about pulp collecting, and dealers in pulp magazines, can be found in the following publications: *Pulp Review*, 4704 Colonel Ewell Court, Upper Marlboro, MD 20772; *Echoes*, 504 East Morris St, Seymour, TX 76380; *Golden Perils*, 5 Milliken Mills Rd, Scarboro, ME 04074; and *Pulp Vault*, 6942 N. Oleander Ave, Chicago, IL 60631. The greatest gathering of pulps and pulp fans and dealers is at Pulpcon, a small, amiable, annual convention held each summer, usually in Dayton, Ohio (write to Pulpcon, Box 1332, Dayton, OH 45401 for information).

Acknowledgments

I am very grateful to the following individuals for their generous contributions to the material in this book: Richard Sale, Hugh Cave, Lawrence Treat, Robert Bloch, Jack Williamson, Jack Scott, Fritz Leiber, Mrs. Charles Spain Verral, Theodore Roscoe, John Kobler, Jean Francis Webb, William Campbell Gault, Mrs. Lester Dent, Howard Browne, Raymond Z. Gallun, Tedd Thomey, the late Bruno Fischer, and the late Henry Steeger.

For editorial assistance I wish to thank Terri Hardin, Dean Server, and Arlene Hellerman. Thanks also to the Mysterious Bookshop, New York; Cellar Stories, Providence, Rhode Island; Science Fiction Bookshop, New York; Donato's Fine Books, Las Vegas, Nevada; TLC Custom Labs, New York; Duggal Color Projects, New York; Collectable Books, Upper Marlboro, Maryland.

For photographs and archival research my thanks also to the following individuals and establishments: Glenn Lord; George McWhorter, University of Louisville Library, Kentucky; Teresa Salazar, Special Collection, University of Arizona, Tuscon; Octavio Olvera, University Research Library, UCLA, Los Angeles; Jennifer Lee, Brown University, Rhode Island; Mary J. Walker, Eastern New Mexico University, Portales, New Mexico; Diane Boucher Ayotte, Western Historical Manuscript Collection, University of Missouri, Columbia, Missouri; Carolyn Davis, George Arents Research Library, Syracuse University, New York; Manuscript Department, Lilly Library, Indiana University, Bloomington, Indiana; University of California, Berkeley; Roy Campbell, Columbia University; New York Public Library, Rare Manuscripts Collection.

And a final thank you to Robert and Elizabeth Server.

Bibliography

BOOKS:

Bleiler, Richard. *The Annotated Index to the Thrill Book.* Mercer Island, WA: Starmont House, 1991

Cain, Paul (introduction by David Bowman). *Fast One.* Berkeley, CA: Black Lizard, 1987.

Cannaday, Marilyn. *Bigger Than Life.* Bowling Green, OH: Popular Press, 1990.

Carr, Nick. *The Flying Spy.* Mercer Island, WA: Starmont House, 1989.

Chapdelaine, Perry A., ed. *The John W. Campbell Letters.* Franklin, TN: AC Projects, 1985.

Clarke, Arthur C. *Astounding Days.* New York: Bantam, 1989.

Corydon, Bent and L. Ron Hubbard, Jr. *L. Ron Hubbard: Messiah or Madman?* New York: Lyle Stuart, 1987.

Davis, Norbert. *The Adventures of Max Latin.* New York: Mysterious Press, 1988.

De Camp, L. Sprague, Catherine Crook de Camp, and Jane Whittington Griffin. *Dark Valley Destiny.* New York: Bluejay Books, 1983.

Easton, Robert. *Max Brand: The Big Westerner.* Norman, OK: University of Oklahoma Press, 1970.

Ellis, Peter Berresford. *The Last Adventurer: The Life of Talbot Mundy.* West Kingston, RI: Donald Grant, 1984.

Farmer, Philip Jose. *Doc Savage: His Apocalyptic Life.* New York: Doubleday, 1973.

Gallun, Raymond Z. *Starclimber.* San Bernardino, CA: Borgo Press, 1991.

Goodstone, Tony, ed. *The Pulps.* New York: Chelsea House, 1970.

Goulart, Ron, ed. *The Hardboiled Dicks.* Los Angeles: Sherbourne Press, 1965.

Goulart, Ron. *Cheap Thrills.* New York: Arlington House, 1972.

Goulart, Ron. *The Dime Detectives.* New York: Mysterious Press, 1988.

Grant, Donald M. *Talbot Mundy: Messenger of Destiny.* West Kingston, RI: Donald Grant, 1983.

Gruber, Frank. *The Pulp Jungle.* Los Angeles: Sherbourne Press, 1967.

Holdstock, Robert, ed. *Encyclopedia of Science Fiction.* New York: Octopus Books, 1978.

Hubbard, L. Ron. *Battlefield Earth.* Los Angeles: Bridge, 1982.

Hutchison, Don, ed. *The Super Feds.* Mercer Island, WA: Starmont House, 1988.

Jacobi, Carl. *East of Samarinda.* Bowling Green, OH: Popular Press, 1989.

Johnson, Diane. *Dashiell Hammett: A Life.* New York: Random House, 1983.

Jones, Robert Kenneth. *The Shudder Pulps.* West Linn, OR: FAX, 1975.

Laymon, Richard. *Shadow Man.* New York: Harcourt Brace Jovanovich, 1981.

Lord, Glenn. *The Last Celt*. West Kingston, RI: Donald Grant, 1976.

Lovecraft, H. P. *The Doom That Came to Sarnath and Other Stories*. New York: Ballantine Books, 1971.

MacShane, Frank, ed. *Selected Letters of Raymond Chandler*. New York: Columbia University Press, 1981.

Moskowitz, Sam. *Explorers of the Infinite*. Cleveland, OH: World Publishing, 1963.

Murray, Will. *The Duende History of the Shadow Magazine*. Greenwood, MA: Odyssey, 1980.

Nevins, Francis M. *Cornell Woolrich: First You Dream, Then You Die*. New York: Mysterious Press, 1988.

Noel, Mary. *Villains Galore*. New York: Macmillan, 1954.

Nolan, William F., ed. *The Black Mask Boys*. New York: William Morrow, 1985.

Parente, Audrey. *Pulp Man's Odyssey*. Mercer Island, WA: Starmont House, 1988.

Perelman, S. J. *The Most of S. J. Perelman*. New York: Simon and Schuster, 1958.

Price, E. Hoffman. *Far Lands Other Days*. Chapel Hill, NC: Carcosa, 1975.

Pronzini, Bill. *Gun In Cheek*. New York: Coward McCann & Geoghegan, 1982.

Robbins, Leanard A. *The Pulp Magazine Index*. Mercer Island, WA: Starmont House, 1989.

Roscoe, Theodore. *Toughest in the Legion*. Mercer Island, WA: Starmont House, 1989.

Sampson, Robert. *Yesterday's Faces*. Bowling Green, OH: Popular Press, 1984.

Sampson, Robert. *Deadly Excitements*. Bowling Green, OH: Popular Press, 1989.

Shaw, Joseph T., ed. *The Hard-Boiled Omnibus*. New York: Simon and Schuster, 1946.

Smith, Clark Ashton. *The Black Book of Clark Ashton Smith*. Sauk City, WI: Arkham House, 1979.

Smith, R. Dixon. *Lost in the Rentharpian Hills*. Bowling Green, OH: Popular Press, 1985.

Traylor, James L., ed. *Hollywood Troubleshooter: W. T. Ballard's Bill Lennox Stories*. Popular Press, 1985.

Traylor, James L., ed. *Dime Detective Index*. New Carrollton, MD: Pulp Collector Press, 1986.

Wagner, Karl Edward, ed. *Echoes of Valor II*. New York: Tor, 1989.

Weinberg, Robert. *The Weird Tales Story*. West Linn, OR: FAX, 1977.

Williamson, Jack. *Wonder's Child: My Life in Science Fiction*. New York: Bluejay Books, 1984.

PERIODICALS:

Various Issues: *The Armchair Detective* (New York); *The Pulp Collector* (Upper Marlboro, Maryland); *Pulp Vault* (Chicago); *Mystery Scene* (Cedar Rapids, Iowa).

Particularly noteworthy are the articles and interviews—printed in an array of fanzines and small press publications—by pulp historians Nick Carr, Bernard Drew, Link Hullar, Sam Moskowitz, Will Murray, Albert Tonik, and Robert Weinberg.

Index

144